PRAIRIE
LAKE
FOREST

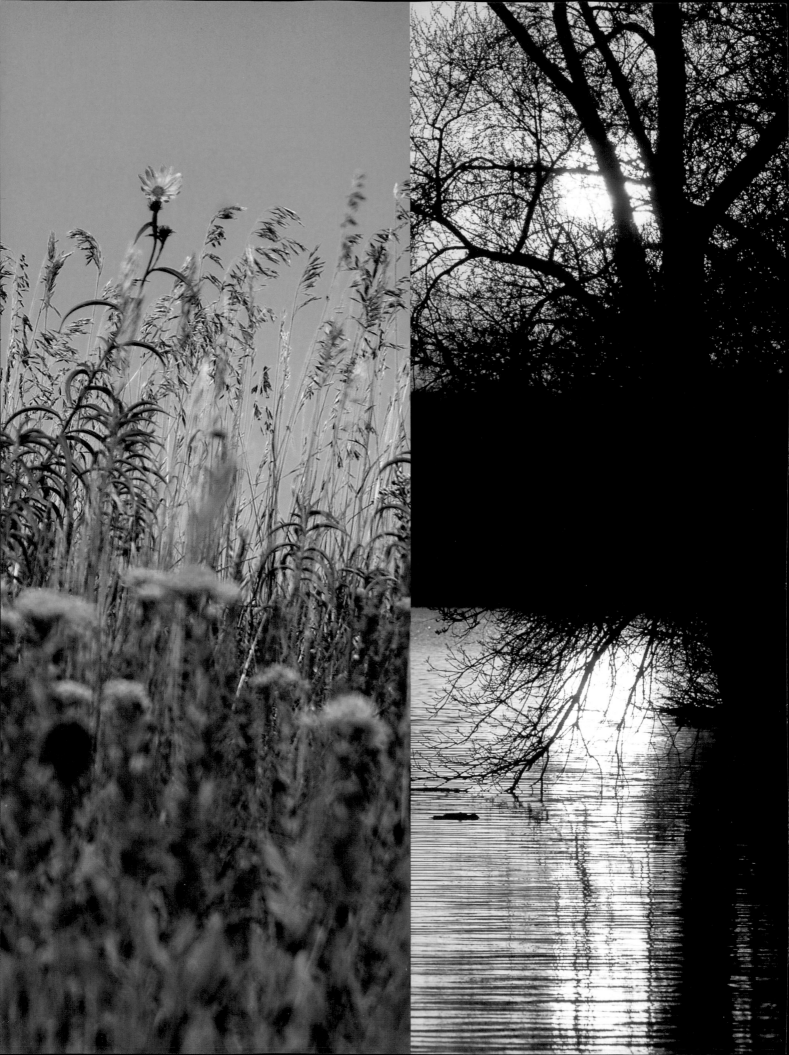

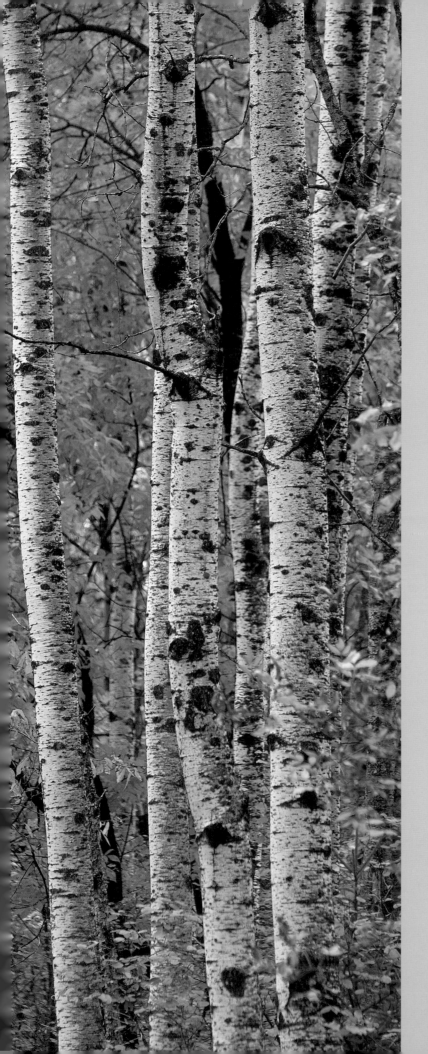

PRAIRIE LAKE FOREST

Minnesota's State Parks

Photography by Doug Ohman

Text by Chris Niskanen

Minnesota Historical
Society Press

www.mhspress.org

The Minnesota Historical Society Press is a member of the Association of American University Presses.

Book design by Brian Donahue / bedesign, inc.

Manufactured in China by Pettit Network Inc., Afton, MN

10 9 8 7 6 5 4 3 2 1

♾ The paper used in this publication meets the minimum requirements of the American National Standard for Information Sciences—Permanence for Printed Library Materials, ANSI Z39.48-1984.

International Standard Book Number
ISBN 13: 978-0-87351-771-3 (cloth)

Library of Congress Cataloging-in-Publication Data
Ohman, Doug.
Prairie, lake, forest : Minnesota's state parks / photography by Doug Ohman ; text by Chris Niskanen.
p. cm.
Includes index.
ISBN 978-0-87351-771-3 (cloth : alk. paper)
1. Parks—Minnesota—Pictorial works. I. Niskanen, Chris. II. Title.
SB482.M6O36 2010
333.78'309776—dc22
2009042010

This book is funded in part by the
Joseph and Josephine Ruttger Descendants Fund
of the Minnesota Historical Society

Contents

Minnesota State Parks and Recreation Areas

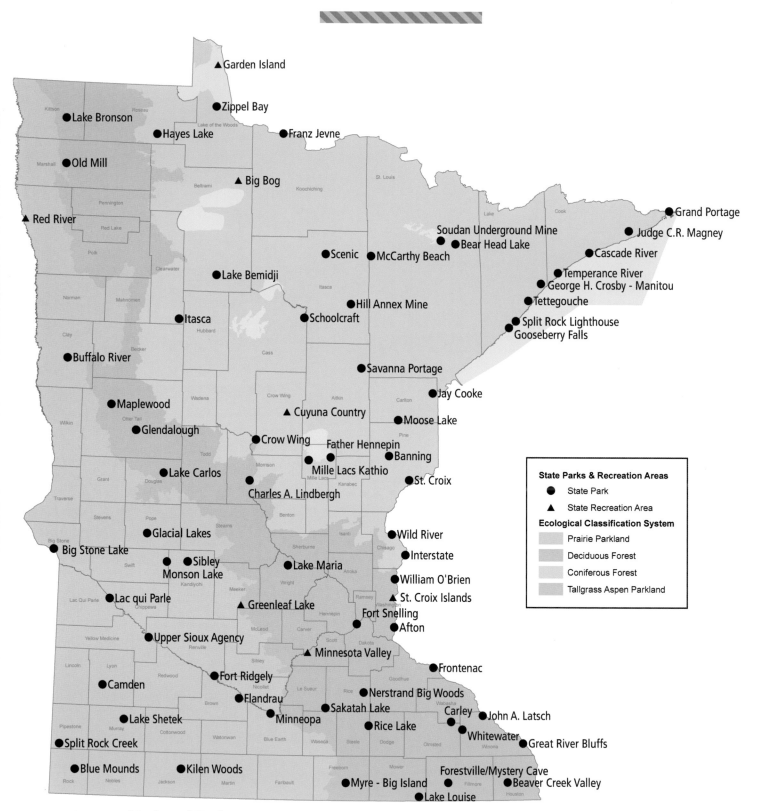

▲ Garden Island

● Zippel Bay

● Lake Bronson

● Hayes Lake

● Franz Jevne

● Old Mill

▲ Big Bog

▲ Red River

● Scenic

● McCarthy Beach

● Soudan Underground Mine

● Bear Head Lake

● Grand Portage

● Judge C.R. Magney

● Cascade River

● Lake Bemidji

● Hill Annex Mine

● Temperance River

● George H. Crosby - Manitou

● Itasca

● Schoolcraft

● Tettegouche

● Split Rock Lighthouse

● Gooseberry Falls

● Buffalo River

● Savanna Portage

● Maplewood

● Jay Cooke

▲ Cuyuna Country

● Moose Lake

● Glendalough

● Crow Wing

● Father Hennepin

● Banning

● Lake Carlos

● Mille Lacs Kathio

● St. Croix

● Charles A. Lindbergh

● Glacial Lakes

● Wild River

● Big Stone Lake

● Interstate

● Sibley

● Lake Maria

● Monson Lake

● William O'Brien

● Lac qui Parle

▲ St. Croix Islands

▲ Greenleaf Lake

● Fort Snelling

● Upper Sioux Agency

● Afton

▲ Minnesota Valley

● Frontenac

● Camden

● Fort Ridgely

● Nerstrand Big Woods

● Flandrau

● Carley

● Sakatah Lake

● John A. Latsch

● Lake Shetek

● Minneopa

● Rice Lake

● Whitewater

● Split Rock Creek

● Great River Bluffs

● Blue Mounds

● Kilen Woods

● Forestville/Mystery Cave

● Myre - Big Island

● Beaver Creek Valley

● Lake Louise

State Parks & Recreation Areas
● State Park
▲ State Recreation Area
Ecological Classification System
 Prairie Parkland
 Deciduous Forest
 Coniferous Forest
 Tallgrass Aspen Parkland

DNR Division of Parks and Trails

*Familiarity
with a place breeds
love of it.*

PAUL GRUCHOW

Preface

No matter how you utter them, the words *state park* are an invitation to hit the open road with a tent in your car—or at least to dream about it. The best part of writing a book about Minnesota state parks was telling people I was writing a book about state parks: every time I mentioned my task in a conversation, people would get a faraway look in their eyes, like I had touched a pleasant childhood memory. Often they would launch into a description of their favorite park or waterfall or a certain trip they took in, say, 1978. That Minnesotans have a fondness for state parks is an understatement. During the nine months I worked on the book, I was a sponge for other people's state park stories, and I never grew weary of them. This wealth of memories eagerly shared meant photographer Doug Ohman and I had tapped into a wonderful vein of Minnesotans' appreciation for the outdoors, natural science, history, and adventure.

Inevitably, people along the road—and this book represents a glorious road trip—would ask, "A new guidebook, huh?" and I could happily reply this was no guidebook. When Doug pitched the idea of a photography book on state parks and I was asked to write the text to accompany his terrific pictures, we knew immediately we didn't want to create a guidebook. That had been done before. Sure, we wanted to touch upon some of the icons of the park system—the Mississippi River headwaters at Itasca, for instance—but mostly we wanted to explore some of the stories within the parks. We wanted to look at parks through the lens of people who know them intimately. I was interested not in recounting

how high Gooseberry Falls is but, rather, what it's like to know its moods, from season to season. For our first brainstorming session, Doug and I sat in a small room and talked about all the things we enjoyed about state parks and then dreamed up every piece of state park trivia we'd ever wanted to know. We left that room feeling like we had been given the best assignment in the world.

Minnesota's state park system, one of the finest in the nation, is one of the best ideas this state has ever had. (I unashamedly steal that line from Ken Burns's recent tribute to our national parks.) That the park system continues to grow in size and attendance is a tribute to the managers, lawmakers, and legions of volunteers who see fit that our parks are not forgotten. Sometimes budget cuts, windstorms, or floods put a ding in the veneer, but Minnesotans never forget that state parks represent their abiding love of the outdoors and history. We hope this book adds to their sentiment and helps it endure as well.

I thank the following people for their invaluable assistance: Bryce Anderson, Pat Arndt, Amy Barrett, Randy Carlson, Connie Cox, Jason and Sarah Geisel, Bob Janssen, Dan McGuire, Warren Netherton, Travis Novitsky, Dennis O'Hara, Ed Quinn, Lee Radzak, Paul Sundberg, Judy Thomson, Kaija Webster, Chris Weir-Koetter, Mark White, and Rick White.

And I wish to thank Diana Boger, my wife and best friend, for making this book and all my dreams possible.

Chris Niskanen
Stillwater, Minnesota

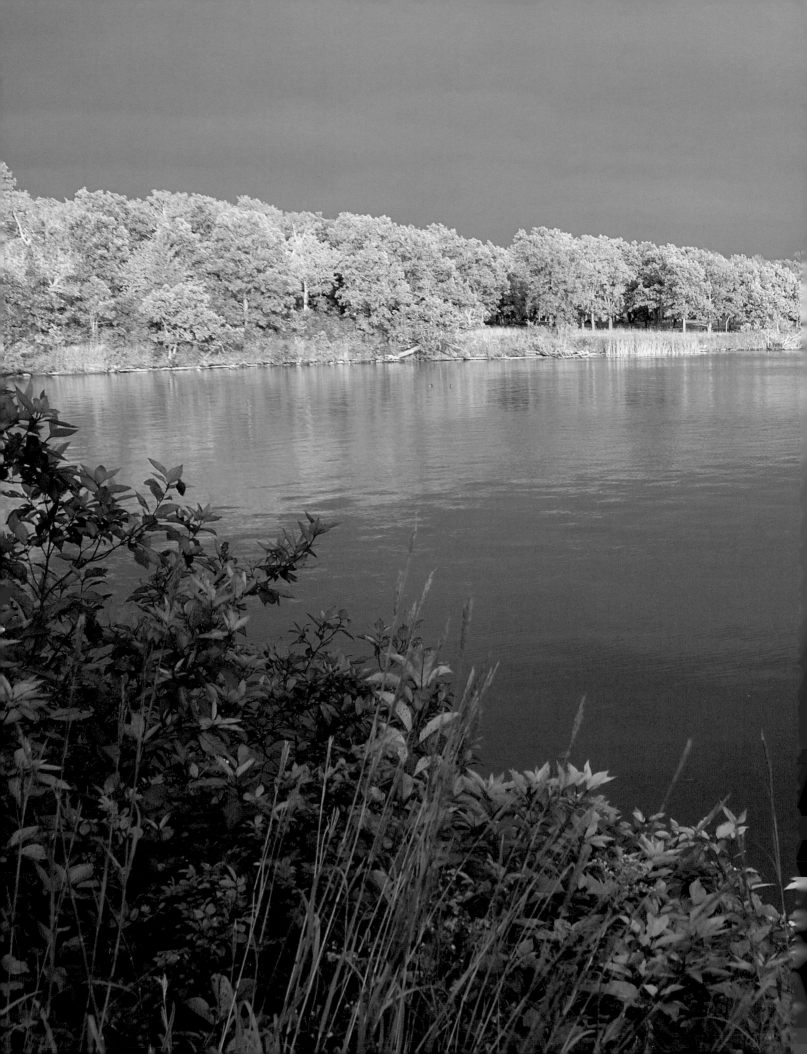

PRAIRIE
LAKE
FOREST

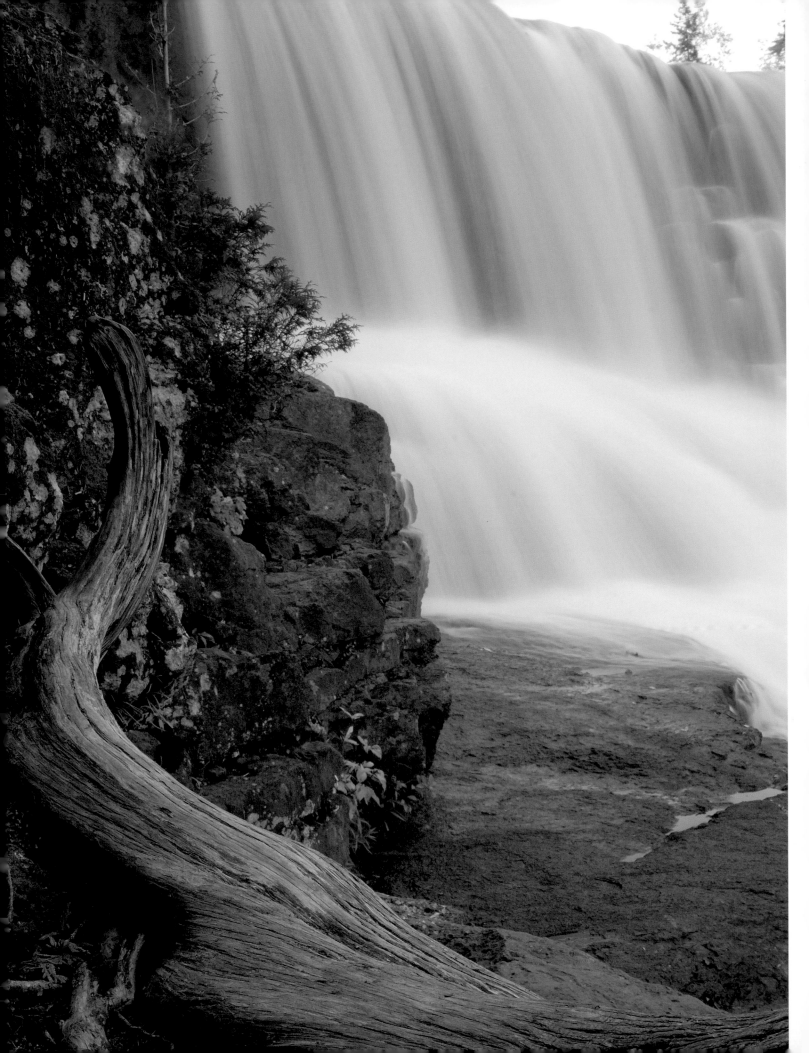

The Unsung Beauty of Falling Water

Paul Sundberg has seen Gooseberry Falls rushing in a mad torrent, fueled by Lake Superior storms. He has seen it reduced to a trickle, when hikers gather and giggle under the gently falling water. He has hiked in winter along the falls' icy ledges, when the river becomes a frozen edifice. Manager of Gooseberry Falls State Park since 1983, Sundberg has seen the Upper, Middle, and Lower falls in all their moods. And he is never bored with them.

"I never tire of seeing the falls," says the accomplished nature photographer who, not surprisingly, has a voluminous Gooseberry photo collection. "You never see the same thing twice. There is no time when it's not fun to see the falls."

Waterfalls may be Minnesota's least appreciated natural wonders. Or perhaps we quietly admire them and refuse to fuss. The state's foremost geologist, George A. Thiel, once gushed, "Minnesotans are proud of their many picturesque waterfalls. They have the kind of beauty in which diversity is more prominent than unity."

Our Yellowstone is Lake Superior's North Shore, which wasn't seriously considered for state parks until the construction of U.S. Highway 61 in the 1920s. Today, eight parks—Gooseberry, Split Rock Lighthouse, Tettegouche, George H. Crosby-Manitou, Temperance River, Cascade River, Judge C. R. Magney, and Grand Portage—are pearls in the necklace of North Shore attrac-

Gooseberry Falls State Park

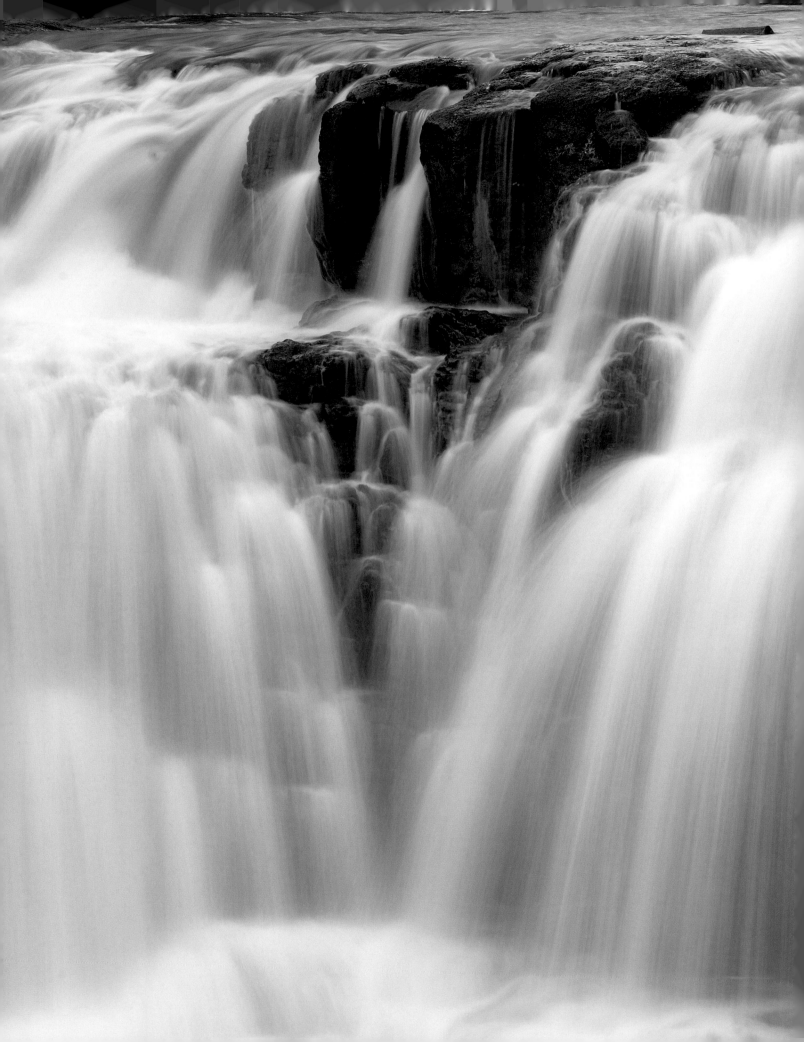

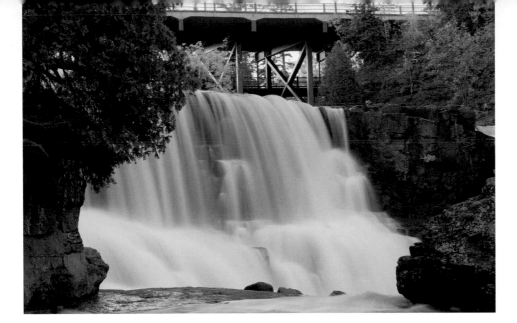

Gooseberry Falls State Park

tions, places we go to forget we're flatlanders and to get giddy over tumbling, spraying waterfalls.

Gooseberry is one bookend in this string of waterfall parks; the other is Grand Portage, 110 miles to the northeast. Here, Highway 61 drops you off at the U.S.–Canada border, but your last available turnoff is Grand Portage State Park and the aptly named High Falls of the Pigeon River. A single drop of 120 feet, High Falls is often cited as Minnesota's highest waterfall (though an arguable point is frequently made that a portion of the falls and river lie in Canada). Chester. S. Wilson, commissioner of the Minnesota Department of Conservation, said of High Falls in 1946, "For striking beauty and historic interest, it rates among the most notable waterfalls of the continent."

Like Sundberg, Travis Novitsky is a student of the waterfall in his "backyard" park. He grew up in nearby Grand Portage and is a member of the Grand Portage Band of Lake Superior Chippewa. Novitsky has hiked along the falls since he was boy, observing its seasonal and even daily moods, and began photographing it when he was a teenager. He also works at Grand Portage State Park.

"The sheer power of it grabs your attention," Novitsky says of High Falls. "It's such a big fall, a single drop, so the sound associated with that water falling is astounding. They say the average amount of water going over the falls is something like 3,200 gallons per second. That much water falling from a straight drop, hitting below, allows you to hear the water from the parking lot if there is no wind. That right away grabs you."

Gooseberry Falls State Park

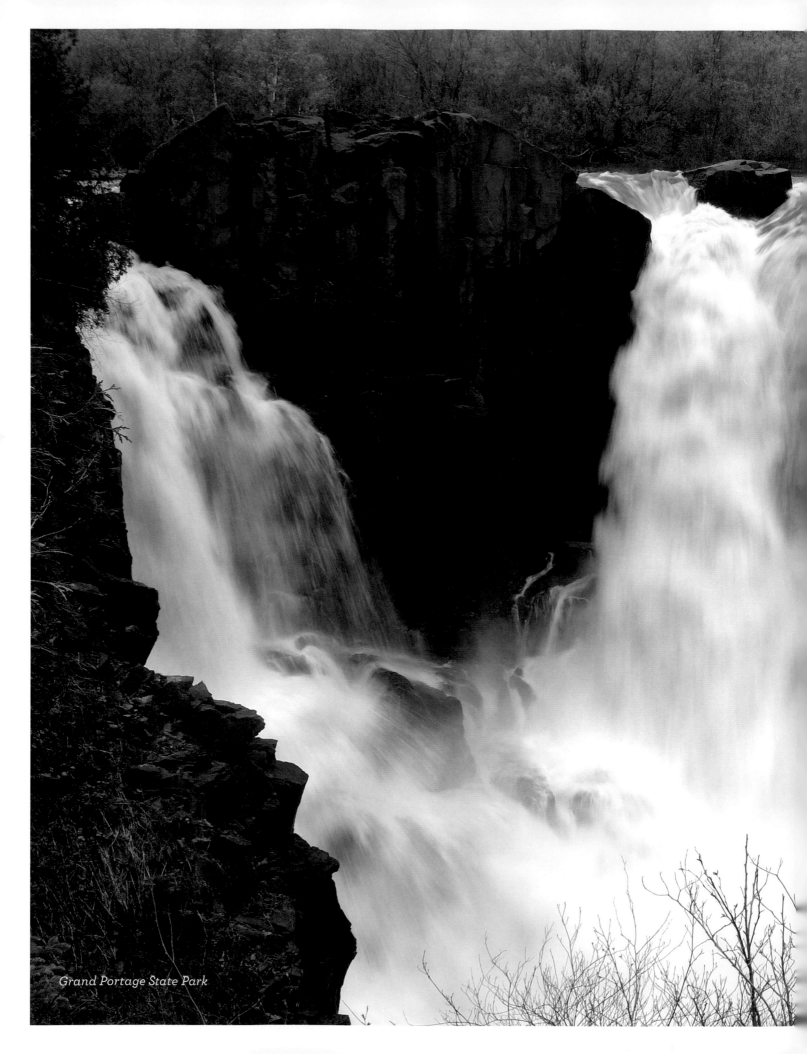

Grand Portage State Park

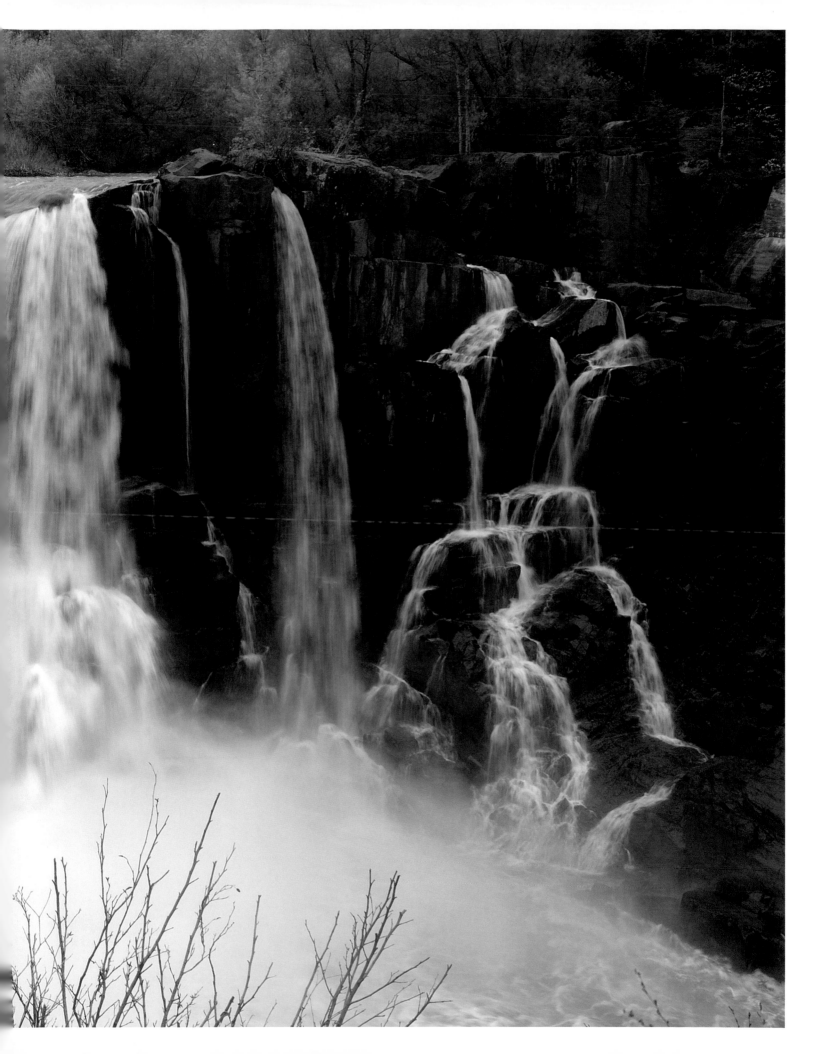

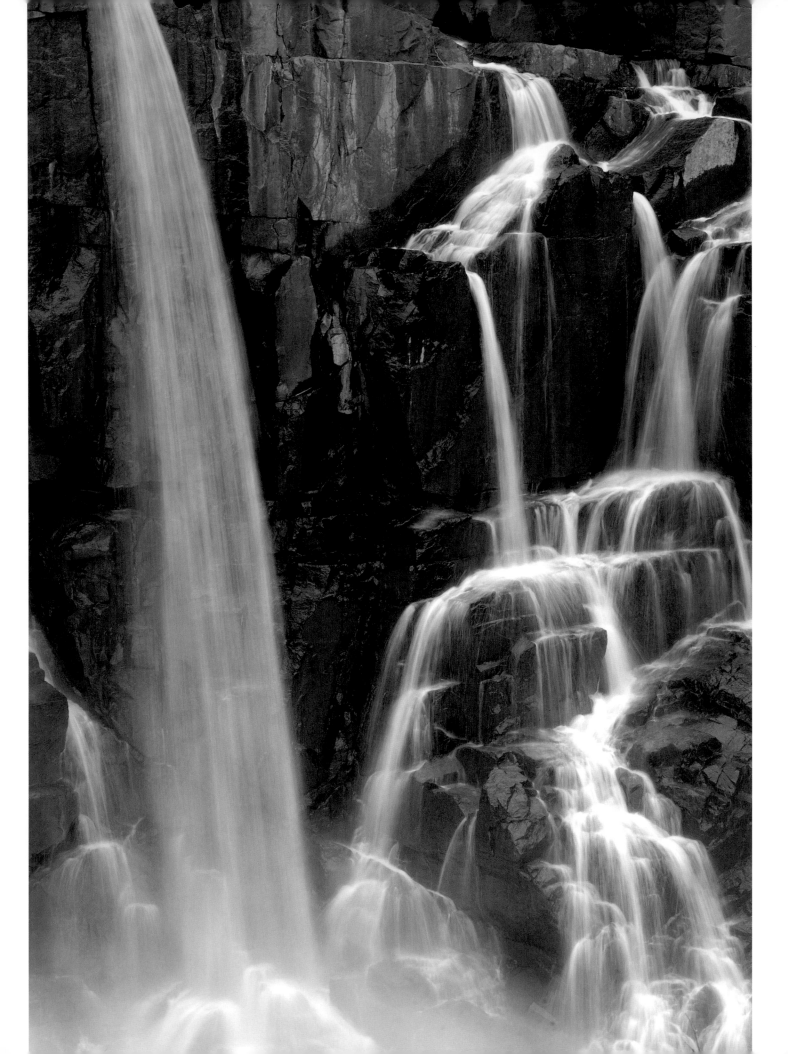

You'll sometimes find Novitsky, who also has a career as a nature photographer, admiring the falls in the dead of night. Moonlight is his favorite photographic backdrop. He often stays awake all night, prowling the rocks around the falls and nearby Lake Superior, hoping to capture the perfect image of the moon-illuminated landscape. One October, when he hiked to High Falls during a full moon and stood looking at the mist from the water, he noticed something peculiar suspended in the air. His old friend had a new trick: a faint rainbow had appeared over the falls, created by the light of the harvest moon. "I could actually see the rainbow with my naked eyes," he recalls with wonderment. "It took a long exposure, but the rainbow became apparent on the camera. It's one of my top three favorite pictures of High Falls."

Another photograph, taken in November, has an otherworldly feel to it. Spray the color of root beer from the falls (a natural tint from soil and plant tannin) has covered everything within reach of the storm-swollen falls. Blades of grass are long, glistening tubes, encased in four inches of ice. They look like creatures living near a deep-ocean volcanic vent. In the spring, Novitsky brings his rain jacket to High Falls. The Pigeon River, brimming with snow melt, turns the falls into a tourist-soaking machine. Novitsky's challenge then is keeping his expensive electronic camera gear dry. "You'll get drenched on the viewing platform," he says, but the photos are always spectacular.

In August 2007, when the North Shore was suffering through a drought, Gooseberry Falls had dwindled to a trickle. Visitors still came to the state park, among Minnesota's three most popular, and Sundberg noticed some were eager to prowl around the bare precipice. With merely a thread of water headed downstream, the stilled falls emitted a fascinating melody of water sounds through fractured rock. "When it's real low, it is interesting to walk closer to the falls," Sundberg says. "There is something about the sound of water slowly coming over the falls. I don't know quite how to describe it."

Gooseberry's quiet mood often doesn't last long. Sundberg remembers when the drought ended later that fall and a meteorological spigot was turned on. A series of moisture-filled October storms hit, and in a matter of a few weeks the falls went from their lowest level in Sundberg's memory to one of the highest. Water rushed down the gorge tsunami-like, closing trails and sending forest debris crashing over the falls and down into Lake Superior.

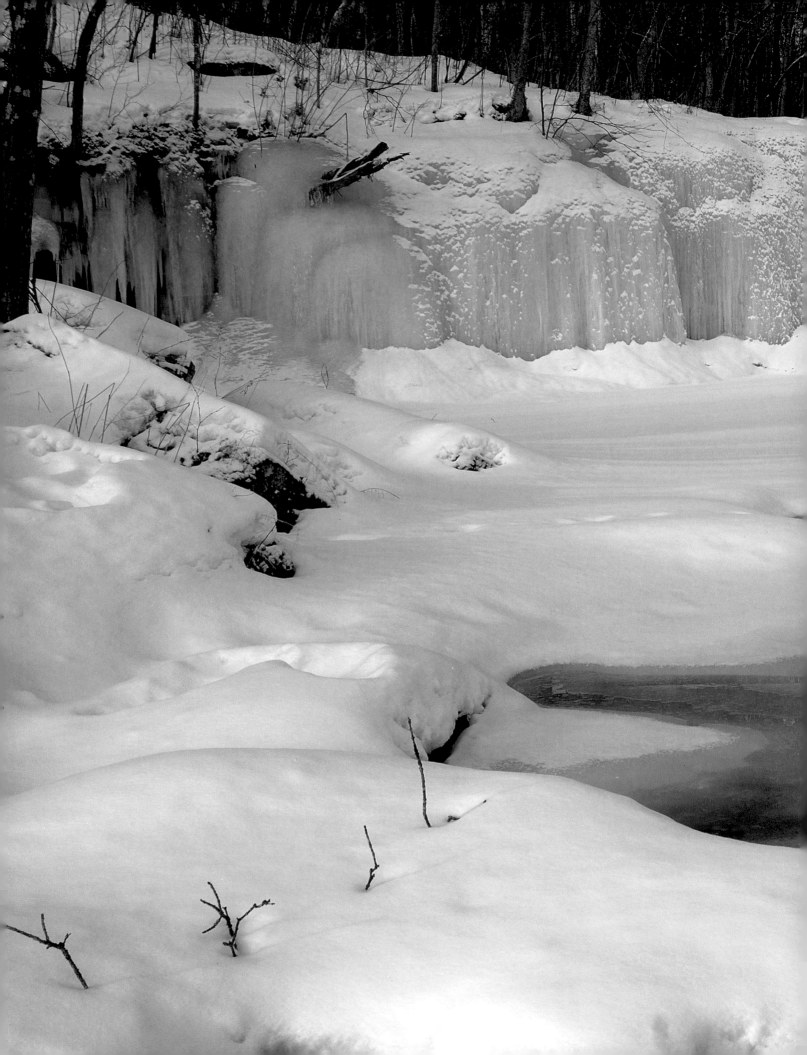

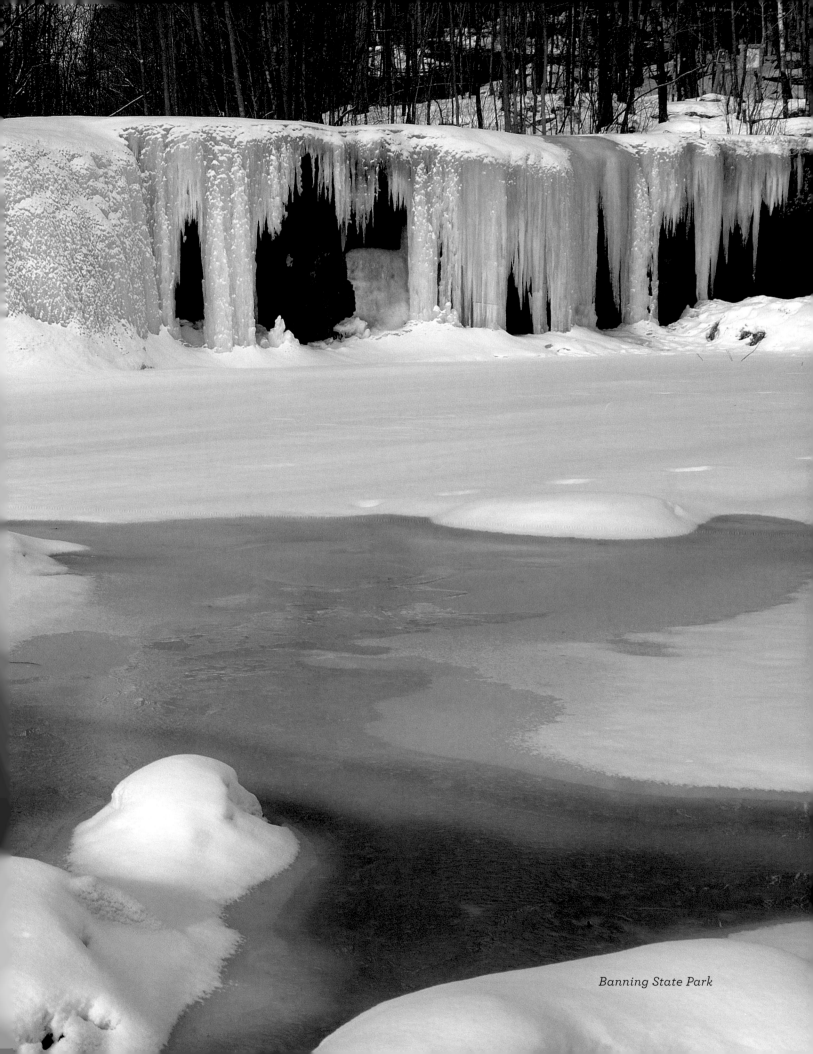

Banning State Park

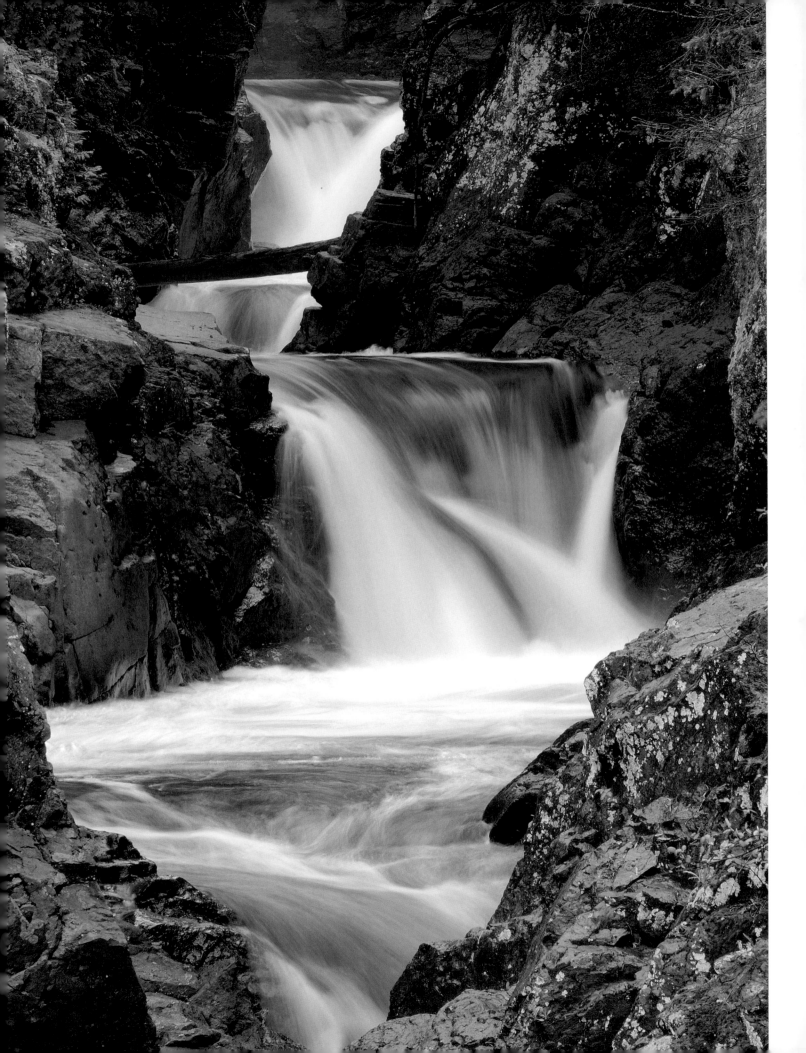

Blue Mounds State Park

Sundberg recalls, "Seeing the power of the water was breathtaking. You'd stand there, and millions of gallons of water were going by you every second. Every so often a whole tree would go by."

The following June, when the tourist season was under way, the falls returned to full fury. Heavy snow had kept the region's rivers brimming, and then another storm whiplashed the North Shore in early June. Sundberg gave an interview over the phone to a Twin Cities reporter who got a tip about the spectacle. "She's roaring today," he yelled into the telephone. "You can stand in the visitor's parking lot and hear the water roaring through the gorge. It's really impressive." Sundberg said the ground doesn't actually vibrate when the falls are that full, "but it feels like it." He described the illusion created by the thundering water, tricking the brain into thinking the Earth is thumping like a bass guitar.

Sundberg's favorite time to visit the falls is winter. He hikes down to Lower Falls on days when there are scant visitors, hoping to watch the tumbling water create veils of ice. Each new layer adds an opaque window on the moving water behind it. After a fresh snowfall and with temperatures hovering around twenty, Sundberg sits

Cascade River State Park

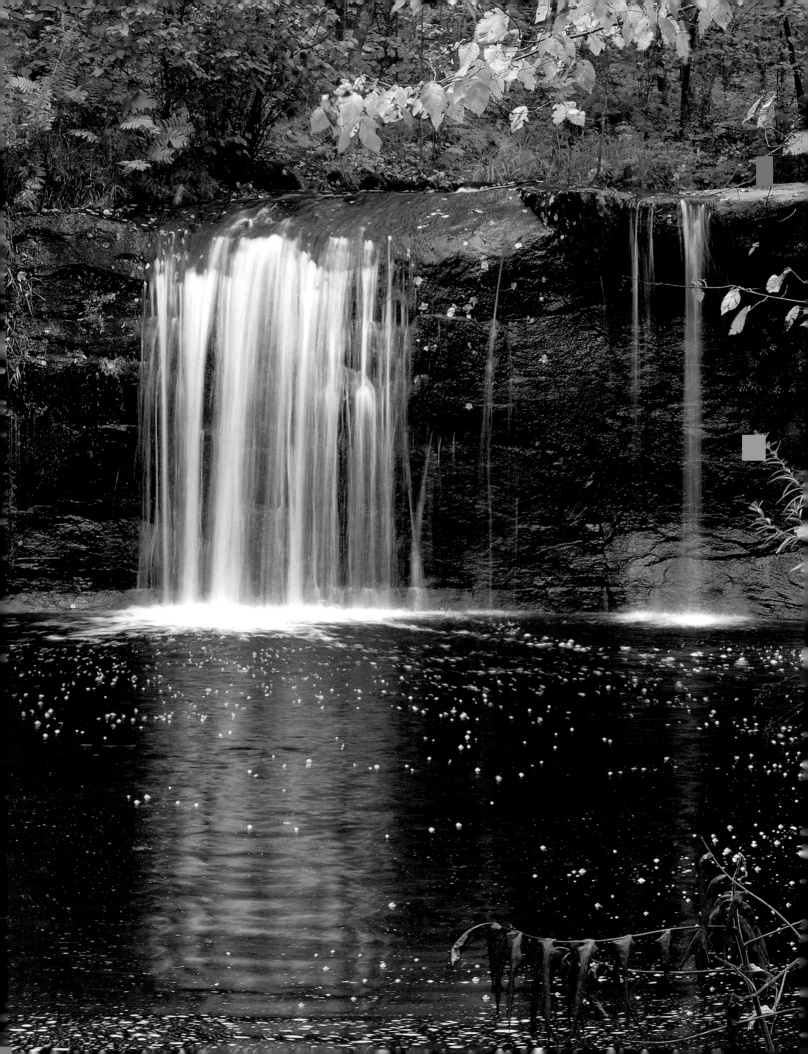

Banning State Park

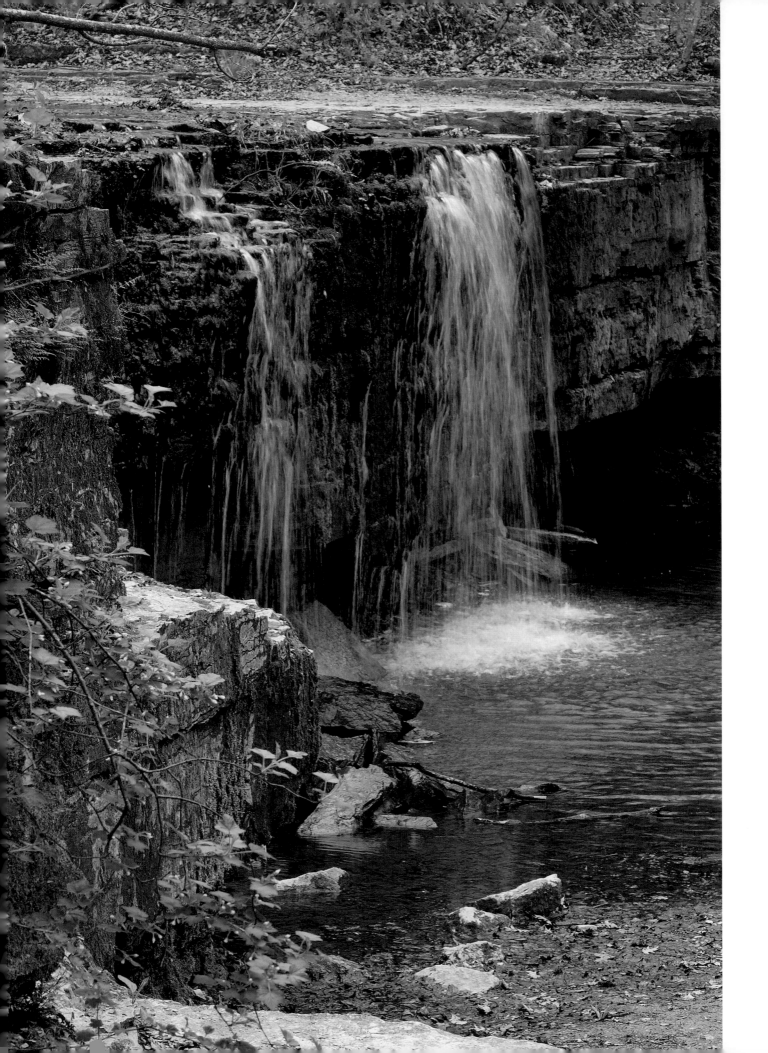

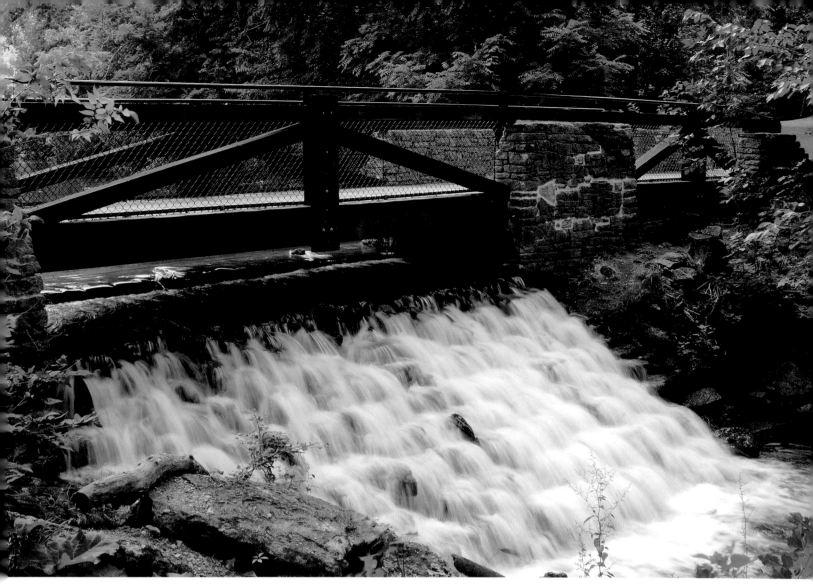

Whitewater State Park

Trickle or Deluge?

The most-visited waterfall in the state park system, Gooseberry Falls draws thousands of visitors a day during the peak summer and fall season. Toward the end of summer, however, the falls can fade to a trickle, exposing the one-billion-year-old lava flows that created the region's basalt bedrock. Why does Gooseberry Falls run high and low? For such a large river, its watershed is comparatively small—about one hundred square miles— meaning it draws water from a limited area. Thus, the river flows are greatly affected by drought or heavy rains.

"When you get a few inches of rain inland, it is quickly pushed through that narrow gorge in the park," said Paul Sundberg, manager of Gooseberry Falls State Park. "Even during the day, from morning to evening, you can see substantial flow changes."

And why do North Shore rivers appear brown? They carry a heavy load of clay soil during high-water periods; during low water, the tannins from swamps and dead vegetation color the water a brownish hue. ☒

Nerstrand Big Woods State Park

17

and listens for the hidden murmur of the water moving under the ice. "It always feels warmer down there on those cold days," he says.

Only twice in his career has Sundberg witnessed the cataclysmic breakup of Gooseberry's ice pack. After months of adding layer upon layer of ice, the falls can unleash its burden in great, glacier-like chunks the size of buses. When those chunks get pushed over the falls' rim, it's not dissimilar to the calving of an Alaskan glacier. Sometimes Gooseberry cleanses its ice at night, when nobody is around to witness the show. But if visitors get lucky and arrive in April when the ice gets blown downstream, "you can't hear someone talking next to you," Sundberg says.

Thiel, the Minnesota geologist, once wrote that "as modern man sees the waterfalls of today, he should recall that nature spent millions of years preparing the scene for his arrival." Even as a scientist, Thiel understood the ability of falling water to move the soul.

Novitsky says that 90 percent of visitors to Grand Portage spend an hour or less at the park. Perhaps the High Falls of the Pigeon River are less appreciated because of their remoteness: most anyone visiting the falls from the United States arrives at the end of a long automobile drive. Still, Novitsky says, another 10 percent linger at the falls, soaking in its spray and energy. Some hike farther into the park, visiting Pigeon River's rugged Middle Falls. From where he works in the state park gift store, Novitsky talks to people about the falls and answers their questions. Long ago, the Indians of Grand Portage created the nine-mile trek around the falls, which links Lake Superior to inland waterways and is celebrated at Grand Portage National Monument. Novitsky says whether they were perceived as obstacles or wonders of beauty, High Falls and other North Shore waterfalls have always been a source of awe.

"A waterfall seems to be a living and breathing thing," he says. "It changes from one day to another, from one month to the next. People don't know what to expect when they go up to High Falls. They might see a trickle of water or a raging river. Or two or three rainbows in the mist." ☒

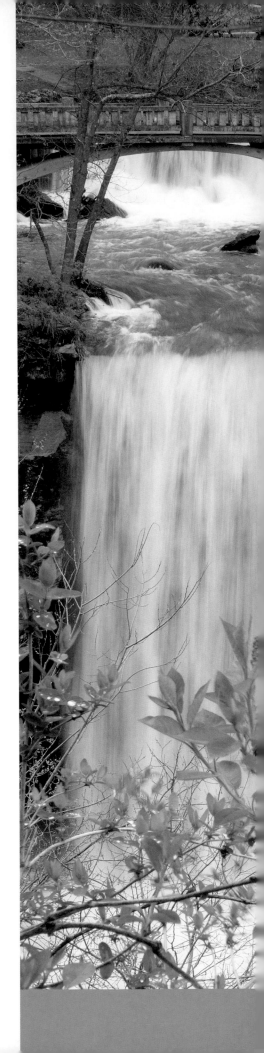

Minneopa State Park

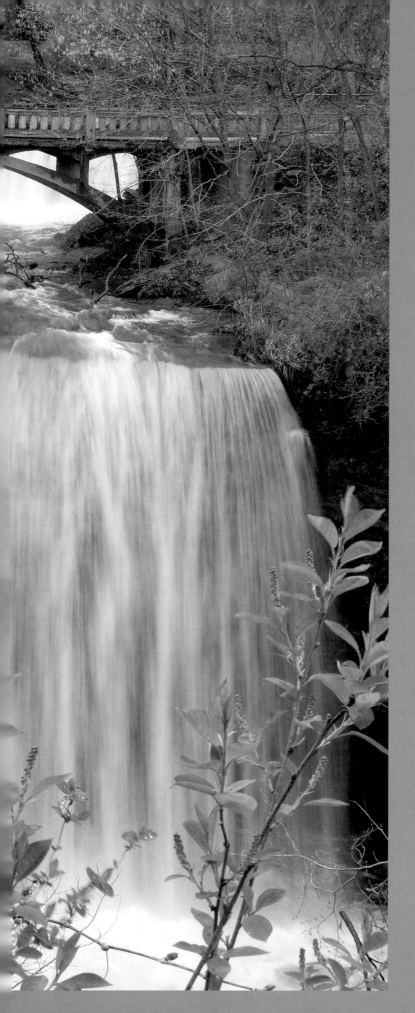

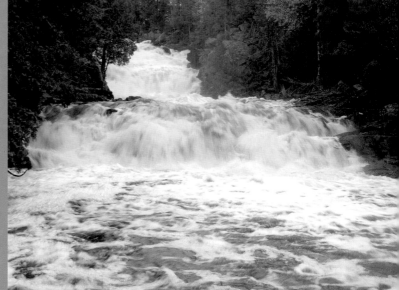

George H. Crosby–Manitou State Park

Must-see Waterfalls

Devil's Kettle: The Brule River rumbles through Judge C. R. Magney State Park, then hits a chunk of rock and splits in two. One half of the river blasts into a pool below; the other fork rages down and disappears into an echoing pothole.

High Falls: The Baptism River in Tettegouche State Park roars over an escarpment and falls sixty feet.

The Cascades: A three-step drop on the Manitou River, the falls are one of the main attractions at the rugged George H. Crosby–Manitou State Park.

Temperance River: Everyone visits Hidden Falls along Minnesota 61, but further upstream the river gorge in Temperance River State Park opens up and offers another lovely set of waterfalls.

Minneopa: The word in the Dakota language means "water falling twice," aptly describing the falls at one of the state's oldest parks. ⊠

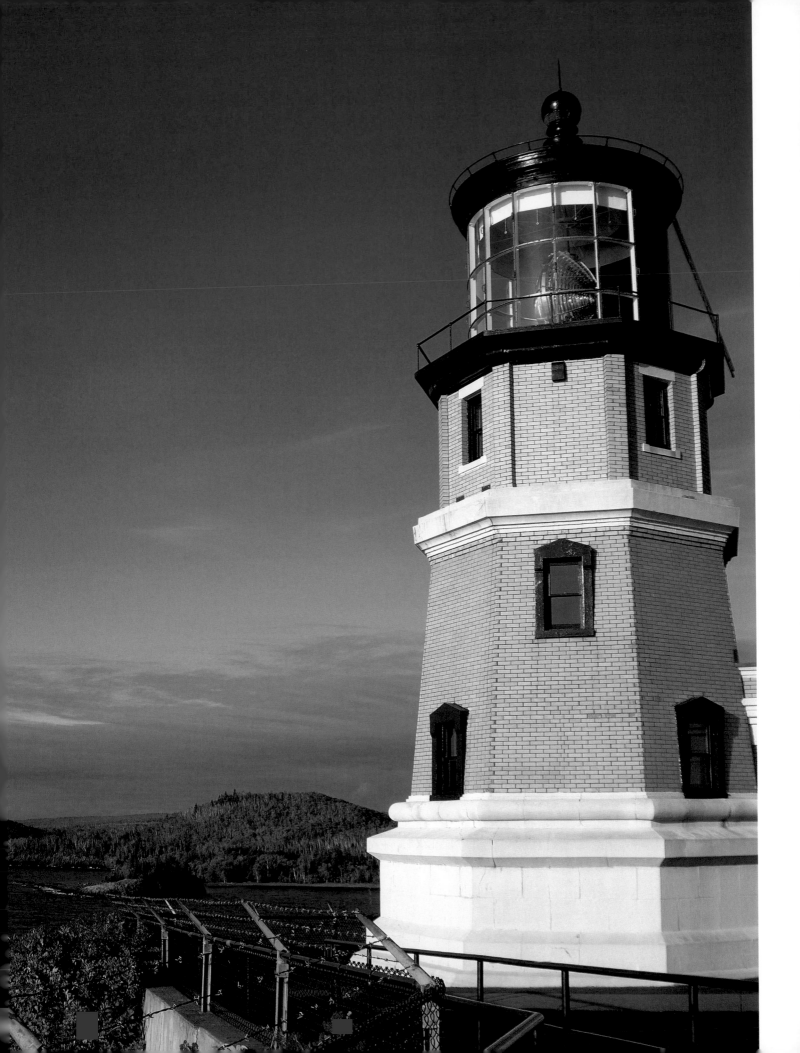

On a chilly fall evening on the North Shore of Lake Superior, a large crowd is gathering around Split Rock Lighthouse. In the dying light, staff armed with flashlights direct a stream of cars into the last remaining parking slots in the overflow lot; the hustle and bustle feels like the Fourth of July, but the calendar says November 10. Throngs of sightseers hike up the paved trail to the century-old lighthouse. Children ride on their fathers' shoulders, couples in stylish fleece jackets hold hands, and an elderly man in a wheelchair gets a push up the hill to where the dark beacon stands over the lake.

They have traveled here from across Minnesota and Wisconsin and beyond to honor a catastrophe still vivid in the minds of many: the 1975 sinking of the ore boat *Edmund Fitzgerald*, which departed from Superior, Wisconsin, and made its way past Split Rock Lighthouse on its final journey. Though the boat sank far from Minnesota's shore, near Michigan's Whitefish Bay, the Split Rock Lighthouse staff open the building every November 10 for a special ceremony to honor the dead sailors. It is the only formally announced lighting of the Split Rock beacon, which was decommissioned in 1969.

On this day, the lighthouse has been open since noon, and therein lies another attraction: it is the only time during the year when the public can see the famous lighthouse from inside, after dark and with the beacon lit. As visitors hike up the lighthouse stairs, a feeling of solemnity suits the evening.

Split Rock Lighthouse State Park

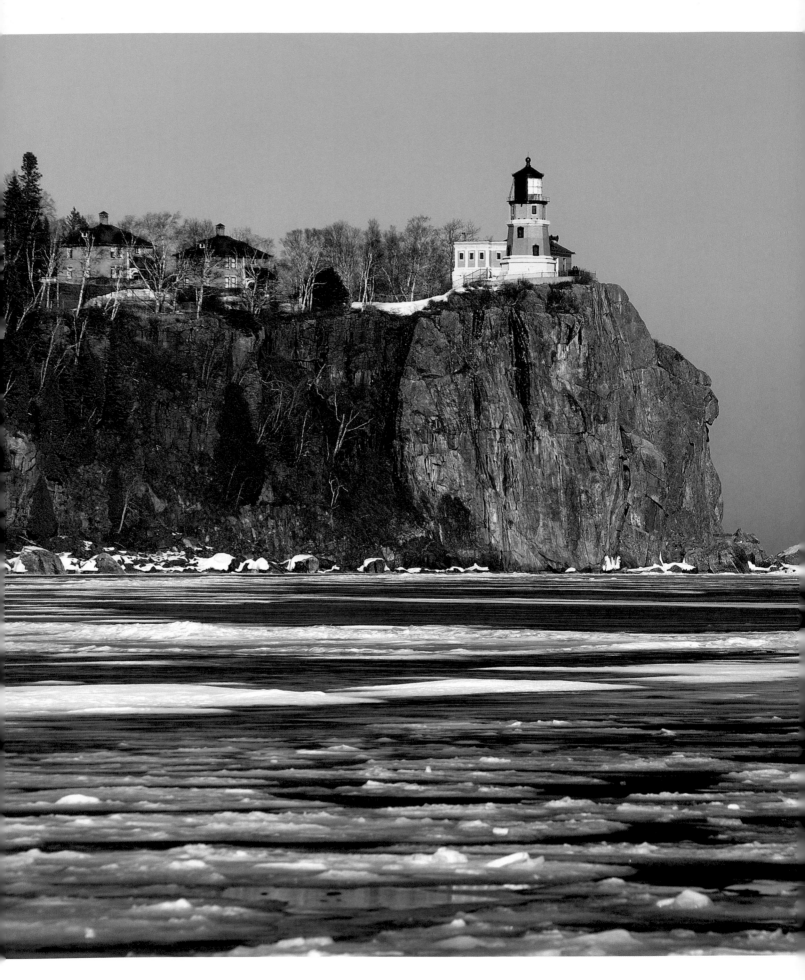

Split Rock Lighthouse State Park

Just after 4:30, staff usher the crowd out of the lighthouse. Lighthouse supervisor Janny Harling, after hiking the thirty-two-step spiral staircase to the lens room, is poised for the lighting. The view is spectacular, but Harling is not distracted. Outside, the crowd waits attentively. Then comes the ringing of the bell—a haunting, plaintive sound. All stand quietly as a voice reads the names of the twenty-nine crew members lost on the *Edmund Fitzgerald*. With each name the bell rings sonorously, a ceremony called the muster of the last watch. Children stop fidgeting. The bell rings one last time, the thirtieth toll to honor all sailors ever lost on the lake, and Harling throws a switch, directing electricity to the thousand-watt bulb that sits in the center of the four-thousand-pound Fresnel lens. The lens, powered by a hand-wound, mechanical clock, turns. Officially, based on the height of the lighthouse and the power of the lens and light, the beacon can be seen twenty-two miles offshore. Unofficially, the crowd is here to bask in its illuminating glory.

Below the lighthouse about four hundred yards away, I am standing among about fifty camera tripods of various sizes, their spindly legs balanced on billion-year-old rock. I take a

↓

Split Rock Lighthouse State Park

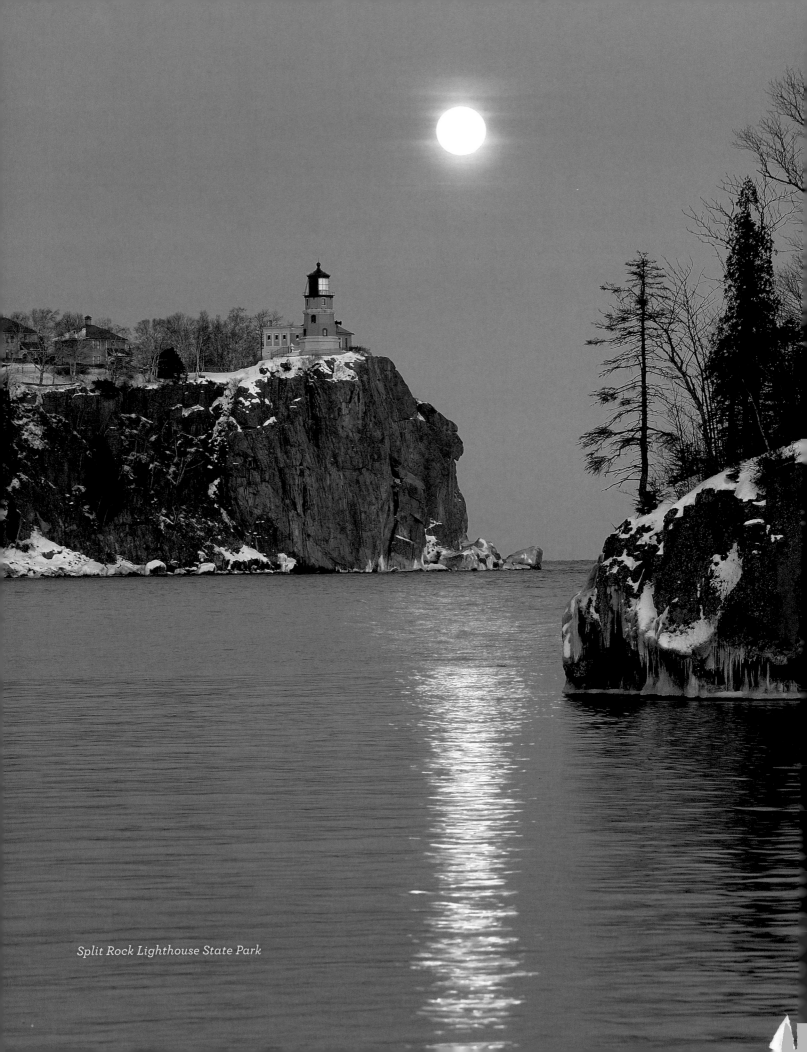

Split Rock Lighthouse State Park

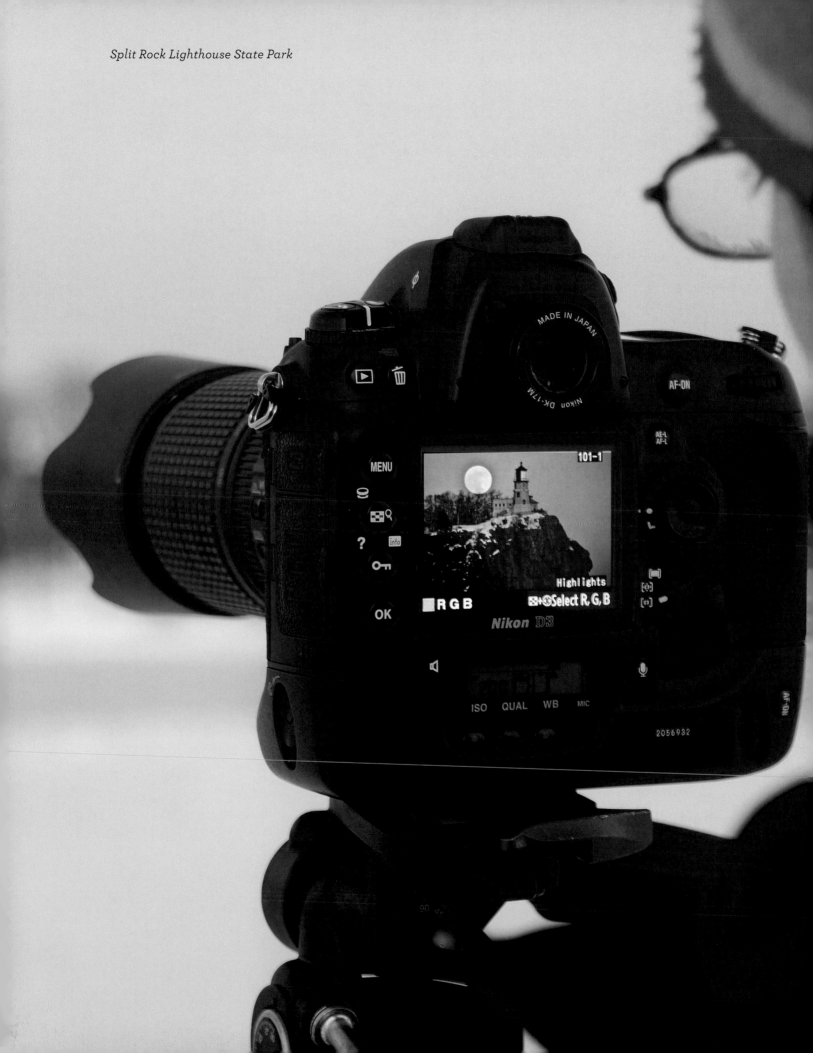

George H. Crosby–Manitou State Park

The Legend of the Fall

Fall is the best time to visit the North Shore state parks, and not just because of the spectacular leaf color.

Bird-watchers toting binoculars are drawn to the area to watch migrating raptors, or birds of prey, following the Lake Superior shoreline during their southward journey. Hawk Ridge Nature Reserve in Duluth, one of the most famous bird-watching locations in the United States, can record up to twenty thousand broad-winged hawks between September 10 and 20. Don't worry if you're busy those ten days: the raptor migration begins in mid-August and ends in mid-November.

November 10 is a special date for Split Rock Lighthouse. The state historic site, a twenty-five acre subunit of the state park administered by the Minnesota Historical Society, marks the anniversary of the *Edmund Fitzgerald*'s sinking with a public program that includes lighting the beacon at dusk and reading the names of the twenty-nine men who died when the boat sank on November 10, 1975. With a cold autumn wind coming off the water, the tribute is memorable and moving. Although the Split Rock Lighthouse Visitor Center is open five days a week during the winter, the lighthouse is normally closed, opening especially for the *Fitzgerald* event. ⊠

head count: about seventy-five photographers are standing or sitting on the rocks, their cameras at the ready, and when Harling throws the switch, a hum of appreciative *aahs* rises from the assembled. They've been waiting for this magical moment all year.

Tammy Wolfe and her husband, Randy, drove from Lake Elmo. It is her ninth consecutive year to see the *Edmund Fitzgerald* commemorative lighting. She once had a picture of Minnesota's iconic lighthouse published in a magazine, a proud moment for her. "It's a serious hobby," she says of photographing lighthouses. Wolfe explains the allure of Split Rock: it sits atop a cliff, with one of the world's greatest freshwater lakes as a backdrop. With the right lens and shutter speed, she hopes to capture the perfect blend of water and light. "I always try to get a better picture than I did last year," she says.

"This is amazing," Randy murmurs as we all attentively watch the lighthouse beacon.

Ellen and Rob Empson have staked out a spot on the rock with their tripod. They drove up from Chaska the day before, to soak in the fall splendor of the North Shore. But this is the event they have been waiting for. "I'm a semi-professional photographer," says Ellen. "I just love this area. I've been coming up here since I was fifteen."

Rob says, "You excited, honey?"

"You bet I am."

Ellen fiddles with her camera; her cable release on the shutter is being stubborn, and she knows she can waste much time by not clicking the release. "The lighthouse is like visiting an old friend," she says. "You put the camera on automatic focus. I have a slow shutter speed. That makes the water velvety."

I have my own camera but no tripod. I feel a bit foolish, lying on the rocks, my Nikon balanced precariously on a flat stone, but Ellen assures me no one is comparing equipment. There isn't tripod envy; everyone is focused on the soft beam of light radiating off the cliff—a beam that from 1910 to 1969 warned ship captains to stay away from the treacherous North Shore.

In the growing darkness, David Barthel appears over my shoulder. He sets up his tripod and points his camera toward the shimmering point of light. He looks like a college student, but I learn he is a twenty-six-year-old electrical engineer from Sauk Rapids. Photography, he says, is an avocation, but he is serious enough to be

Banning State Park

standing on a rock on a chilly November evening. "It's something about this night," he says. "I've been coming up here on this night the last three years. It's so peaceful. A couple of years ago, it was pretty cold. The wind was blowing. Every year, the weather is a little different."

Soon the crowd thins. Only a few photographers remain. About forty-five minutes have passed since the light came on. Barthel announces it is too dark to photograph the lighthouse anymore; even a modern digital camera can't compensate for darkness and distance. The Wolfes and Empsons pack their things. The shore empties of tripods. Someone has a headlamp, and we follow the tiny light over a trail through the woods, down to the parking lot. I hike up to the visitor center, where a small crowd still mills about the lighthouse. Children clamber around the displays, and as I read the plaques describing the hardships of life on the North Shore, I am transported to another time and place.

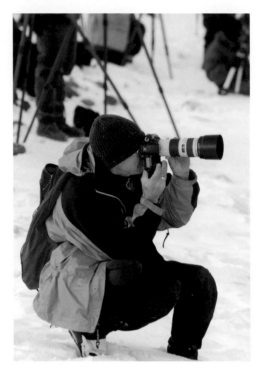

Split Rock Lighthouse State Park

Months later, I'm on the telephone with Dennis O'Hara of Duluth. In the 1970s, he operated a camera from the backseat of an RF-4C reconnaissance jet with the Minnesota Air National Guard. In 2006, he retired from his full-time job in system operations at Minnesota Power and devoted time to his true love: photographing Duluth and Lake Superior. He is an expert on capturing Minnesota's most famous shoreline landmark, and I'm eager to soak up his expertise.

"Out of all the Lake Superior lighthouses, and I've photographed most of them, Split Rock is the most scenic, for sure," O'Hara says. "It is one hundred feet on a cliff above the lake, and most of the best views are at lake level. The beach is easily accessible, and it shows a lot of the perspectives and scenery that people go to the North Shore to see: rocks, trees, and high cliffs and sky— and a lighthouse with a unique history. You can photograph it from most perspectives, and, of course, the light is different every time you go there."

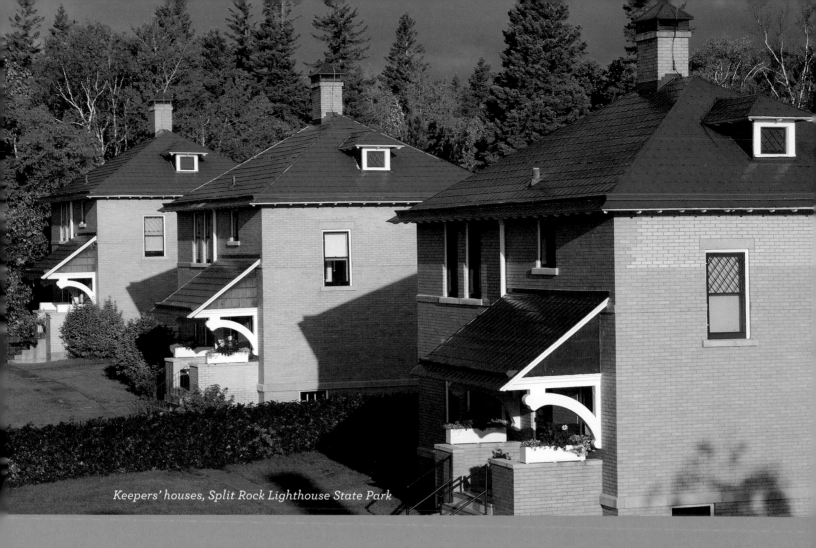

Keepers' houses, Split Rock Lighthouse State Park

Fast Facts about Split

In 1854, a surveyor canoeing Lake Superior's North Shore looked upon a great escarpment and noted in his diary that it would be a good spot for a lighthouse. After several shipwrecks in 1905, Congress appropriated $75,000 to build one in that very spot. The lighthouse, known as Split Rock, began warning ships in 1910.

Perhaps the most fascinating component of the lighthouse is its lens, which, according to manager Lee Radzak, is a third-order bivalve Fresnel. *Third order* relates to size: the smallest lighthouse lens is a seventh order, while the largest is a first order. The Split Rock lens falls toward the larger scale. *Bivalve* refers to the "clam shell" shape of the lens, which is actually two identical lenses

back to back. One revolution every twenty seconds causes the light to flash every ten seconds. The lens is named for the French designer Augustin Fresnel. Built in Paris, it was installed in the lighthouse in 1910.

The clockwork mechanism that rotates the lens has been restored to its original condition. The original light source, an incandescent, oil-vapor kerosene lamp, was replaced with an electric light in 1940. Although the light is no longer used for guiding ships, every day the lighthouse is open, staff wind up the weights, operate the clockwork mechanism, and, for special occasions like November 10, light the beacon much the same way keepers did from 1940 to 1969, when it was decommissioned. ⊠

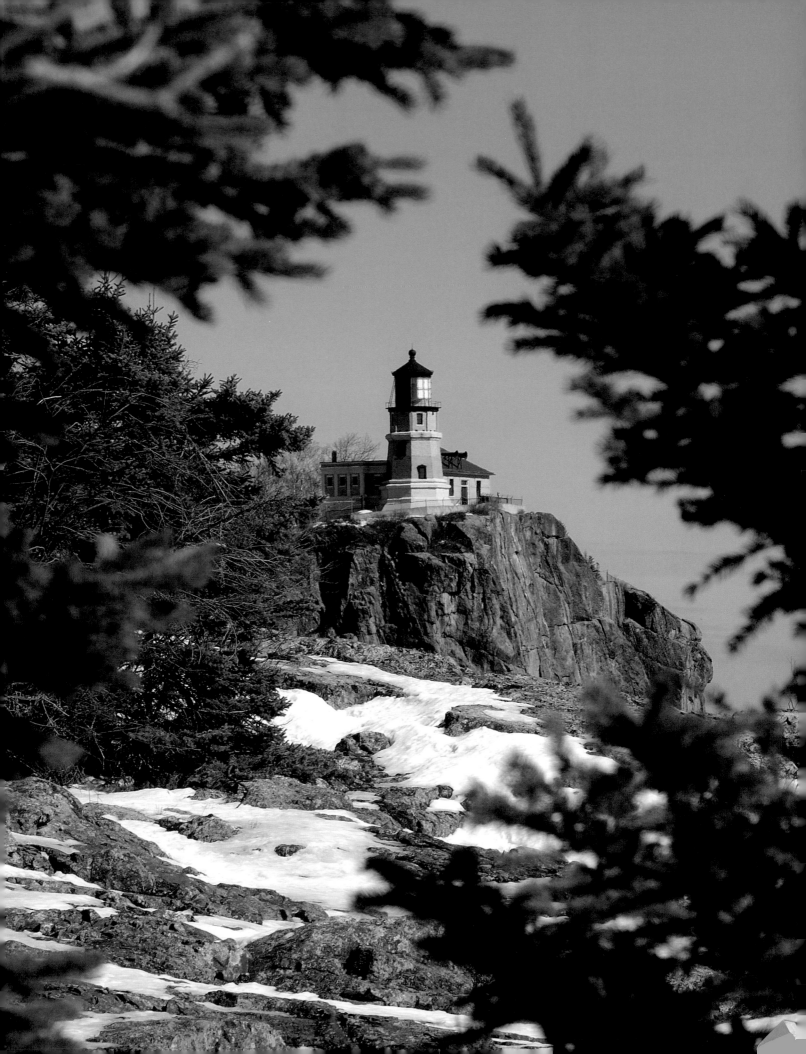

"Is Split Rock the most photographed lighthouse in America?" I ask. O'Hara doesn't think so; that honor is regularly claimed by Portland Head Light Station at Cape Elizabeth, Maine. "But Split Rock is certainly the most photographed lighthouse on the Great Lakes," O'Hara says.

During January's full moon, you'll find O'Hara huddled over his camera, waiting for the perfect nexus of the Split Rock Lighthouse and the rising orb over the cliff. He tells me it is a scene that attracts only the hardiest of photographers, those willing to scramble over snowy, icy rocks.

"There are three days where, depending on the cloud cover, you can get a good shot, but there is only one day out of three where the light and sky is perfect, and that's the night you take the picture. If you don't get the picture on that night, you wait until next year."

O'Hara isn't seeking the same picture every year. He makes the January pilgrimage, even in the foulest weather, because he knows conditions always change, providing opportunities for a newly evocative view. "The moon is pretty much in the same spot, but it really depends on the lighting and the atmosphere changes. If there are some clouds, that's good. They pick up the reflection of the moon and add atmosphere. It's a better photograph. More moisture makes the moon look bigger. Sometimes ice will cover on the bay and there will be snow on the hills. That's nice. If the bay is still open and there's no wind, you can get the moon's reflection," he says.

Digital cameras and information on the Internet have given photographers a chance to take better pictures of Split Rock at unique moments. O'Hara says more photographers than ever are making the trip on November 10 and in January, even under the harshest conditions. He's not bothered by the extra company: he knows the lighthouse holds a special attraction.

"This past January, there was probably fifteen photographers in the same location, and that makes it fun," he says. "You're chatting, and you're trying to guess where the moon will come up. There's a lot of anticipation. You have only a few minutes before the moon is above the lighthouse. When it arrives, we're all surprised by what we see." ⊠

Split Rock Lighthouse State Park

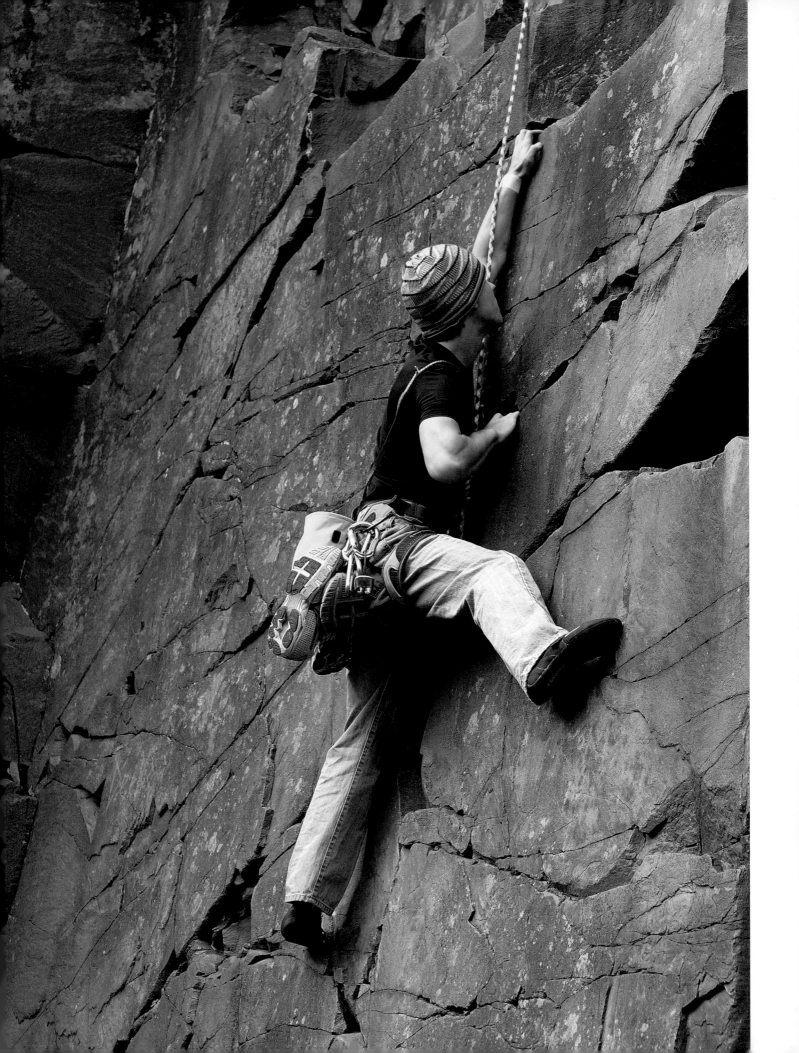

Towering over Lake Superior, a pair of cliffs made of billion-year-old lava rise two hundred feet over the water, providing some of the finest lake vistas of the North Shore. Palisade Head and Shovel Point in Tettegouche State Park are often showcased on gift store postcards, and they're one of the reasons this stretch of biologically diverse shoreline, known as the North Shore Highlands Biocultural Region, was preserved as a state park in 1979.

But many Tettegouche visitors are probably unaware that among the cliffs there are cracks and crevices with colorful names like "Urge to Mate" and "Dirty Harry." There are cautionary names like "Laceration Jam," "Danger High Voltage," and "Sudden Impact." And someone had a chuckle when they coined "Old Men in Tight Pants" and "Dance of the Sugar-Plump Faeries." This is rock climbing lingo, and if you've ever hung by a rope over a cliff on the North Shore, you know these to be some of the most popular routes used by climbers to ascend the cliffs at Tettegouche State Park, whose managers have embraced rock climbing for years.

Four Minnesota state parks—Interstate, Blue Mounds, Tettegouche, and Temperance River—allow rock climbing, and climbers report that each offers a different sort of adrenaline high. Interstate, where climbing occurs over the St. Croix River below Taylors Falls, is a time-honored hot spot that is busy with both tourists and climbers. The landscape of Blue Mounds rises above

Interstate State Park

Tettegouche State Park

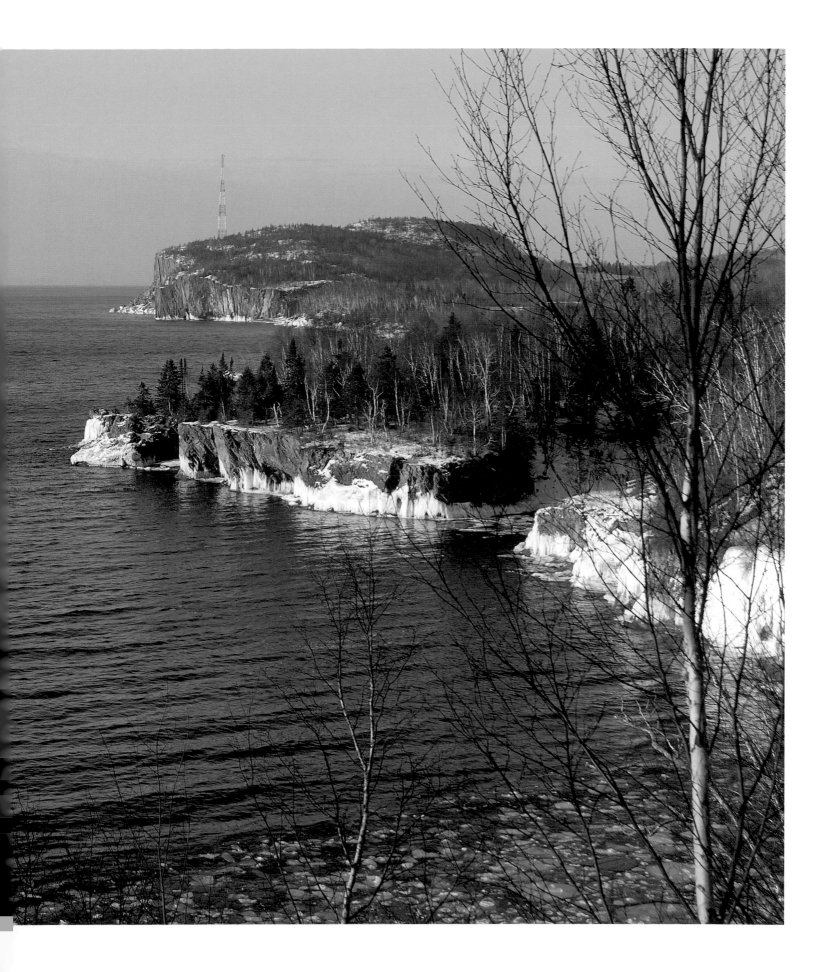

the Minnesota prairie and farmland, and its quartzite rock is hard, dense, and climber friendly. Tettegouche has been called the "crown jewel" of Minnesota climbing, with routes ranging from beginner to highly technical. Temperance River's Carlton Peak provides spectacular views that rise nine hundred feet above Lake Superior. It's anorthosite rock, notoriously sharp and abrasive, that magma pushed up from miles deep in the earth. One guide describes the magma as having been "burped" to the surface.

No one is sure when rock climbing became popular; some say people were likely scrambling up the rock as far back as the 1930s. But climbing as a sport experienced a boom in popularity in the 1990s, and it had some growing pains at the North Shore state parks. Climbers weren't often viewed as traditional park users, but over the years they and park managers have worked through their struggles. When park officials realized climbers were trampling and killing fragile vegetation on the cliff tops, the

Tettegouche State Park

two parties created agreements to keep foot traffic on trails and to discourage climbers from anchoring their ropes to trees.

In 1999, Tettegouche added a platform as a staging area for climbers and a viewing spot for visitors; a second platform was built in 2005. The DNR also installed permanent anchors for climbers' ropes. On occasion, some climbing routes are closed to protect against disturbing nesting peregrine falcons, a move embraced by climbers.

"Park managers have been very friendly to us, and they've worked with climbers to develop a management plan for Tettegouche and other parks," says Kaija Webster, climbing coordinator for the University of Minnesota–Duluth Recreational Sports Outdoor Program. When a young male climber died in a fall on Shovel Point at Tettegouche State Park, there were calls to ban climbing in the park. The DNR didn't: "Park officials were very evenhanded about how they dealt with it," Webster says.

Interstate State Park

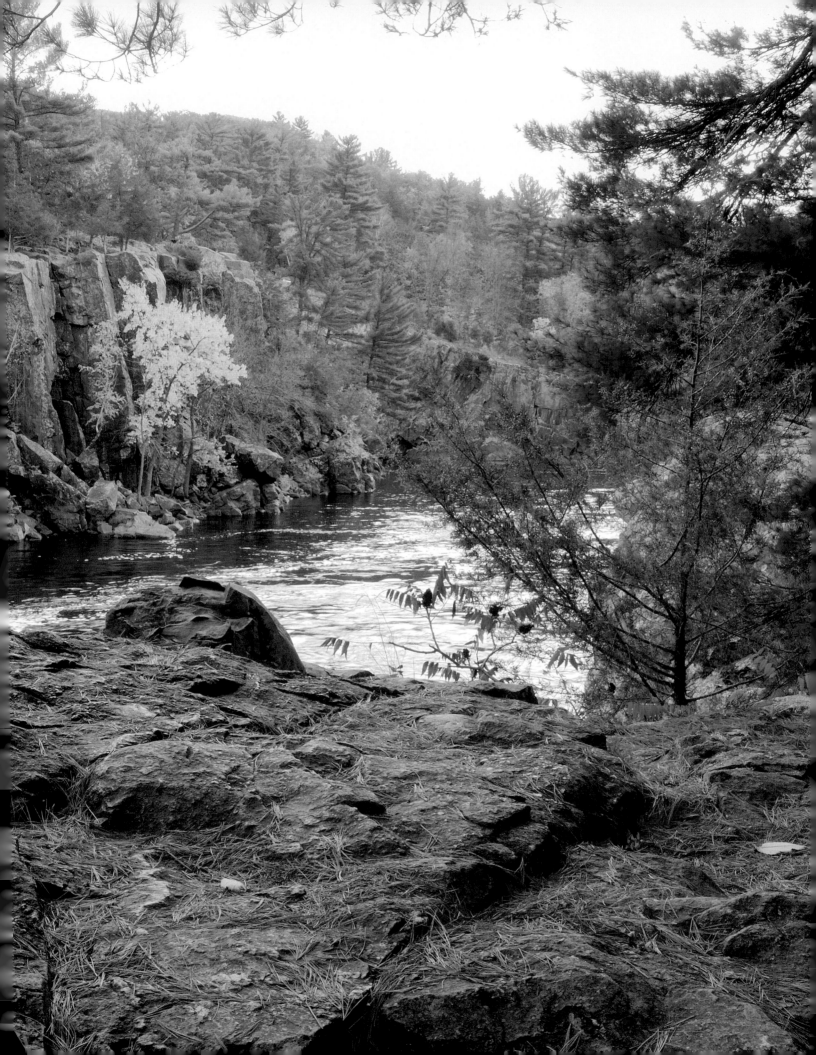

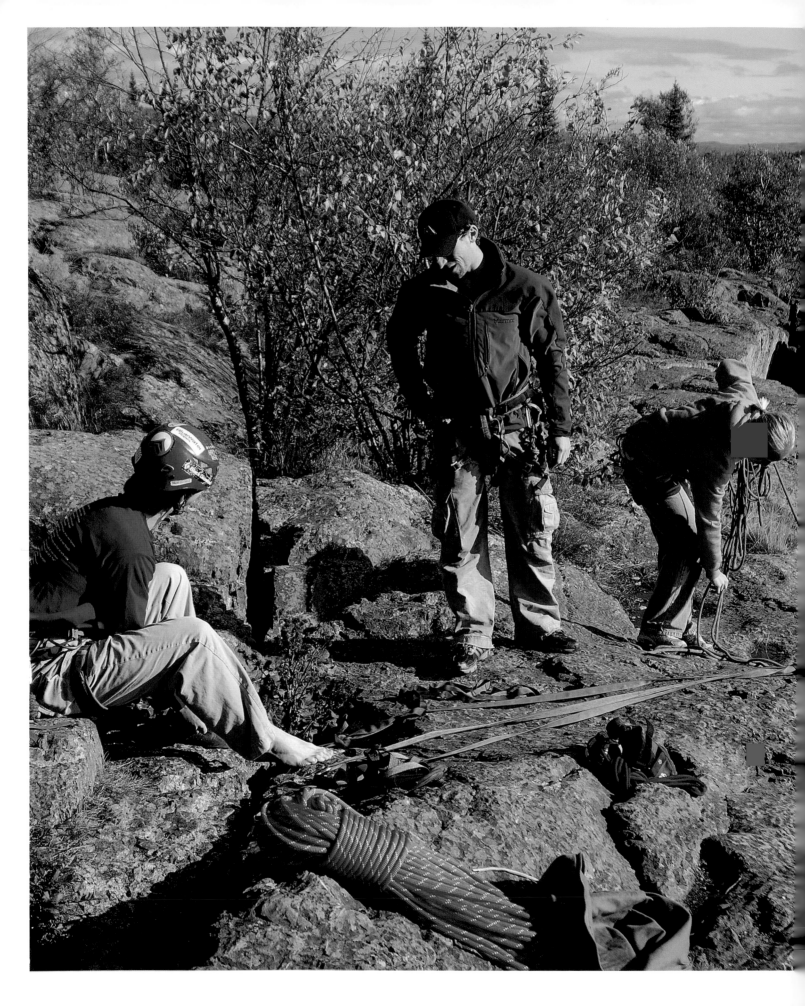

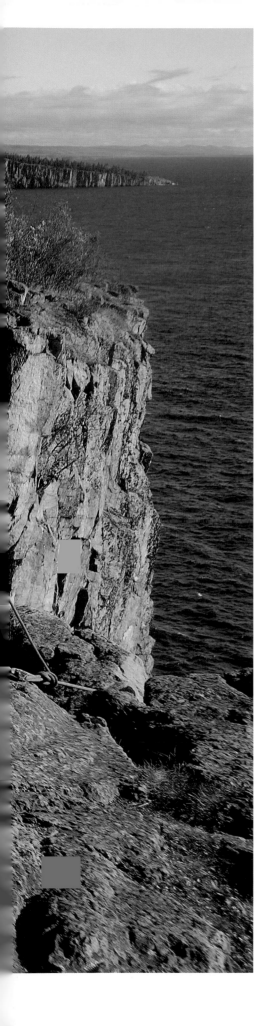

Among the more controversial aspects of North Shore climbing is the no-chalk ethic. Chalk, though helpful to climbers in keeping their hands and fingers dry, is frowned upon by most North Shore climbers and park managers. "Chalk usage is a visual eyesore to almost everyone (climbers included), and this threatens climbing access to the cliffs," says Minnesota climbing expert Mike Farris, author of *Rock Climbing Minnesota and Wisconsin*.

Nick Fleming, manager of the Duluth indoor climbing facility Vertical Endeavors, is a frequent climber at Palisade Head, where Lake Superior creates "a spectacular backdrop." "I have climbed in Spain and in the Mediterranean and in the desert," Fleming says, "and to have a place like Palisade Head in your backyard is terrific. Urge to Mate is a beautiful hand crack, and when you're climbing it, you have the lake off your left side. You can just hang off your hands—it doesn't hurt your hands; the crack is the perfect size—and you have the lake right there. On a good day, with no haze, you can see over to the Apostle Islands."

Webster, who has been climbing since the mid-1990s, coaches a lot of novices in the UMD climbing program. She says Shovel Point at Tettegouche, perhaps the busiest climbing locale on the North Shore, is her favorite place to take beginners because the cliff's angle is less steep than, say, Palisade Head. "Palisade is something you want to graduate to," she says. "The climbs are steeper and more exposed to wind and weather. No one should climb there until they have some skills." Because much of Shovel Point drops directly into the water, climbers start by rappelling down to ledges. One of these ledges is the starting point to a classic beginner's route, Dance of the Sugar-Plump Faeries.

The adventure begins when climbers lower themselves to the ledge, a rubble spot just big enough to stand on. The large, empty slab of rock rises above you. "From there, when you look down, you see the lake maybe one hundred feet below. The top of the cliff is maybe sixty feet above," Webster says. "It's one of those areas that if you're new to climbing, it looks like a blank slab. You think, 'How will I get to the top?' But the beautiful thing about this spot is the more you look at it carefully, the more you notice the rock's texture. You begin to see seams and crevasses and nubbins. Climbers use these really grip-y shoes these days, and you realize that you can stand and grip something on the rock that is the size of a dime."

Tettegouche State Park

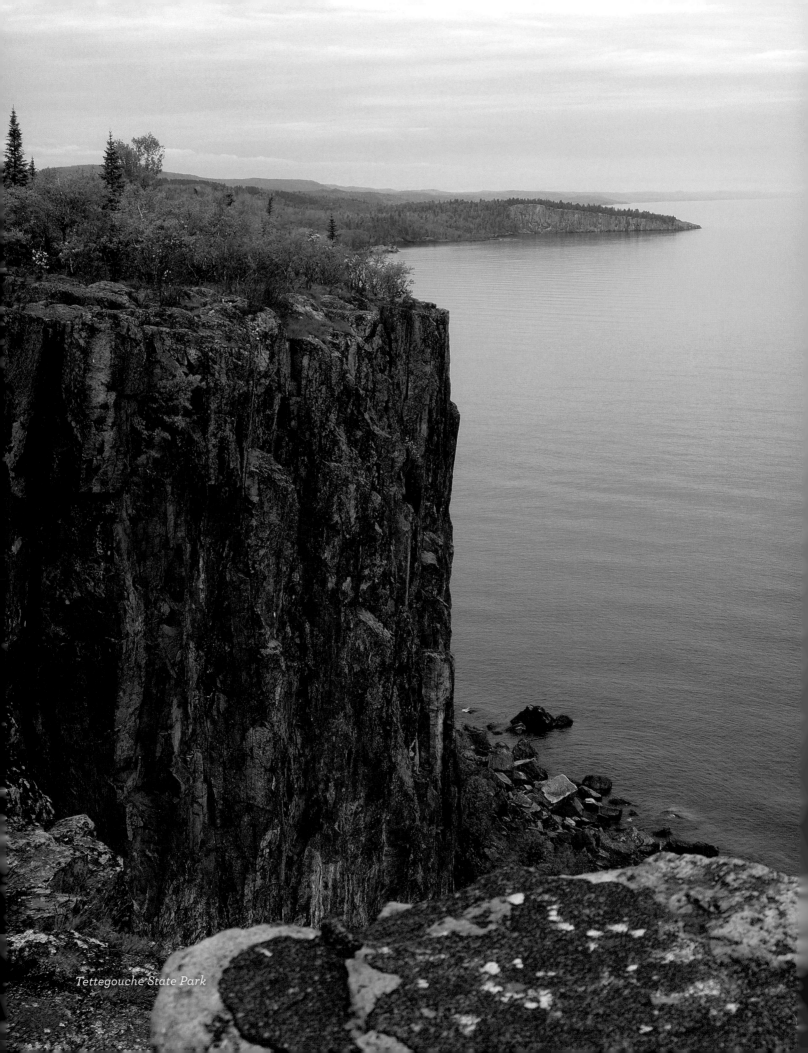

Tettegouche State Park

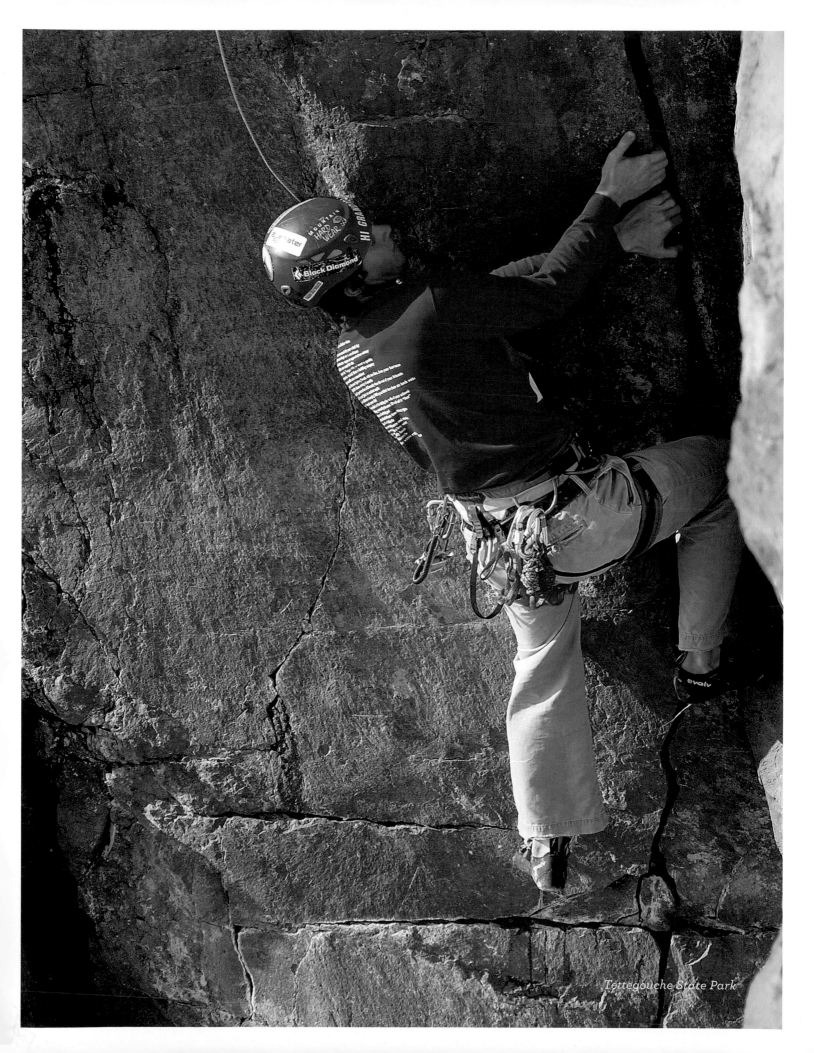

Tettegouche State Park

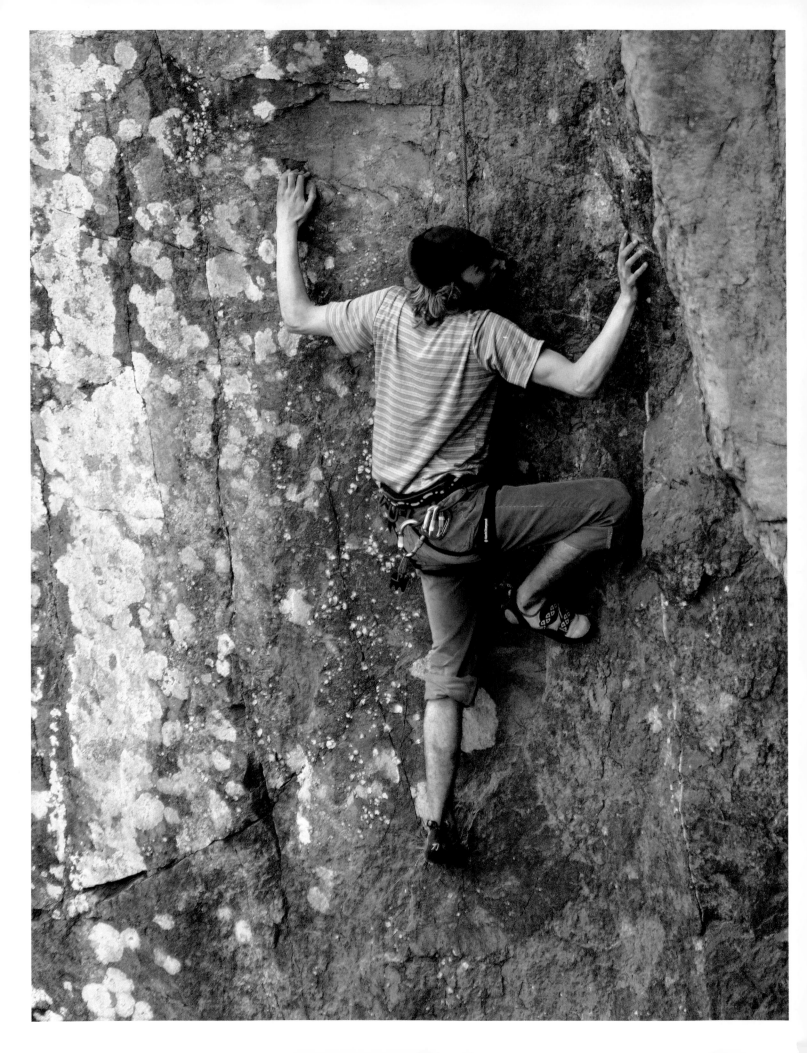

Webster says climbing Dance isn't about holding onto rock: it's about finding "a little texture" or a contour in the rock and holding onto that. "Dance of the Sugar-Plump Faeries is a fun climb," she says, "because you have to bring yourself into focus and make your feet grip on the tiniest things. When you're a beginner, you don't realize what you're capable of climbing. You look up and think you can't do that. But you dig down and try it, and when you've done it a few times, your brain says, 'you can do that.'"

On the other end of the difficulty scale is Laceration Jam on Palisade Head, a climb of three *pitches*, or rope lengths, that Webster has done once. The route makes a pitch up the head and then crosses the cliff's face along a sharp flake of rock. "You put your hands in the sharp flake, and you climb sideways," Webster says. "Imagine you walk up to a wooden fence, and you don't have anything to put your feet on, and you're holding yourself up. That's where the 'laceration' comes in: some people look pretty cut up when they are done."

Webster says she enjoys Laceration Jam because it forces a climber to move deliberately and to train his or her concentration. "It happens to fit my style of climbing. Believe it or not, I don't like to work hard. Some people tend to breathe hard, but I'm always telling people to remember to breathe. Some people find climbing very meditative. You bring your focus into the moment, and breathing is part of that. I like to do that."

Since 2000, Webster has helped organize Adopt-a-Crag, a cleanup program that includes the Minnesota Climbers Association, UMD, and Vertical Endeavors. Climbers travel to cliffs and clean up trash. "We really want to support the state park because they are supportive of climbing as a recreational activity," Webster explains. "We don't just clean up at the parks. We ask park managers, 'Do you need some bodies for extra help?' We'll move lumber or we'll plant trees."

At the base of Palisade Head, the climbers find assorted debris thrown deliberately over the precipice. "There is something about human beings: we love to throw things off cliffs," Webster says. "We've hauled amazing things up the cliffs: grills, motorcycles, and a toilet that was smashed on the rocks—we're still picking that up. We find chairs and furniture. Once we found a French horn. You wonder about the story behind that." ⊠

Tettegouche State Park

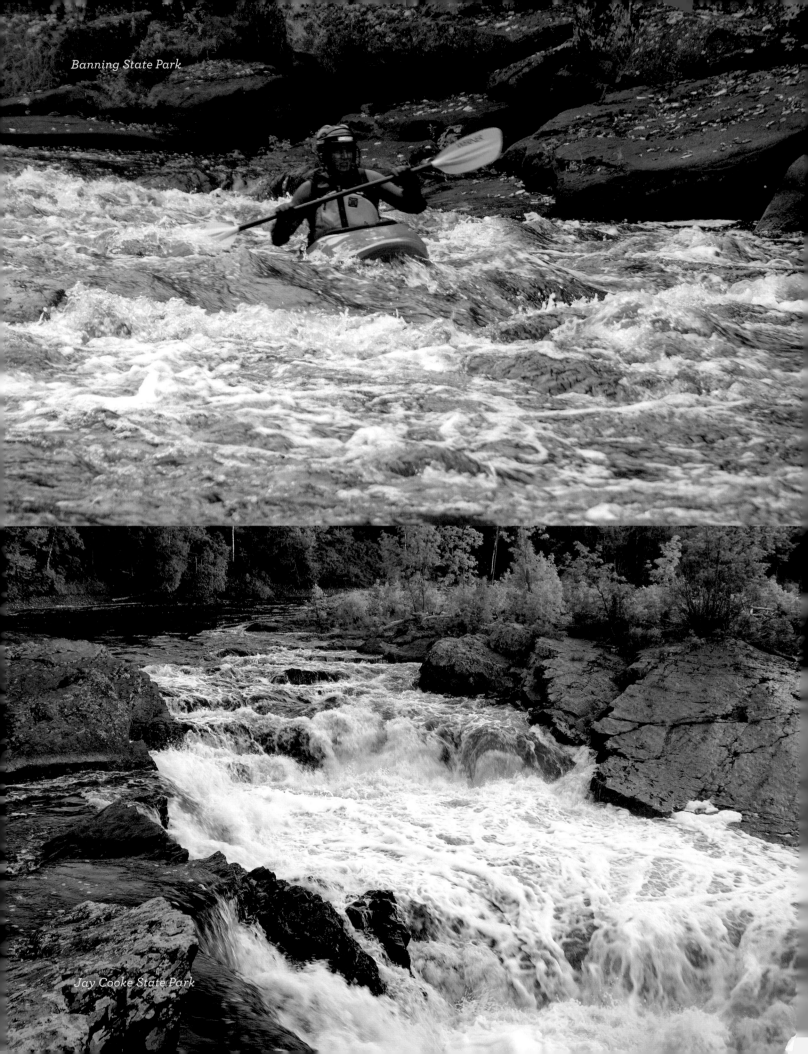

Banning State Park

Jay Cooke State Park

On a breezy summer morning, I'm standing on the Minnesota 210 bridge in Jay Cooke State Park, looking down on the frothy St. Louis River where artistry is being practiced with a paddle. Tomorrow marks the St. Louis River Whitewater Rendezvous Slalom and Sprint Races, an event in its thirteenth year. Kayakers and canoeists in brightly hued boats are testing their skills below the Thomson Dam, running rapids in preparation for the races. They plunge down the river, deftly working through poles that hang over the water and serve as gates.

Michelle Grimm of Stevens Point, Wisconsin, paddling a bright yellow white-water canoe, catches my eye. Just a tad over eleven feet long, the stubby, deep-hulled boat spins like a maple leaf as Grimm skillfully jabs her paddle into the water and turns into an eddy. It's only practice day, but spectators stand along the river and admire the skills of the kayakers and canoeists. "I'm in awe of their balance and strength," says Gary Layne of St. Cloud, who was spending the weekend camping and hiking with friends at nearby Jay Cooke. "It's amazing."

The paddlers were equally impressed with the river. During a summer of low water conditions, the St. Louis has been the exception to many midwestern rivers suffering from drought. The owner of Thomson Dam, the electric company Minnesota Power, agreed to increase water flow for the white-water event, allowing what kayakers call a *release*. "It's really a beautiful place," says Grimm,

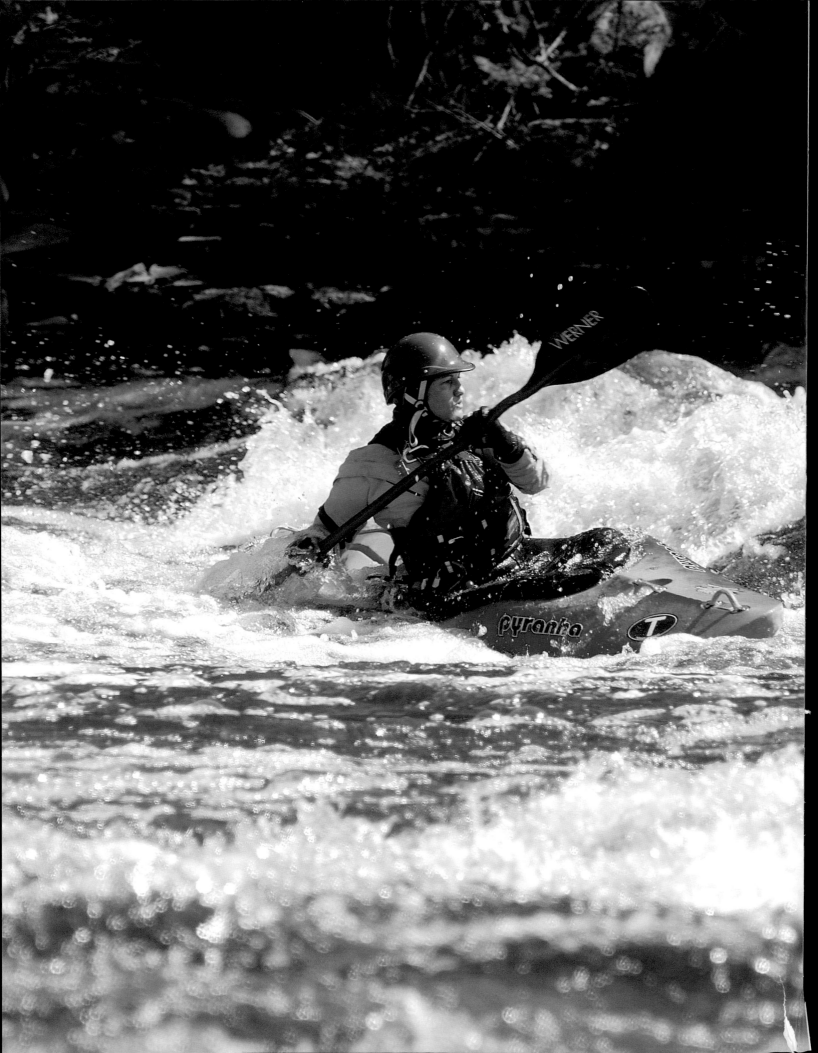

Banning State Park

of the most hair-raising white water in any state park. "You have to be on the top of your game to get safely down the Baptism and lots of rivers on the North Shore," Carlson says. "But it's kind of a special experience to come down the river and paddle out into the lake."

The Temperance River (Temperance River State Park), the Cascade River (Cascade River State Park), the Manitou River (George H. Crosby–Manitou State Park), and the Brule River (Judge C. R. Magney State Park) are others that get high marks from kayakers, though along the Brule paddlers have to portage the famed and dangerous Devil's Kettle and Upper Falls.

Carlson came to UMD as an undergraduate in 1983 and got involved in the student kayaking program. He received a degree in outdoor education and "got hooked on paddling and never left."

"In the late eighties and early nineties, there was a lot of attention given the North Shore rivers," says Carlson. "Many of us had been kayak racing, but river running got a lot easier with the arrival … [of] polyethylene kayaks that were more durable and shorter. It's funny: we used to have to be careful about tying down our kayaks on

Banning State Park

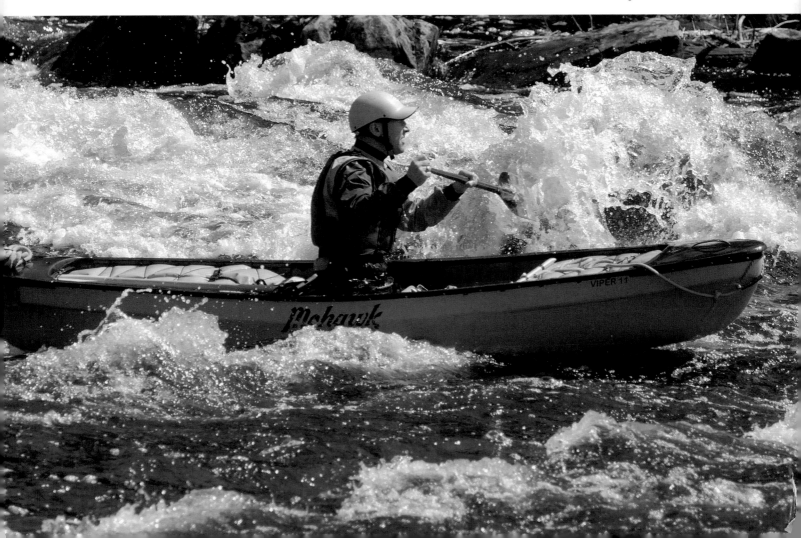

Schoolcraft State Park

Travel Routes through History

Minnesota is a region of Native American and fur trader byways and travel routes, many of which are found in state parks.

Savanna Portage State Park celebrates one of the travelers' arduous obstacles: the continental divide marking the division of water flowing to the Mississippi and Lake Superior. Visitors can learn about the six-mile portage from the East Savanna River to the West Savanna River, a route used by Dakota and Ojibwe Indians and explorers and fur traders more than two hundred years ago.

Rice Lake State Park

Jay Cooke State Park preserves a travel route called the Grand Portage used by voyageurs and Native Americans to make their way around the rapids of the St. Louis River. Park interpretive signs describe the difficult portage and its rest spots, called *pauses*.

Schoolcraft State Park is named for Henry Rowe Schoolcraft, who with an Anishinaabe guide explored the headwaters of the Mississippi River. The park is located on a spot along the river where it is believed Schoolcraft camped during the expedition.

Visitors to Grand Portage State Park often mistake it as the location of a travel route connecting Lake Superior to inland waterways. This famous route is celebrated at nearby Grand Portage National Monument, operated by the National Park Service. ⊠

Banning State Park

Short Life for Town of Rock

Banning State Park's history is rooted in stone and fire. Starting in the late 1800s, the region's distinctively pink, hard sandstone was often sought for buildings. At its peak production, the Banning Sandstone Quarry employed five hundred stonecutters and other workers, but in 1894 the great Hinckley forest fire heavily damaged the company's holdings and the St. Paul and Duluth Railroad that shipped its stones.

By 1896, however, a village was platted near the quarry and named after the railroad's president, William L. Banning. Within four years, the village's population grew to three hundred, and the future looked bright. Then, as contractors began favoring structural steel for buildings, stone demand dropped. Work at the quarry ended by 1905. More forest fires plagued the region, and soon the village of Banning no longer existed. By the 1920s, not even a road to the ghost town remained.

In 1934, however, talk of establishing a park along the Kettle River began. Momentum grew in the early 1960s with support from Sandstone citizens, and in 1963 the Minnesota legislature put aside $137,000 for land and capital improvements and established Banning State Park. ☒

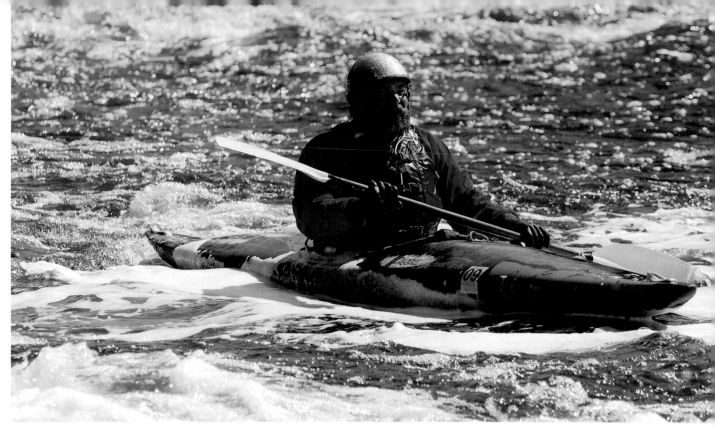

Banning State Park

our roof racks. Now the preferred transportation method is a cargo trailer. You throw your kayak in there and let it bounce around."

While river kayakers were testing their limits and their boats on inland waterways, another group was flocking to long touring boats designed for open water. Sea kayaking became *de rigueur* on Lake Superior, with paddlers taking lengthy trips or even circumnavigating the lake. The sport got a boost with the creation of the Lake Superior Water Trail, established by the Minnesota legislature in 1993, which runs 155 miles from St. Louis Bay in Duluth to the Pigeon River on the Canadian border. The trail, used primarily by sea kayakers, utilizes a string of campsites along the North Shore, including some at state parks.

But the most recent trend to hit the North Shore is surfing. Improvements in neoprene full-body suits allow surfers to play in Lake Superior's extreme cold (even in summer, water temperatures may be only in the high forties). The latest iteration is stand-up paddle boarding, a hybrid between paddling and surfing where the participant stands on a floating board and paddles on flat water or rides waves or river rapids. Carlson teaches classes in beginner paddle boarding. He jokes that he might start a kayak museum with some of the older boats, dinged and scratched from years of use. "I have two sons, eleven years old and thirteen, and they love paddling

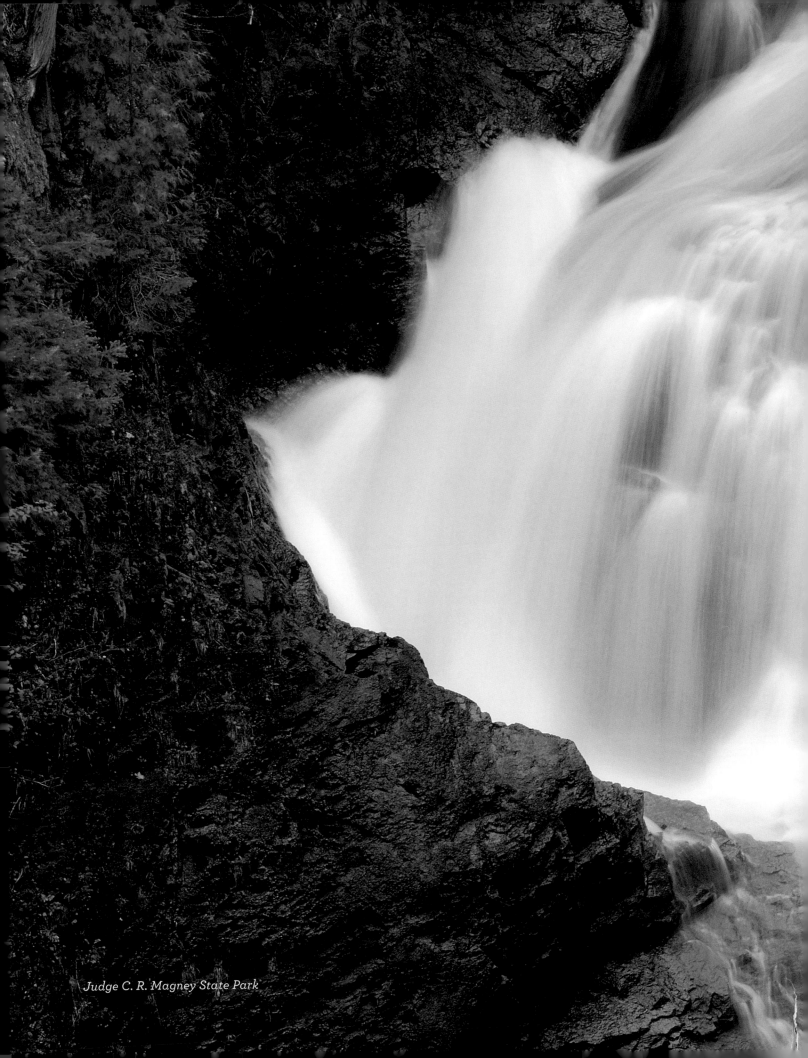

Judge C. R. Magney State Park

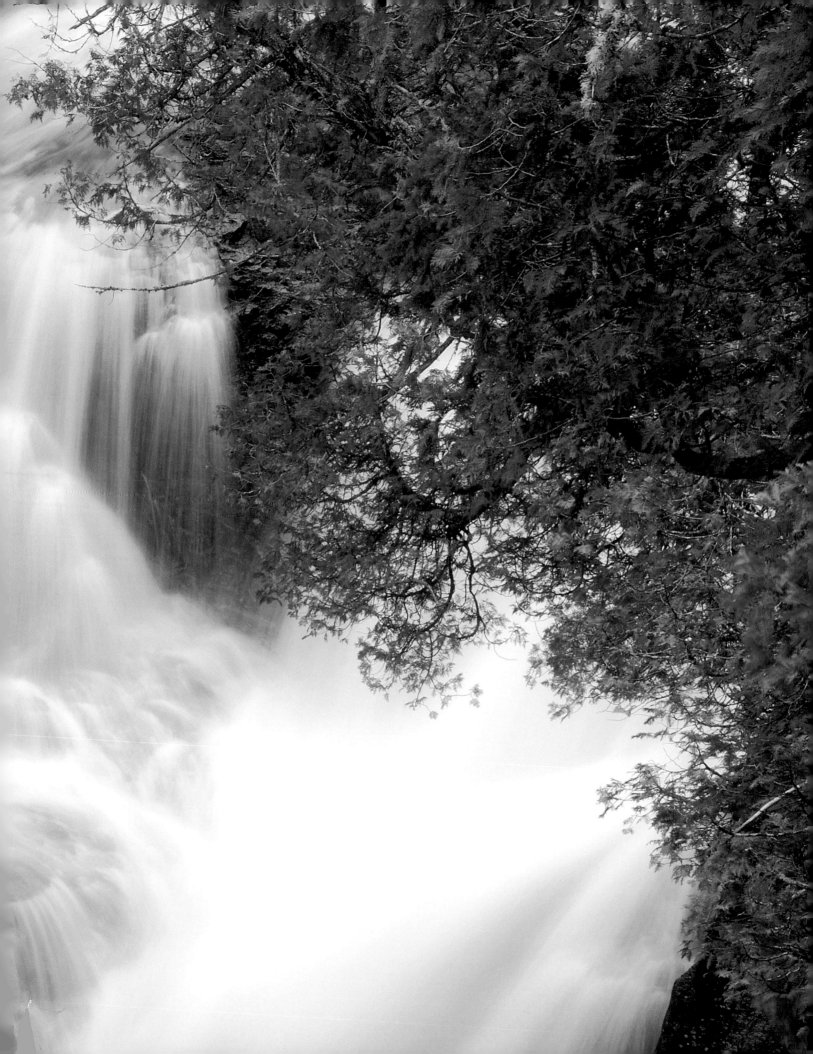

in the new boats. I get one year older, but the students stay the same. It's been fun to stick with. I just have to keep evolving."

Drive south of Jay Cooke State Park on Interstate 35 and you'll find Banning State Park, which lies next to the town of Sandstone and straddles the Kettle River. Says Rada of this river: "The Kettle… has no doubt provided more hours of fun for Minnesota kayakists than any other river in the state. Mile for mile, it can be one of the best play rivers anywhere." The river's importance was recognized in 1975 when it was added to Minnesota's Wild and Scenic Rivers Program, which offers additional protection to rivers with outstanding natural, historic, and recreational value. The river is celebrated every May with the Kettle River Paddle Festival, a weekend of paddling events culminating with the Kettle River Run race from the state park to Robinson Quarry.

For paddlers, most of the Kettle's white-water highlights come inside Banning, where famous rapids go by the names Blueberry Slide, Teacher's Pet, Mother's Delight, Dragon's Tooth, Little Banning Rapids, and Hell's Gate Rapids. The Rapids Riders, Minnesota's biggest kayaking club, describes the Dragon's Tooth as having "an aluminum filling at times" because of the boats that have scraped their bottoms over the rocks.

Kayakers and canoeists were rewarded with a new view of the Kettle River's white water when in 1995 the DNR, along with the town of Sandstone and the Minnesota Pollution Control Agency, removed a dam inside the park. The restored section now showcases Big Spring Falls and the Sandstone Rapids.

Back at the St. Louis River, I'm getting a tutorial in the skills needed to run the rapids. Dozens of kayakers and white-water canoes are gathering in the parking lot of the National Kayak Center, a modest wooden building situated in the woods below Thomson Dam that serves as UMD's white-water paddling program headquarters. I spot license plates from Ontario and about a half dozen U.S. states. Paddlers organizing their gear discuss flows and paddling tricks, freely swapping ideas with each other.

Carolyn Peterson of Austin, Texas, walks up from the river, pulling her white-water canoe on two small portage wheels. She is a muscular, friendly woman who won the 2001 open canoe women's national championship. "Texas doesn't have a lot of big white water," she says. "So I travel a lot to places like this."

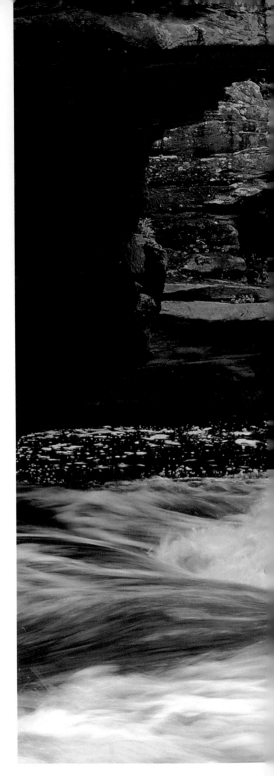

Banning State Park

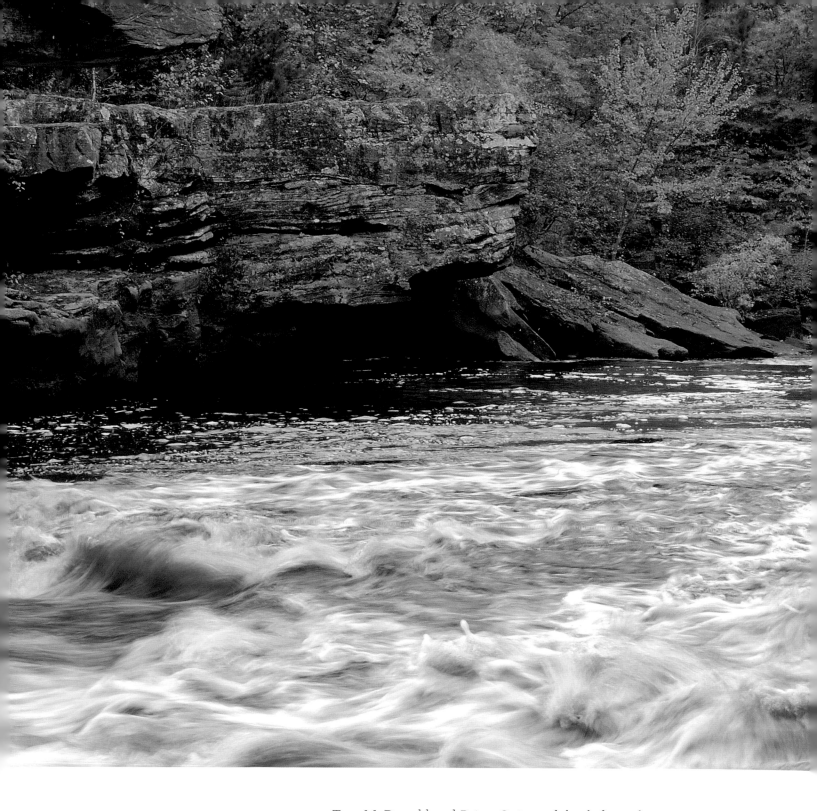

Tom McDonald and Brian Guimond, both from the Twin Cities, are preparing their boats for a trip down the river. They aren't planning to compete in the races the following day; they're here to run their kayaks through the lower section in Jay Cooke State Park. "I'm up here whenever they have a good release," says McDonald, who has been kayaking for a quarter century. "As far as beauty, I'd put this river up against any others." ⊠

My first taste of adventure occurred the summer of my seventh birthday, when I struck out for a nearby sawmill to climb a pile of sawdust.

We lived in Oregon at the time, and I recall that the three-block hike to the mounds of old-growth fir chips seemed like the long road to China. It was my first summer roaming out of sight of my parents' watchful eyes. When the big saws at the mill quit in the late afternoon, the neighborhood kids swarmed the pile of fresh, sweet-smelling dust. It was our Everest. At dusk we wandered home, tired and smelling like sweaty little lumberjacks, our feet full of slivers.

Moose Lake State Park

I'm a midwesterner now, with two daughters of my own. At midnight toward the end of September, the scent of pine and balsam was heavy in the air again. The girls and I were camping on Lake Superior's North Shore, but we were in for a rough night. Lightning flashed over Temperance River State Park, where we had just pulled in after a five-hour drive. The warm, piney air had me thinking of sawdust and childhood adventures, but as a parent I was contemplating: motel, dry bed, Nickelodeon.

With the girls still asleep, I trotted through puddles to get a tarp out of the back of the pickup. I tried to select a level spot and be nonchalant and purposeful in setting up the tarp, but it was obviously folly to pitch a tent in the storm. I

Mille Lacs Kathio State Park

mumbled: should I bail on the campsite or torture us further with wet sleeping bags and fretful sleep?

Back inside the truck, the oldest stirred. "Where are we going to sleep?" asked my stepdaughter, Bailey, age twelve. She and my daughter, five-year-old Grace, were awake now, watching me fumble in the darkness for temporary shelter. That morning their mom had flown to Washington, DC, on a business trip, and in her absence I had announced that we would go camping. It was the season when the North Shore is aflame with scarlet maples and yellowing birches and aspens. It seemed like a dad thing to do.

"What do you say we sleep inside the truck tonight?" I proposed.

"Yea!" Grace shouted.

"I call the backseat," Bailey said.

It wasn't the first time during the weekend I wondered if I was wimping out as Outdoors Dad.

A few raindrops still tapped on the roof of the truck topper at 7:00 AM. Grace and I were stretched out in sleeping bags in the bed of the truck; I looked through a foggy window at a verdant evergreen forest. Through another window I saw Bailey curled up, cocoonlike, in the backseat. I crawled out of the truck wearing boxer shorts and came face to face with a silver-haired woman walking a Pekingese. She smiled and continued her power stroll.

Around the camp cul-de-sac were Airstreams and Winnebagos and a few waterlogged tents. It was the first time I'd felt relaxed in weeks, even though the bottom of my sleeping bag had soaked up water during the night and felt like a soggy cotton ball.

We ate Cheerios out of plastic bowls, bought some firewood at the park store, and perused

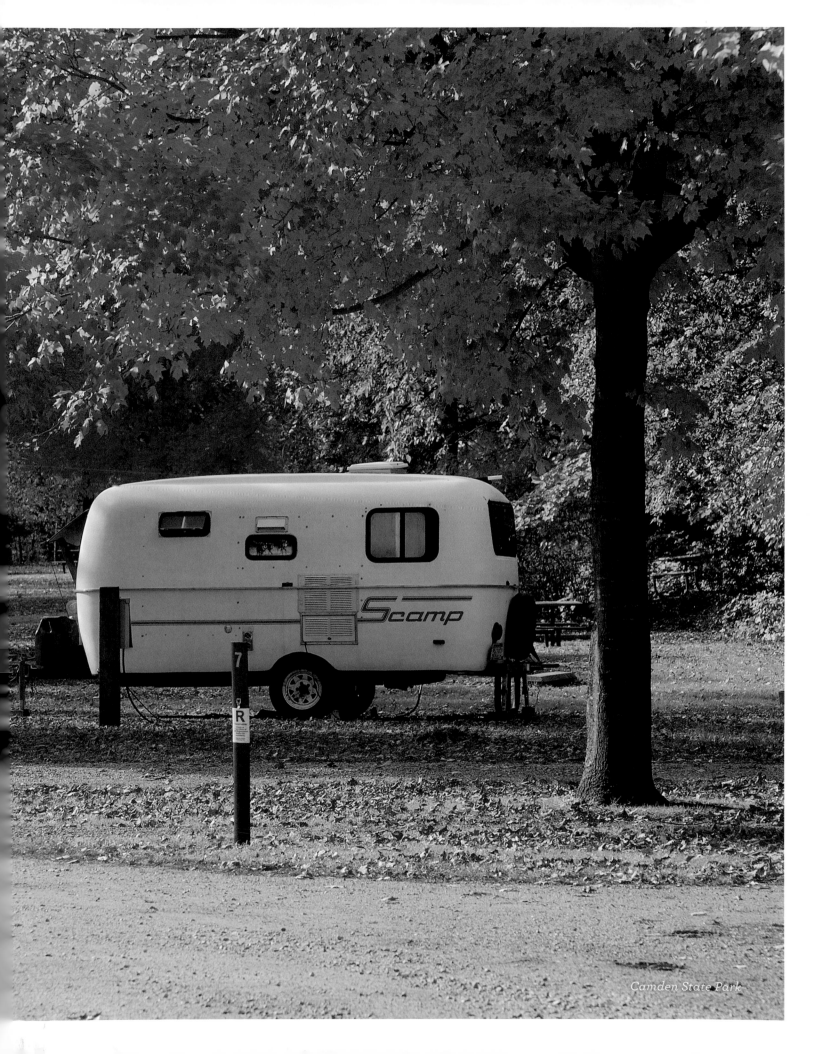

Camden State Park

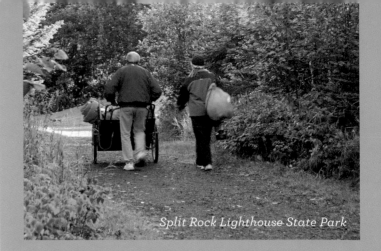

Split Rock Lighthouse State Park

Pack In or Two Wheels: Your Choice

Not all Minnesota state park camping experiences need to begin at the trunk of your car.

Many of the state's sixty-six state parks offer three other options: cart-in sites, where you can use park-provided carts to carry your gear to spots away from car traffic; walk-in sites, which still require a short walk but without a cart; and backpacking sites, to which you hike, with your gear, at least a half mile.

"For those who want more of a wilderness experience, we have backpack sites," says park spokeswoman Amy Barrett. "For those who can't backpack—whether because they don't have the equipment or the time or the stamina—we have walk-in and cart-in sites."

Nineteen parks offer walk-in camping and twelve offer cart-in sites.

Three parks with the most backpacking sites are Afton (28), George H. Crosby–Manitou (21), and Lake Maria (17). Other parks with backpacking sites are Banning, Bear Head Lake, Cascade River, Glacial Lakes, Itasca, Jay Cooke, Lake Bronson, Maplewood, Mille Lacs Kathio, Myre–Big Island, St. Croix, Savanna Portage, Scenic, Split Rock Lighthouse, Tettegouche, and Wild River. ⊠

Franz Jevne State Park

the gift shop. Grace broke into tears when she realized her favorite stuffed lamb was still at home, so we pored over the selection of stuffed animals amid the tourist sweatshirts and books about animal tracks. She picked out a puffy and friendly looking gray wolf. "I'll name him Pup," she said, and the day seemed a little sunnier.

The ground was still too damp to set up the tent, so we wandered down to the beach, a rough shore of pebbles gradually increasing to cobblestone and driftwood. Waves crashed against the pebbles, spitting up freshwater spray that twinkled against the warming sun. Propped against a log, a woman with tousled hair read a thick book. Two boys chased waves while their parents, exhaustion moderately camouflaged by sunglasses and floppy hats, sipped from coffee mugs. Was there any better place to be after a fall thunderstorm?

The girls made a beeline for a fort made of scarred, barren driftwood, decorated with gull feathers by an imaginative mind. Bailey and Grace climbed the driftwood and jumped into a pit inside the fort. I thought to say something about slivers but changed my mind.

Jay Cooke State Park

The beach was deceitfully fascinating, and the morning sped away like the scudding clouds left over from the storm. We filled our pockets with pretty rocks and studied tiny pieces of driftwood shaped like queer animals. A large, polished piece of bedrock was anchored on the south end of the beach, and the girls climbed atop and screamed when a crashing wave sprayed cold, clean droplets in their blond hair. Grace, nearly soaked, was incorrigible. She discovered a perfectly round hole carved in the middle of the exposed beach bedrock, curving downward to emerge as a smaller hole at ground level. She jumped inside, crawled to the exit hole, and dug to make it bigger. I snapped a picture of her scurrying out of the hole like a woodchuck. Pretty soon, she had attracted other ruddy faces to crawl in and out of the rock.

Returning to our campsite, we followed a path crowded with yellowing ferns and riots of blazing leaves that looked like the work

Living Large on the North Shore

In the 1860s, Robert Barnwell Roosevelt, the uncle of a future U.S. president, took a trip by ship from New York to Lake Superior's North Shore to do what only a few wealthy outdoorsmen could afford to: fly-fish. His travel account in the book *Superior Fishing* offers a few amusing insights into camping on Minnesota's North Shore during the era. In the company of his effete friend, Don Pedro, Roosevelt describes tortured decisions over their alcohol requirements. (They eventually settle on nine bottles of whiskey and three bottles of brandy, which Pedro protests is too little.) Their gear is hardly spartan: Pedro brings a "handsome" dressing gown, a portable bootjack, and a large bottle of cologne. And he complains endlessly about the camp food until Roosevelt finally makes him a four-course gourmet meal of preserved vegetable soup, fried trout, broiled duck and rice, and a cornstarch and jelly dessert.

While early on it was only the wealthy who pursued camping with gusto, future generations of rich and poor Americans would benefit from Roosevelt's nephew's vision. As president, Theodore Roosevelt protected 223 million acres of national parks and forests. ☒

of a graffiti artist. Bailey sat at the picnic table and dutifully made PB and Js while I put together thin-shafted poles and erected the tent. Rays of light created spots of warmth along the picnic table, and I found a glowing autumnal space in which to eat my sandwich and close my eyes. Pretty soon I heard a zipper open on the tent and two lithe girls slipped inside, ostensibly for some sisterly rough-housing. After a few moments of tumbling and guffaws, there was silence. I opened my eyes and set about reading a three-day-old *Wall Street Journal.* I crumpled the stock listings, tucked the wad against a chunk of hard maple, and touched a match to it.

The campground was an afternoon mural of Americans at play. A church group of mostly boys crowded around a campfire and sang songs. Several twenty-something girls with thin, gauzy skirts propped their kayaks against an aging Toyota Camry with a rusty front panel. A man wearing a marine corps hat frowned while examining a dent in his fifth-wheel trailer. A couple astraddle a three-wheeler motored through the campground, stopping to snap pictures of the surf and never-ending blue lake. We were too tired that night to cook the American campfire dessert— s'mores—and crawled into our sleeping bags under a cool, starry sky.

The next morning, we were back at the beach. I spied three middle-aged men standing awkwardly against a boulder; one wore a ponytail, another

Lac qui Parle State Park

Temperance River State Park

was dressed in Dockers. They seemed together in a familiar way, but their attention was elsewhere. The ponytailed guy took a vial out of his pocket and walked toward the water. When a wave crashed, he tipped the vial and fine dust floated away in the breeze. The Dockers man put his arm on the shoulder of the ponytailed man. They spent

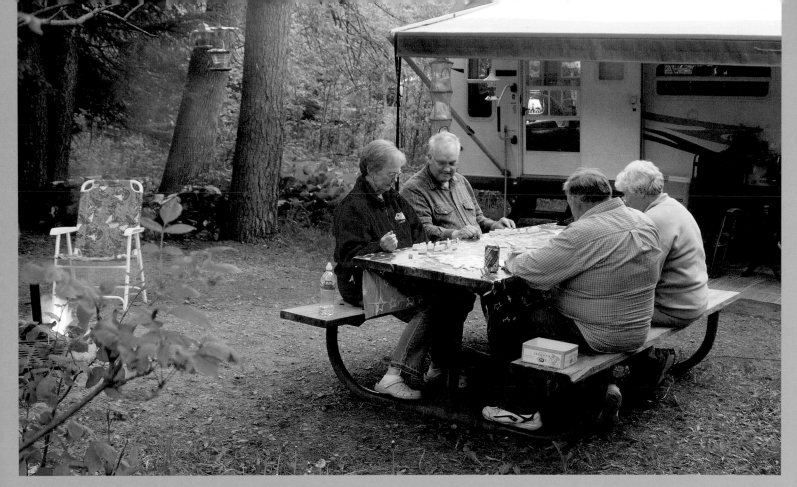

Jay Cooke State Park

Taking Care of Campers

Richard Young loves his summer job. Not only does he get to camp for free at Minnesota state parks, he and his wife enjoy meeting travelers and campers, often helping them along the way. The Youngs, of Fridley, are state park campground hosts.

"We're in our seventh year, and it has been a fantastic experience," says Richard, a retired schoolteacher. "If I can help a camper or out-of-state visitor have a more enjoyable weekend at a state park, I've done my job."

Campground hosts are required to be live-in helpers for at least four weeks. Some split their summers among different parks. In addition to light duties, such as picking up litter, a host's job is to help campers with any of their questions. In exchange, hosts live at the campground for no charge.

The Youngs have hosted at Scenic, Lac qui Parle, Lake Bemidji, and William O'Brien state parks. They've spent from one to two months at each site, including at least part of every summer at William O'Brien. They've loaned sleeping bags and axes to campers who've forgotten theirs, and they'll frequently pass along an egg or some butter to campers missing a key ingredient. In many ways, they're the ideal neighbor.

State parks are always looking for volunteer hosts, and Richard Young says the job requires few special skills. "It takes someone who is outgoing and willing to meet people and solves problems. I could sit in my trailer all day with the door shut, but that's not how I operate. I like to help." ☒

Hayes Lake State Park

Creature Comforts

Want to visit a state park and don't have a tent? Maybe you've thought of trying winter camping but hesitate about sleeping in a snowbank. Camper cabins will put a roof over your head and keep you warm.

These 12-by-16-foot spartan buildings will accommodate five to six people. Their furnishings include two bunk beds with mattresses and a table with benches; many have screened porches. A picnic table, fire ring, and grill are available for outdoor cooking and eating. Some even have electricity. They don't have indoor bathrooms, but most are located near the restrooms, showers, and drinking water stations. Vault toilets are available year-round, making the cabins an option for winter camping.

As of 2009, twenty-three state parks had camper cabins; at least fifteen parks rent cabins in the winter. More are being added each year. Some camper cabins are at hike-in sites, which means you can enjoy a remote camping experience without heading for a wilderness area. Sounds like a good night's sleep. ☒

the whole morning at the rock, smoking cigarettes and staring into the blue horizon.

We went for a hike. The beach was a tumble of exposed bedrock, some formations looking like model pirate ships in silhouette, but soon the gravel narrowed and an outcrop of jagged rock faced us. The girls scrambled up a well-used trail, and then I saw Grace climbing, hand over hand, up the final short rock wall. I was about to yell my customary warning, but she had summited and Bailey was on her heels. They raised their arms, the Lake Superior wind whipping their hair, and I breathed two words: *their Everest.*

The evening meal was brats with bright yellow mustard and lily white buns, potato chips, baked beans out of a can. We wore fleece jackets around the campfire; a hard frost felt probable, and I commented that we'd seen the last thunderstorm until April. The nip in the air caught my breath, and I put another piece of maple on the roaring fire. We toasted marshmallows but again were almost too tired to enjoy the blackened sugar mixed with chocolate and sweet, molasses-y crackers.

We crawled, single file, into the tent. I thought: perhaps I should tell them ghost stories or play a harmonica. Maybe I should insist on everyone reading a chapter from their book. Instead, I took out a laptop computer and unsheathed a copy of the *Addams Family* television show. While the monitor's warm glow filled the tent and Gomez and Morticia paraded through their marvelous house, I imagined John Muir rolling in his grave.

No matter. We were sleeping on the ground tonight. We had breathed deep of nature and felt the spray from Earth's greatest lake and walked among autumn's finest floral arrangements. Minutes passed, and I noticed two pairs of closed eyes. The tent was dark now, and a breeze tousled the primeval trees. From somewhere I heard the gentle surf. ⊠

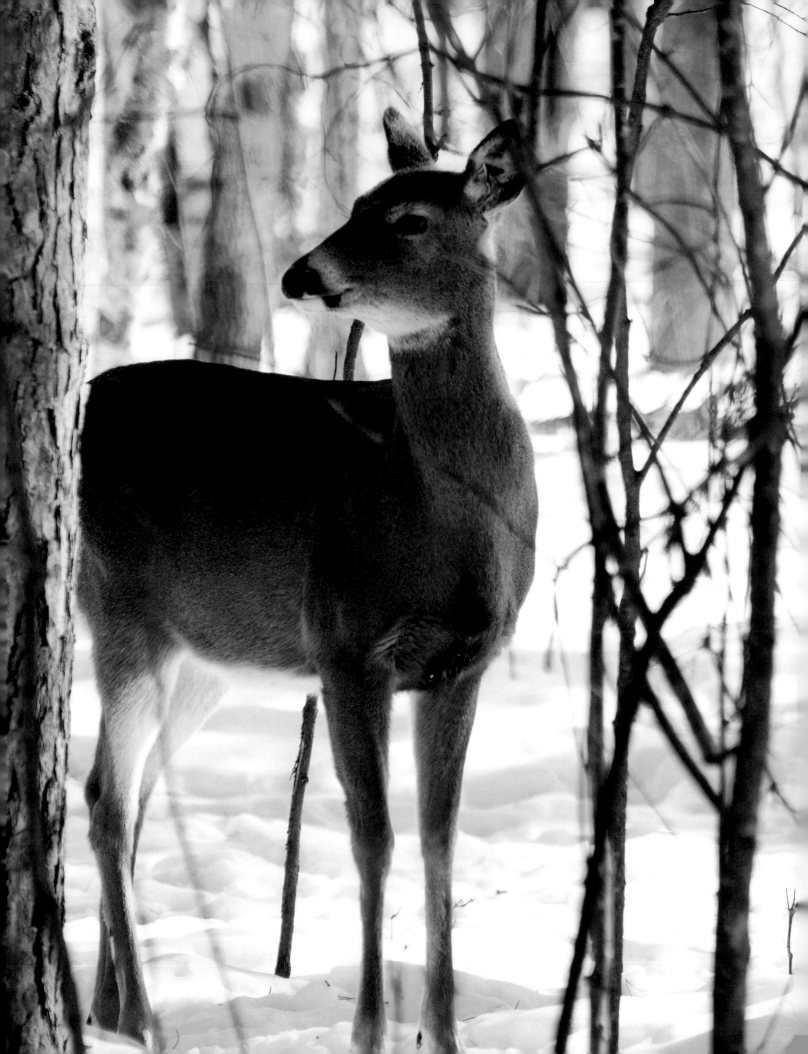

The campground at Wild River State Park is quiet on a cold November morning, though a dozen or more tents and campers are set up under the leafless oak trees. Looking for deer hunters, I'm greeted by Jack Wachlarowicz and his wife, Grace, who are having breakfast. My random knock has turned up my old friend Jack, but I'm not terribly surprised: he and Grace are avid deer hunters and campers. It's just like them to combine their two passions, even when the weather is on the cusp of winter.

"I've seen a lot of good sign," Jack says modestly, pointing to a young doe hanging from a tree outside their camper. "We've hunted here at Wild River four times in the past eight years, and it's always a good hunt. Being next to the St. Croix River adds another level of beauty."

State parks as hunting destinations? It's not a contradiction, even though state statute expressly declares state parks are designed to conserve Minnesota's "scenery, natural and historic objects and wildlife." Park managers face a conundrum when it comes to deer. Visitors enjoy seeing deer and often yearn for a Kodak moment with one. But left unchecked, white-tailed deer populations can wreak devastation on plants, to the point that well-defined "browse lines" develop under trees where deer have eaten everything they can reach.

Later in the morning, I stop by the park office to see manager Paul Kurvers. He explains his job is to balance the size of the deer herd with the need to regenerate trees and native plants. "They really hit our white pine seedlings hard,"

Father Hennepin State Park

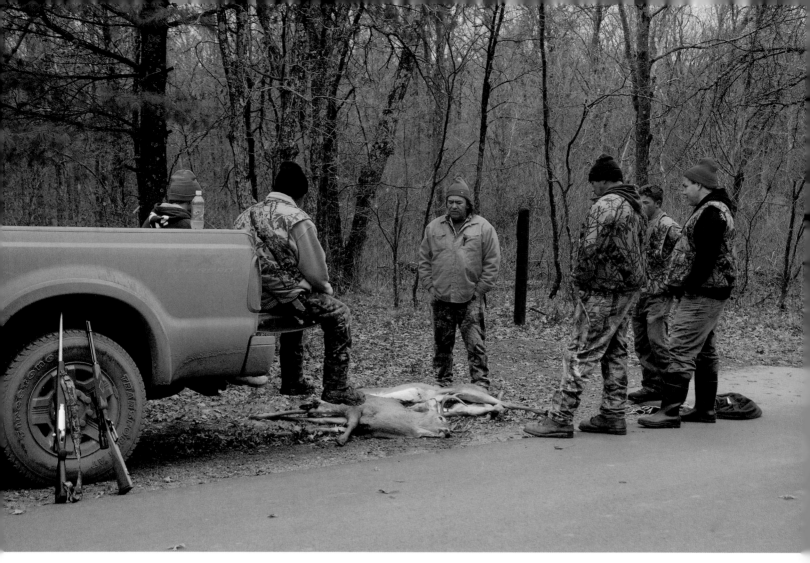

Wild River State Park

he says of the deer. "We're also trying to restore oak savanna in the park, which is a native ecosystem, and they keep browsing off our oak seedlings. They also chew down our forbs and wildflowers."

Deer are, however, a significant draw. At Father Hennepin State Park, a family of true albino white-tailed deer (true albinos have pink noses and other light-colored body parts, such as hooves and ear membranes) has made for memorable photos for park visitors. In 2008, the albino family consisted of a ten-point buck, an older doe, and one white yearling. They're believed to be the only albino deer at any state park, and no one is sure how or why they live in the area.

"We believe the older white doe is about eight to nine years old," says Roseann Schauer, the park's assistant manager. "She was born in the park, according to the former manager. We're not sure on the age of the white buck, but he does seem to be the dominant one in the herd at the park. He is only around the park during the winter months. We're not sure where he goes during the rest of the year."

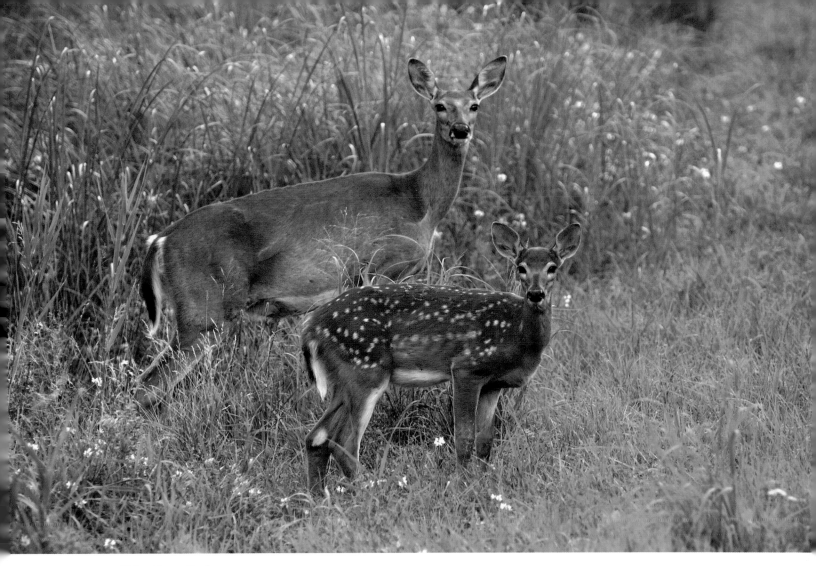

Sibley State Park

Schauer reports local deer enthusiasts are very protective of the albinos, though state law does not shield albino deer from hunters. In the last decade, Father Hennepin State Park hasn't had an over-abundant deer problem and has not been opened to deer hunting.

But the problems parks suffer from burgeoning deer herds isn't new. Ever since Itasca State Park was created in 1891, Minnesota has grappled with deer munching on park vegetation. While state parks are often managed in favor of native ecosystems, the changing distribution of key predators, such as wolves, and the landscapes of younger forests created through logging and agriculture have made Minnesota and state parks havens for deer.

In the 1940s, Professor C. O. Rosendahl, who taught botany at the Minnesota Forestry School in Itasca State Park, had a standing offer of an "A" grade to any forestry student who could find a pine seedling over two feet tall in the park. There simply weren't any young pines because deer were eating them. Through the 1930s and early 1940s, experts realized the overpopulation of deer in Itasca

Bear Head Lake State Park

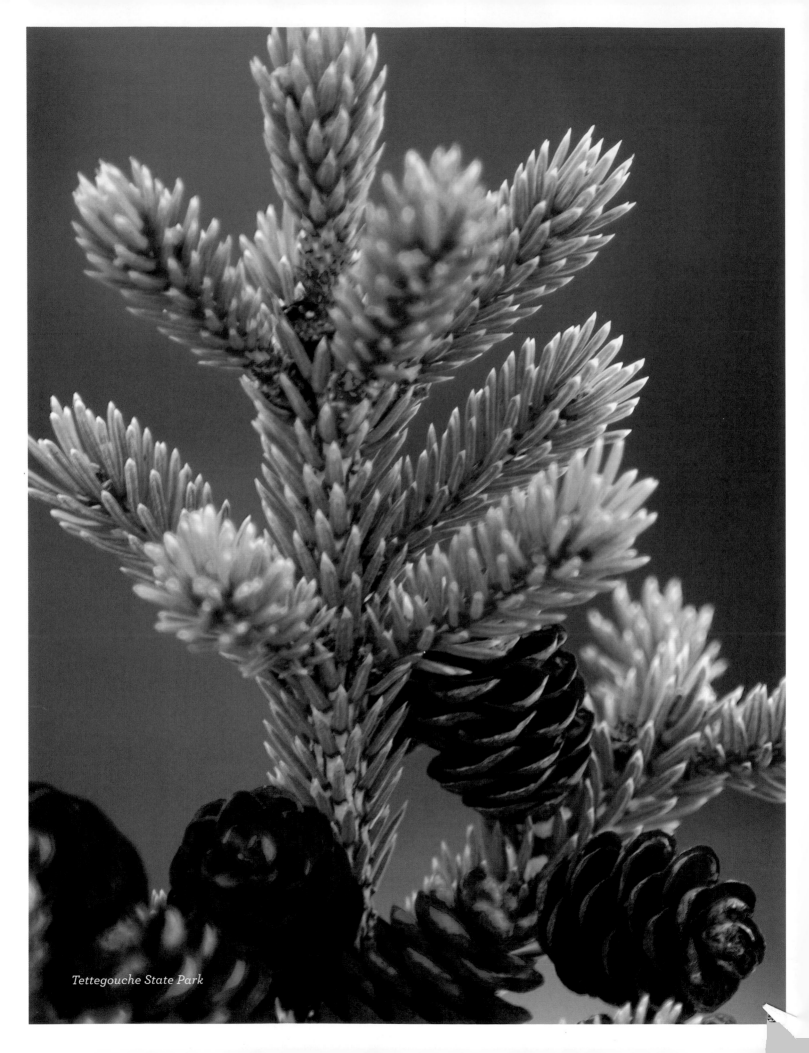

Tettegouche State Park

and other parks was destroying all efforts to grow new trees in these places. By 1945, foresters believed that one million seedlings in Itasca State Park, planted by forestry students and Civilian Conservation Corps workers, had been eaten by deer. Similarly, three hundred thousand seedlings at St. Croix State Park were destroyed. Conservationists, calling the situation a crisis, wanted a solution. The Minnesota legislature in 1945 responded by rescinding a long-standing ban on deer hunting in state parks, and fall seasons began immediately at Itasca and St. Croix.

Chester S. Wilson, head of the Minnesota Department of Conservation, a forerunner to the DNR, wrote that in both parks, "deer were literally eating themselves out of house and home." Wilson penned an article, "Toward Better Conservation of Trees and Deer in State Parks," published in the *Minnesota Conservation Volunteer* magazine in 1946, to call attention to the ongoing deer problem and to commend lawmakers for making the right decision. He was

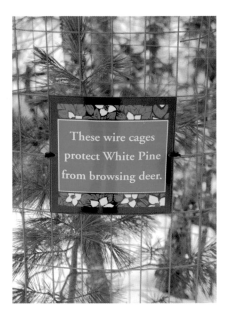

Cascade River State Park

Smile: You're on Camera

In 2006, Minnesota DNR researcher Emily Dunbar used Itasca State Park for an unusual mammal study. She set up remote digital cameras—also known as trail cameras— to estimate the number of deer in the park. She installed forty-two cameras over sixteen thousand acres in the center of the park, and near each camera she placed a pile of corn. When deer came to eat the corn, they broke an infrared beam and the camera snapped a picture.

The cameras eventually took 16,700 pictures, eleven thousand of which showed deer, but they also photographed black bears, fishers, bobcat, Canadian lynx, gray wolves, and even a guy hiking with an ax. Dunbar never figured out who he was—or what the ax was for—but he did stop by the park office to ask why his picture had been taken.

Gooseberry Falls State Park

Using a complex mathematical formula, Dunbar determined there were about thirty-three deer per square mile in the park, an estimate similar to one generated by a computer model. Why not use an airplane to count deer? Dunbar says in heavily forested, conifer-dominated Itasca State Park, you can't see the deer from the air to count them. ⊠

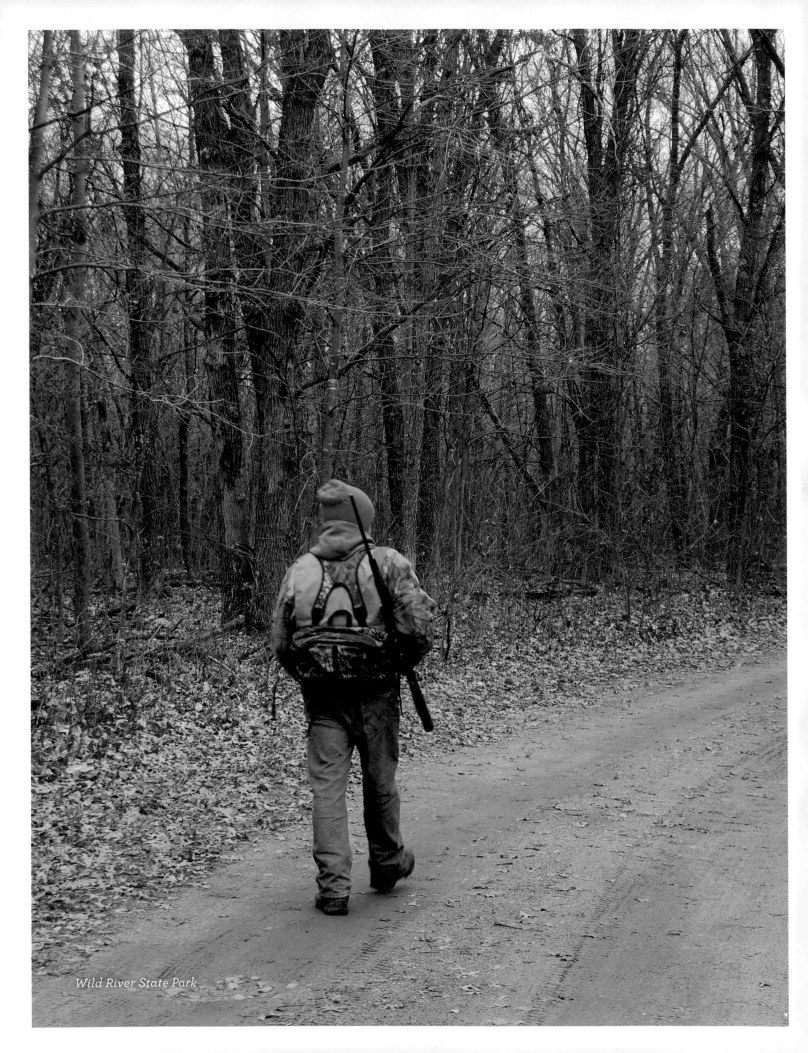

Wild River State Park

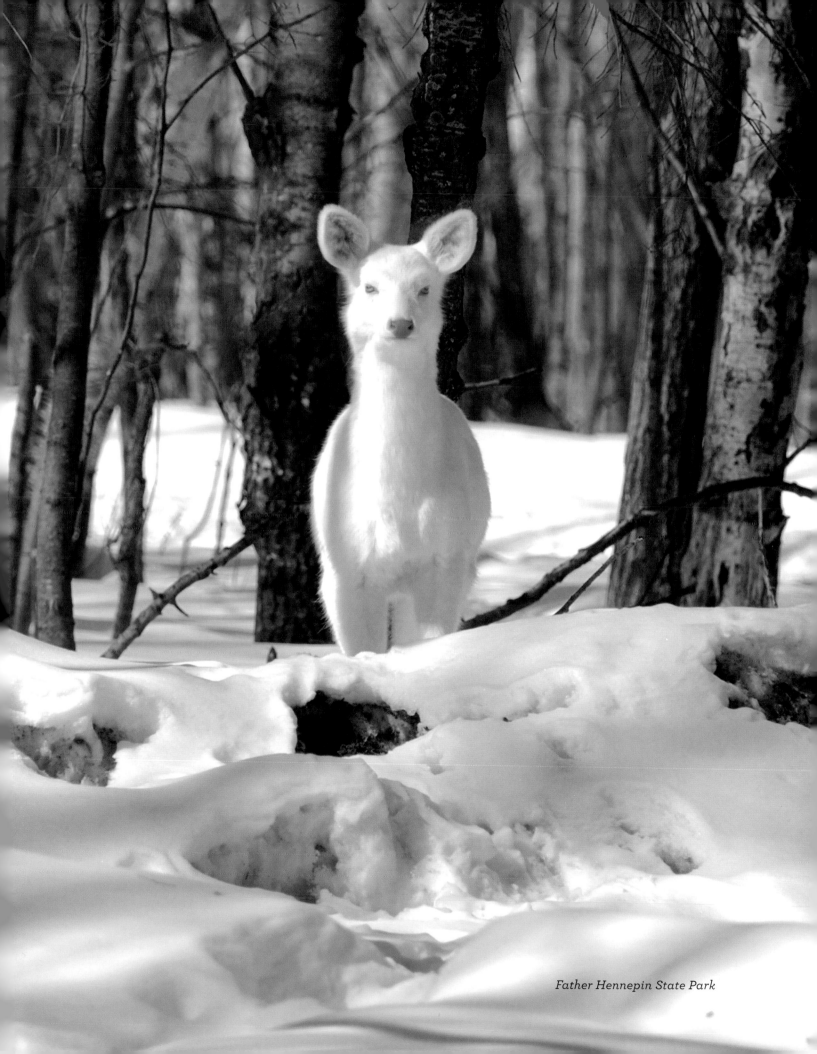

Father Hennepin State Park

concerned both about the plight of tree regeneration and about deer starving once their numbers grew past the point that the landscape could sustain them.

Since the 1940s, hunting and winters have helped check deer populations in state parks; during severe winters, nature is most effective indeed. More recently, wolf populations have grown past state goals; no longer do the animals need to be on the federal endangered species list, and they do their part to cull the deer herd. Minnesotans experienced some of the most severe winters on record in 1996 and 1997, and in northern Minnesota, deer populations plunged by more than half. But 1998 ushered in a string of mild winters, and deer herds exploded in size. Throughout the last decade, the list of parks with deer hunters expanded almost annually.

Jay Cooke State Park

In 2008, twenty-three state parks had special deer hunts, with the kill ranging from 318 deer at St. Croix State Park to three at Judge C. R. Magney. Until the winter of 2008–9, managers struggled to keep the deer population under control not just in parks but throughout the state. Deer hunters happily offered their help, with some bagging the limit of five per person in choice areas. With the exception of Itasca State Park, hunters can only join a state park hunt if they successfully apply for a special license, but the hunts have proven so popular that licensees aren't guaranteed a permit every year.

"Because deer impact forest diversity, parks have to manage for lower densities of deer. If you want to see orchids, trilliums, and any other forest wildflowers, deer have to be controlled. There are only a few they don't eat," says Lou Cornicelli, the DNR's big game program manager. "But parks have also given us an opportunity to experiment with regulations to see which are best for lowering deer populations."

Cornicelli was referring to a five-year experiment to gauge how to focus hunters' efforts on does, which are the reproductive engines of deer herds. In some parks, hunters are allowed to kill only antlerless, or doe, deer. In others, hunters are required to shoot an antlerless deer before they can tag a buck. Elsewhere, hunters

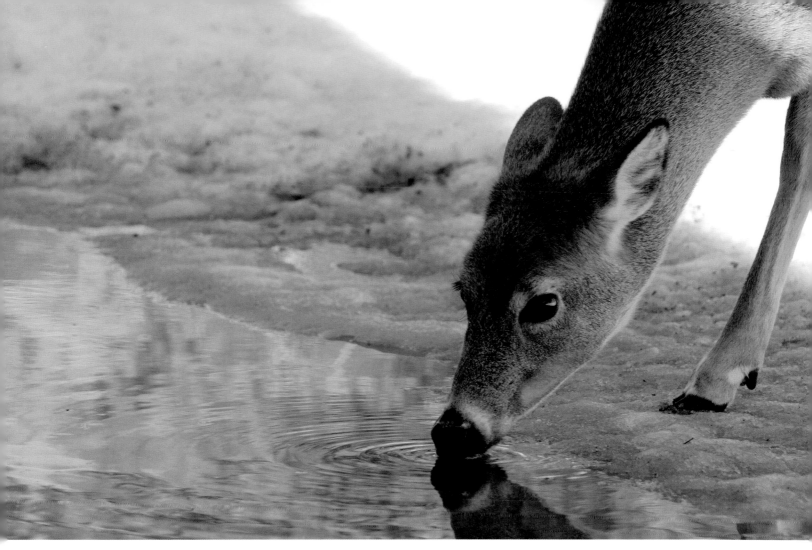

Gooseberry Falls State Park

The Food of Our Ancestors

Native people of Minnesota often chose high, prominent places near good water and food supplies to camp and prepare meals. Not surprisingly, some of these prominent land features later became Minnesota state parks. These locations have also given scientists precious information about what ancient native people ate.

When a broken pot was found in Lake Bemidji State Park, scientists studied plant residue on the sherds and found the eight-hundred-year-old pot once contained wild rice and possibly maize, or corn. "Bemidji is pretty far north for raising corn, so it could

be they traded for it," says Dave Radford, Minnesota state park archaeologist.

At Mille Lacs Kathio State Park, archaeologists have discovered wild rice pits dating back two centuries that were used to parch, thresh, and store grain.

And the Itasca Bison Site is an archaeological treasure. Eight thousand years ago it was a prairie and marsh where ancient hunters killed and butchered bison. "I think it's clear the site was visited periodically [by hunters]," Radford says. It's "one of the premiere archaeological sites in the Midwest." ⊠

could shoot bucks and does, but the bucks had to have exceptionally large antlers.

Modern deer hunting at state parks has also meant special hunts organized just for youth. Jack Nelson, manager of St. Croix State Park, is an ardent supporter of youth deer hunts there. "I've seen too many glowing faces of successful young hunters not to embrace it," says Nelson. "The DNR is a pro-hunting organization, and state parks are part of the department. My feeling is if you have deer in a park and you can safely have a youth hunt, we need to do it. We wonder where we will get our deer hunters of the future. This is one way, and the young hunters who get drawn for our hunt really see it as a privilege."

Nelson says controlling deer herds at the sprawling, thirty-four-thousand-acre St. Croix State Park is a challenge. Deer hunts

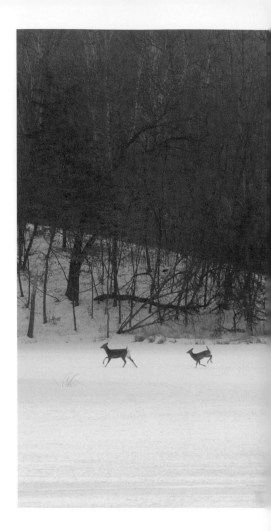

there are no longer periodic: they're annual events out of necessity. "It's not a good control method to do brief periodic hunts. The most effective is to have ongoing hunting, and maybe in a good year, you can make some inroads into the resident deer population. Deer are still a huge issue when it comes to regeneration of pine species. It's like candy for them."

Wild River State Park

Jack and Grace Wachlarowicz look forward to getting their deer hunting permits for Wild River State Park every other year. Jack says the park is part of their tradition to camp near the St. Croix River, "which adds such a neat and beautiful element" to their hunts. At Father Hennepin, visitors are thrilled when they're able to capture on film the albino buck, doe, and their offspring together—perhaps the most unusual wildlife view available in any Minnesota state park. At St. Croix State Park, Jack Nelson sees young hunters and their parents carrying on a deer hunting tradition while helping control the park's herd and benefit native vegetation.

"Deer will forever be a part of our state parks," Cornicelli says. "Balancing people's desire to see them and the need to protect our native vegetation will likewise always be our challenge." ⊠

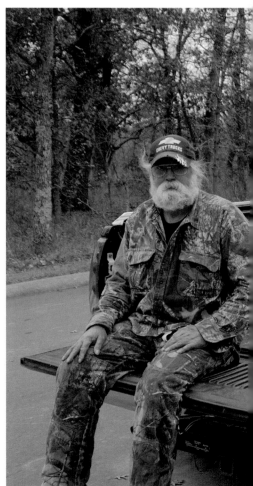

Lake Maria State Park

Gray Wolf Rebound

Minnesota has about three thousand gray wolves, according to a 2007–8 survey, more than any other state save Alaska. Do state park visitors stand a good chance of seeing a wild gray wolf?

Park officials say gray wolves, also known as timber wolves, might live in or travel through any of Minnesota's northern state parks within their range. Some parks in central Minnesota might even have resident gray wolves. But actually seeing a gray wolf is a different matter.

These stealthy animals don't avail themselves for viewing, except for fleeting glimpses. I've seen an occasional gray wolf along Minnesota 61, where they feed on wintering North Shore deer herds. I've also seen gray wolves crossing lakes near Ely. On a calm night, you might have the good fortune of hearing a wolf pack howling. But seeing a gray wolf along a state park trail is still a rare occurrence: if you catch sight of one, consider yourself lucky indeed. ⊠

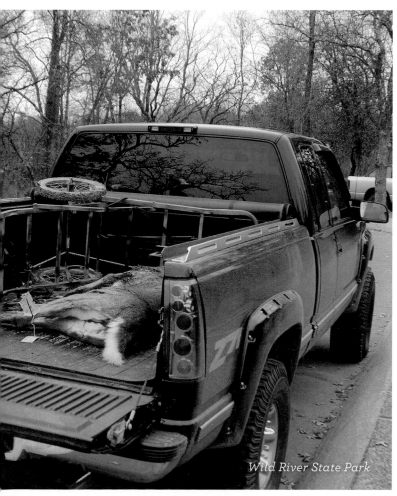

Wild River State Park

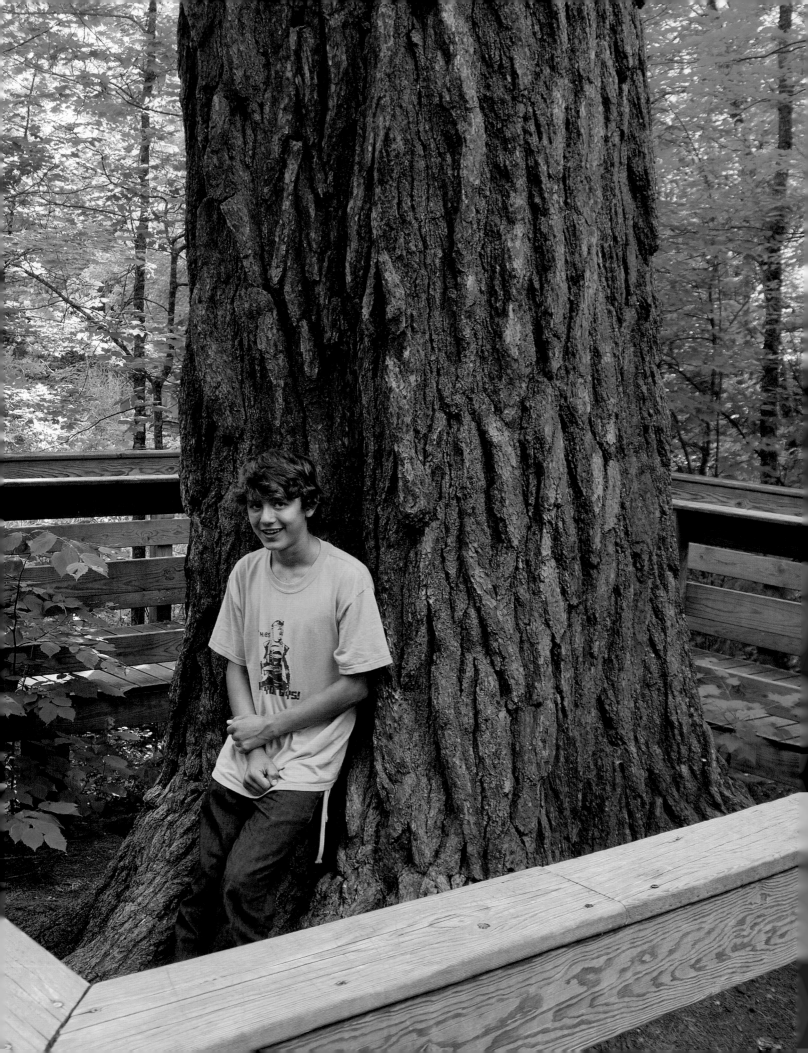

The massive red pine along Nicollet Creek at Itasca State Park has an attractive, curvaceous trunk that one writer compared to the Leaning Tower of Pisa. Its bark has deep fissures, common among large, old red pines; the thick outer layer has protected the tree from at least six forest fires over the past three hundred years. Most notable is its enormous girth and prominent location, says park naturalist Connie Cox. Its circumference is ten feet, overwhelming the other sizable red pines nearby. "When you stand on the boardwalk, your center of focus is on that tree," Cox says. "You don't get the same view of the other trees; they didn't have the same character. This tree seems to have a persona."

It was also the champion—or at least the cochampion—of all red pines in the world. Trees are certainly a draw for state park visitors, but the monster red pine at Itasca had more than its share of fans ever since it was declared the state's largest red pine in 1967 and eventually designated co-world champion by the National Register of Big Trees. Even though it shared the title with a Michigan specimen for many years, visitors at Itasca were in awe of the Minnesota champ. "It was always an icon," Cox remembers.

Always, that is, until a fateful day in 2007. Without any witnesses, a vicious spring storm cracked off the top thirty feet of the tree, thus erasing it from the record books. "We were always so proud of it," Cox says. "It was like losing a member of the family."

Itasca State Park

The tree is still alive, and plenty of visitors continue to marvel at the former champion, which resides near another prominent park landmark, the Bison Kill Site, where hunters slaughtered buffalo eight thousand years ago. Itasca State Park is well known for its red pines. Preacher's Grove, where a religious convention was once regularly held, is populated by trees that began growing in 1714 after a massive wildfire swept through the area. And who doesn't marvel at the four huge white pine logs used to construct the Old Timer's Cabin, built in 1934 by the Civilian Conservation Corps?

Minnesota has an estimated twelve billion trees that cover one-third of the landscape, and some of the most memorable, loved, and impressive specimens live in state parks.

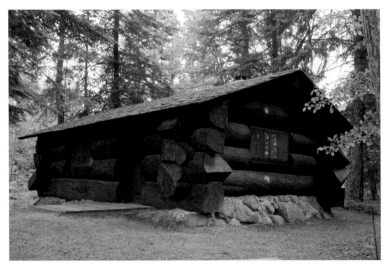

Itasca State Park

Near the entrance of Forestville State Park grows a massive white pine that currently reigns as the state champion. Champion trees are judged by their circumference, height, and crown spread, or width of their top branches. Like the Itasca red pine, the Forestville champion white pine has an enormous trunk. To get a full sense of its trunk size, you have to walk completely around the tree and view it from different angles. Given the prominence of white pines in northern Minnesota, "You wouldn't think of the state champion white pine being in southern Minnesota," says Jennifer Teegarden, who oversees the state's Native Big Tree Registry, but this white pine has a story.

The tree was planted by the first European settlers in the area, in a row of other white pines, says Forestville manager Mark White. "The homestead where it was planted was settled by a family named Satterlee. The Satterlees still have descendants in Minnesota, we believe."

On a trip to Forestville State Park, I located the mighty white pine along the entrance road and, after parking my car, I had to do a double take to determine which was greater—the tree's girth or the length of my compact. I concluded the car had the tree by just a few inches.

There is no plaque denoting the tree as a state champion—Teegarden says you can't count on individual trees to hold their record status for long—and brush and grass had grown up around its trunk. "Beauty doesn't always describe a champion," I thought, examining its many thick stems rising from a massive trunk. Each stem was a branch the size of my thigh. The branches lend the tree the appearance of a brown octopus.

A more beautiful tree in the park, says White, is a stately black oak along Forestville Creek, used occasionally by foresters to take grafts for the state nursery. And for a journey through history, White sends visitors on a hike to the abandoned Forestville cemetery, where Twin Pine looms over the horizon. Wedged in the center of the double trunk is a small tombstone, which legend says belongs to a child who died in the village's early days. The pine was planted at her grave site.

Wandering around the restored village of Forestville, I came across another of the park's famous trees: an Ohio buckeye brought to Minnesota by the politician William Jennings Bryan. This buckeye isn't much to look at—it was damaged by a storm a few years back—but searching the ground, I found a few hollow hulls of its namesake fruit. Buckeyes aren't native to Minnesota, but that didn't matter to the Meighen family, who originally owned the property. They were active in Minnesota politics and invited their friend Bryan for a visit. That he brought and planted a tree in their yard says volumes about political patronage back then. A tree was an apt symbol of a political friendship.

Humans gravitate toward trees. We admire their leaves, their peculiar shapes, their ability to cool us when we're hot. We coddle them in our backyards, loyally mulching them when they're young. We also view them as a commercial commodity, mass harvesting them with efficient cutting machines that grab a bundle of aspen and snip them off at the base like daffodils. Children can spot an appealing tree a mile away. A tree that can be climbed? It chums them like the Pied Piper. William O'Brien State Park staff have dubbed an old white spruce the Ugly Climbing Tree. The branches droop down to the ground, providing springy steps up the trunk. On a summer day, a half dozen kids will be hanging on the tree, exploring its branches, says park naturalist Diane Hedin. Pike Island at Fort Snelling State Park has a grove of cottonwood trees so large that visitors can stand inside their hollow trunks. A two-hundred-

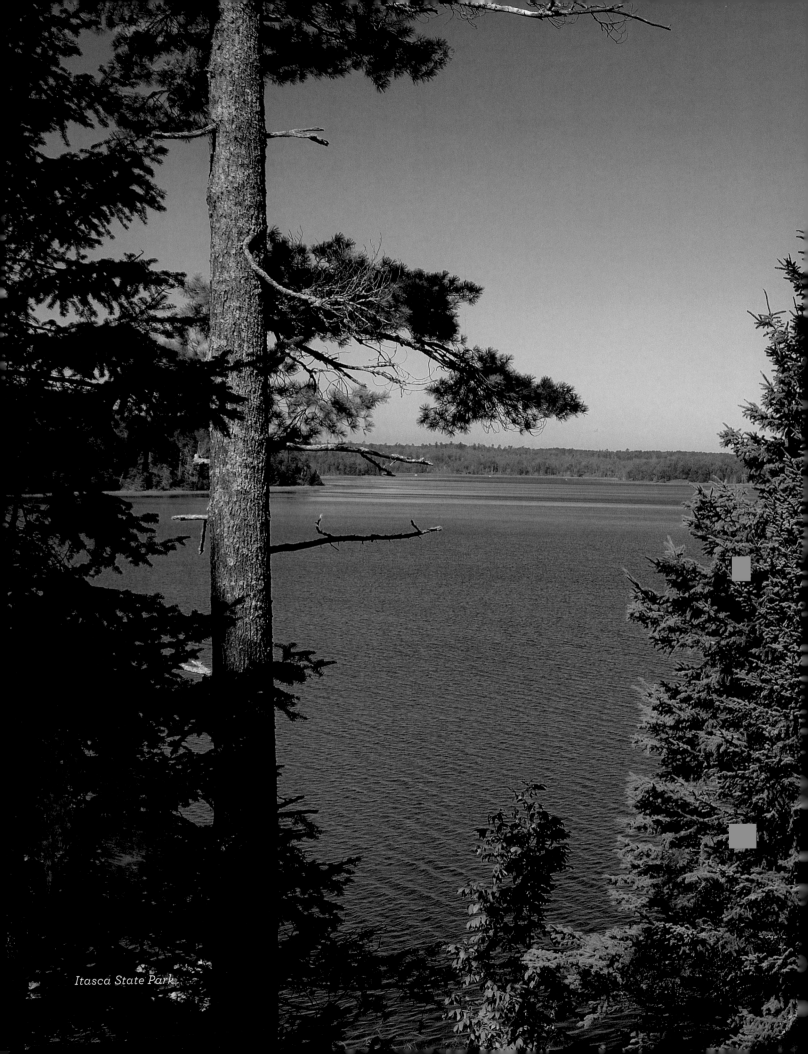

Itasca State Park

Zippel Bay State Park

Camden State Park

Interstate State Park

year-old bur oak at Lake Bemidji State Park has a hollow trunk that draws local elementary schoolkids like bees to honey. Local teachers call it the Magic Tree, and students return every year to make sure a storm or disease hasn't claimed their pal.

Glendalough State Park has a child favorite: a large basswood whose trunk lies nearly parallel to the ground. It is known as the Climbing Tree, says manager Jeff Wiersma. Other trees in the park pose a unique problem, one that has surprised a few staffers wielding chainsaws. The previous owners of the Glendalough property left dead trees standing for the benefit of wildlife but shored them up by filling the trunks with concrete. One tree destroyed two chainsaws because of a huge rock embedded in its base. Wiersma says those earlier owners also leaned rocks against saplings to support them and the trees eventually grew around and engulfed the boulders.

Crow Wing State Park

Another tree, an ancient tamarack at the end of the Lake Bemidji State Park bog walk, is called the Spirit Tree. No one knows its age, but its notoriety earned it a prominent spot on the state park entrance sticker on the park's seventy-fifth anniversary. At Old Mill State Park, five Scotch pines on the west bank of the Middle River were planted by Swedish immigrant Lars Larson around 1882. "He must have planted them with some longing for the trees of his homeland," says DNR resource specialist Chris Weir-Koetter. One of the pines has a visible lightning scar in its crown. Weir-Koetter tells visiting schoolchildren that if they climb the tree and touch the scar, they become invincible.

Sakatah Lake State Park is home to Minnesota's largest slippery elm, also called the red elm. Frequently found in the southern part of the state, the slippery elm species is known for its hard, compact wood; it's been used for furniture, fence posts, railroad ties, and ships. The state record holder, located in the southeast corner of

Minneopa State Park

Buffalo River State Park

McCarthy Beach State Park

Scenic State Park

Wonderful Park Trees

With its wilderness-like setting, Scenic State Park is often referred to as the most primitive park in the system, but—surprise—this lovely northern destination had showers as early as 1940. Still, the real attraction here is the trees: virgin stands of white and red pines cover the shorelines of Coon and Sandwick lakes plus part of Lake of the Isles, Tell Lake, Cedar Lake, and Pine Lake. While parts of the park were logged, Scenic was designated in 1922 to protect the remaining pine stands. If park proponents' desire was to leave the visitor an impression of northern Minnesota before loggers arrived, they succeeded. ⊠

Great River Bluffs State Park

Lake Bronson State Park

Sakatah, is more than seventy-five feet tall and has a circumference of nearly twelve feet.

The one-time world-record jack pine is found in Lake Bronson State Park. Jack pines are scraggly looking trees, but they're hardy souls, living in soil too poor for the likes of the stately red and white pines. Well known among foresters, Lake Bronson's jack pine was first measured for champion tree status in 1979. It's still recognized as the state record for the species but has to be measured and certified again to regain its title as world champion, says Teegarden.

Cox, the naturalist at Itasca State Park, is hopeful a new red pine champion will be found within the park. The DNR, with Teegarden's urging, is asking the public to pitch in and help find the state's next winning red pine. Rumor has it some forestry researchers were back in Wilderness Sanctuary at Itasca in the late 1990s and discovered a handful of red pines that appeared even larger than the former champ. Nobody ever mapped the trees or marked their location with a GPS.

"We've been looking through old guest registers, and you often see people writing things like, 'We came for the headwaters, but we return for the pines,'" Cox says. "A pine forest has a certain feel. It's the smell and the sound of the wind through the needles. They've survived windstorms and drought and fire. It would be amazing to talk to those trees and get their story. People stand next to them and have a quieting sense of awe, a sense of peacefulness. They love these pines, but they can never fully explain why." ☒

Forestville State Park

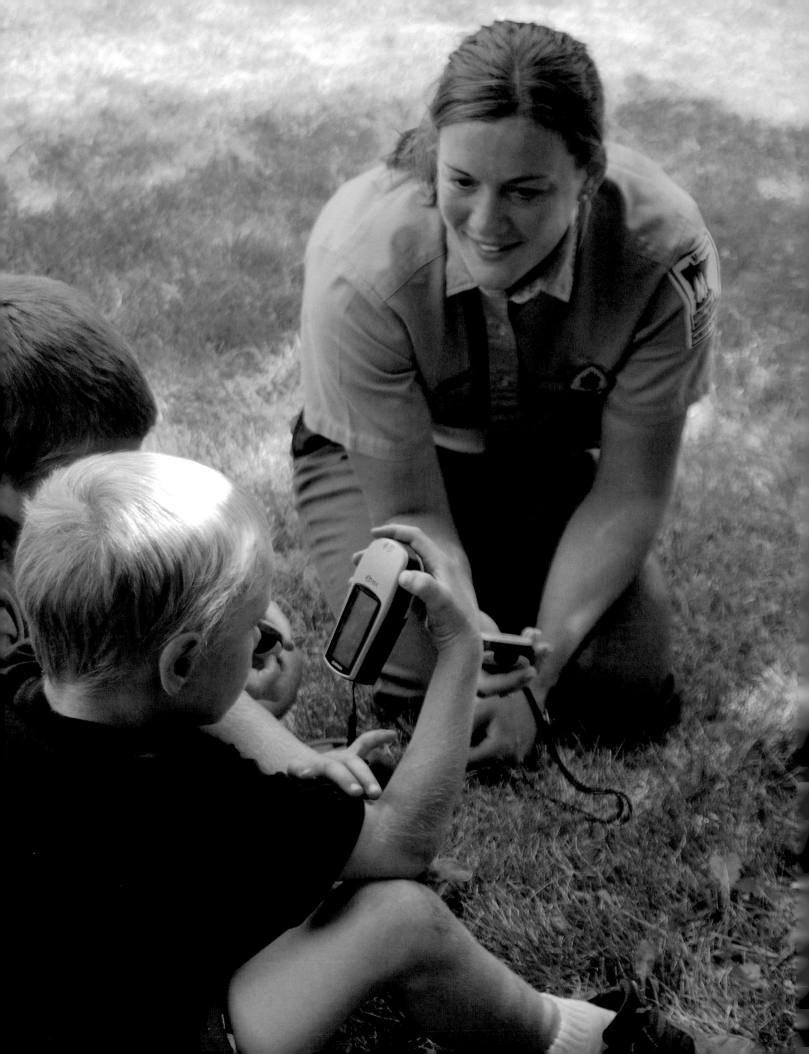

Love, Marriage, and GPS

When all the satellites lined up, they changed Jason and Sarah Geisel's lives. That moment occurred in March 2008, before the Geisels were married. They had only a vague notion of the principles of the Global Positioning System (GPS), a navigational system that relies on orbiting satellites to tell those on Earth precisely where they are.

Jason was shoveling snow outside his Belle Plaine home when his neighbor began describing a new sport where participants use a handheld GPS unit to find caches hidden around the state—and around the world. The treasure hunt was called *geocaching*. Curious, Jason and Sarah purchased a GPS and then went online and discovered there was a geocache hidden near their home. They turned on the GPS and went searching for the box, which they found, after several failed attempts, inside a fence post.

Fort Snelling State Park

"We knew from the first night geocaching was something we can get into," says Jason, a middle-school physical education teacher.

Geocaching also happens to be the hottest thing to hit Minnesota state parks since the invention of the nylon tent. The Geisels are among thousands of geocachers who have plugged latitude and longitude coordinates into their GPS units and headed for a state park to find a hidden box. In 2008, DNR parks staff saw the growing interest in geocaching and, with generous sponsorship from

Lake Carlos State Park

the electronics retailer Best Buy, quickly bought GPS demo units for sixteen state parks and made them available to visitors.

With some help from veteran geocachers, the DNR set up the Minnesota State Parks Geocaching History Challenge that year, hiding containers at all Minnesota state parks and recreation areas. Each cache contained a logbook and collectible history cards for the individual park. History Challenge participants could get coordinates for the caches from parks, the DNR's website, or the official website for geocachers worldwide: www.geocaching.com.

The Geisels had been to only a handful of parks in their lives, but when they learned about the Geocaching History Challenge, they saw an opportunity to test their new geocaching expertise and have some adventure to boot. With school out for the summer, Jason and Sarah sat down and mapped a strategy to find the geocaches at each of the state's seventy-two parks and recreation areas. They also made up online names for themselves for geocaching.com: Jason's name is Nestaron and Sarah's is Aranel.

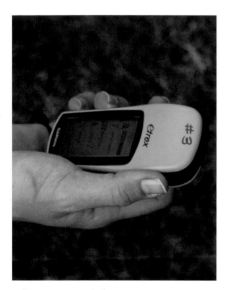

Lake Carlos State Park

"We're both Tolkien fans and nerds," Jason says. "Sarah was doing some research, and she found a website that would change your name into the Elvish language. Sarah's name means 'princess,' and my name means 'healer.'"

They started in May, finding their first cache at the Minnesota Valley State Recreation Area. They finished July 13, having driven nearly ten thousand miles and changed the oil in their car three times. At one point, they visited twenty-five state parks in five days. They paid a minnow trapper $250 for a round-trip ride to Garden Island State Recreation Area in the middle of Lake of the Woods. "While we found our first cache in May, it really wasn't until June 6 that we got going on the History Challenge," Jason says. They were the third group to finish the challenge. In geocacher lingo, they were "third to find."

"We decided if there was another challenge, we'd try to do better," Jason says.

Lake Carlos State Park

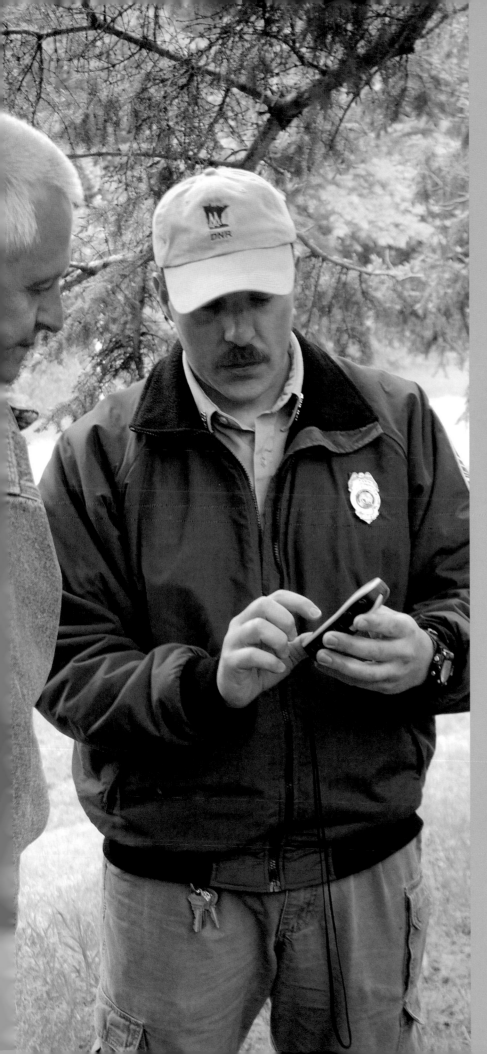

Wired or Not?

How much technology should be available to state park visitors?

In 2008, the Minnesota DNR decided to offer Itasca State Park visitors access to wireless Internet in select locations. The experiment raised questions about the appropriateness of bringing the "wired" world to people seeking solace in nature.

Lack of time is often cited as the major reason people don't use parks. "We thought it might help some people overcome their time restraints," says Patricia Arndt, DNR planning, public affairs, and technology manager.

The wireless service, offered in a few buildings like Douglas Lodge and at one of the campgrounds, proved popular. "We found one person living in Russia did an Internet search for a park that had both great beauty and Wi-Fi, and he came to Itasca for that specific reason," Arndt says. "His business lent itself to working on the computer, so he could work part of the day and enjoy the park the rest of the day."

In 2010, the DNR undertook plans to offer wireless service in other parks, specifically well developed ones that offer other amenities. ⊠

State parks officials were a little stunned—and thrilled—with the response to the Geocaching History Challenge. Though it was difficult to determine how many people participated, clearly geocaching was exploding in popularity.

"One of our staffers stumbled across the fact that Utah state parks were doing geocaching," says Bryce Anderson, who coordinates education programs for state parks. "The Utah parks staff were surprised how popular it was. We thought it might be a bit of an underground thing and only a few people would show up for the History Challenge. When it was done, we had lots of visitors telling us they thought it was very exciting and asking, 'What's next?'" The parks staff quickly decided they needed a new challenge for 2009.

For the Geisels, the summer of 2008 proved to be busy. In addition to visiting all seventy-two parks and recreation areas, the couple went to the boundary waters for a canoe trip, where Jason proposed to Sarah. The wedding date was set for the following June.

As spring approached and wedding plans were under way, the couple learned the DNR had a new park treasure hunt called the Geocaching Wildlife Safari. In this challenge, geocachers were rewarded in each box with a critter card, similar to a baseball card, with a description of an animal known to live in the park. Were Jason and Sarah up for another road trip across Minnesota? "Sarah decided that if we were going to do it, we needed to finish third or better," Jason says. "Plus, we'd get some exercise and get in shape for the wedding."

The Geisels decided to throw themselves into the Geocaching Wildlife Safari. They found their first cache on May 3 and every cache by June 6. Toward the end of May, they monitored geocaching.com to check their progress. One couple was ahead of them by one park. Another hardcore geocacher, the first to find during the previous year's History Challenge, was also in the hunt but had left the state to geocache in Tennessee. The Geisels decided to make their move and ramp up their searching.

On Memorial Day weekend, they visited an astounding thirty-three state parks from Friday through Monday. They knocked off another six during the following week. On Friday, June 5, as soon as Jason finished teaching his final class he and Sarah packed up the car and drove straight through to Zippel Bay State Park, where their last cache was hidden.

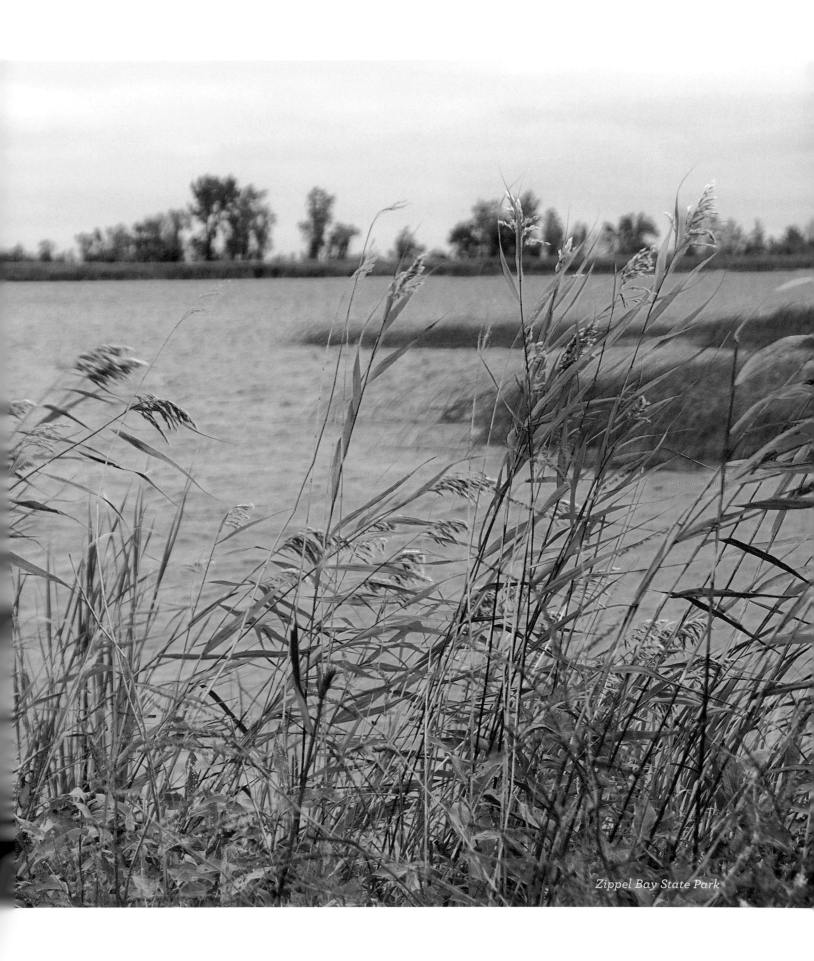

Zippel Bay State Park

"We set up camp, and it was super cold," Jason says. "We were both in three layers of clothing and wearing hooded sweatshirts, both huddled in a sleeping bag together. The dog was so cold she spent the night in the tent going around in circles trying to get warm. I couldn't sleep." The next morning, they found the Zippel Bay cache. The DNR issued a news release that week announcing the Geisels were the first to find, and the couple met state park director Courtland Nelson at a ceremony at Fort Snelling.

I asked Jason whether the couple did little more than drive into each park and find the cache. "In all honesty, that's what we did," he says. "We drove in, turned on the GPS, and went searching for the cache.

"But we enjoyed our state park experiences so much that we've joined the park's Hiking Club [which recognizes individuals who hike each park's signature trail], and we're going back for more visits." On June 27, 2009, the Geisels were married and, not unexpectedly, geocaching found a way into the ceremony. When the best man checked his pockets for the wedding ring and feigned it lost, Jason's brother whipped out a GPS and found the "missing" ring in someone else's jacket. The best man's speech had a geocaching theme, too.

"In geocaching, when you can't find something, it's disappointing," Jason recalls the speech. "But when you find what you desire, it's like finding love—it's exciting."

By the summer of 2009, the DNR had demo GPS units at twenty-five state parks. Anderson had estimated more than twenty thousand "finds" for the 2008 History Challenge. He expects that number represents about five thousand visitors who have located a cache at a state park. As for the growing competitive nature of geocaching, "we're fine with that," Anderson says. "We're seeing evidence that significant numbers of people are visiting state parks because of geocaching and many of them [are] learning things while they're there." For that reason, the Geocaching Wildlife Safari will continue until 2012.

Meanwhile, Jason and Sarah Geisel are planning their next adventure. "There is something called Cache Across America, and there is a cache hidden in every state. That's a ton of room to roam," Jason says. "I know we will start it. I also know we will end up doing it throughout our lives together." ⊠

The State Park Name Game

▪ **Banning:** The former village on this site was named after William L. Banning, president of the St. Paul and Duluth Railroad.

▪ **Charles A. Lindbergh:** He was the aviator's father, a Republican congressman, and a contender for governor (defeated in 1918). The family's house in the park contains many mementos.

▪ **Father Hennepin:** Missionary Louis Hennepin never stayed at this exact location, but he was the first to write extensively about the Mille Lacs area, which he visited in 1680.

▪ **Flandrau:** Charles E. Flandrau helped draft the first Minnesota constitution and was a member of the state's first supreme court.

▪ **Franz Jevne:** The International Falls and Minneapolis lawyer's heirs donated family land for this park along the Rainy River.

▪ **George H. Crosby-Manitou:** A mining magnate, Crosby donated 3,300 acres for the park along the Manitou River.

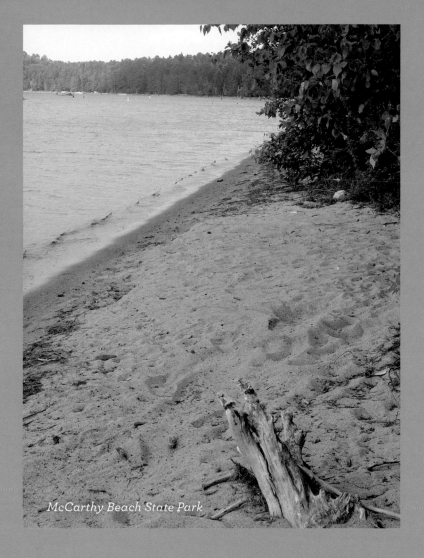
McCarthy Beach State Park

Jay Cooke: A Philadelphia banker and industrialist whose line, the Northern Pacific Railway, started in nearby Carlton and whose heirs donated land for the park.

John A. Latsch: This landowner and local businessman, along with a neighbor, donated 350 acres for the park in 1925.

Judge C. R. Magney: A lawyer, mayor of Duluth, state supreme court justice, and advocate for North Shore state parks, Magney was instrumental in creating eleven parks and waysides along the shore.

McCarthy Beach: A reclusive homesteader, John A. McCarthy allowed visitors to use his land before it became a park.

Sibley: Named after Minnesota's first governor, Henry Hastings Sibley.

William O'Brien: His daughter donated 180 acres for the park in memory of this local lumber baron.

Zippel Bay: Named for settler Wilhelm Zippel, who built a home in 1887 near today's park entrance. ⊠

A Place for PhDs

The Minnesota Division of Parks issues between forty and fifty permits to universities and scientists conducting research at state parks each year. Here are some of their past projects:

Minnesota Department of Health researchers have used state parks to gather and study ticks that carry diseases dangerous to humans.

A University of Illinois at Chicago graduate student gathered bison dung at Blue Mounds to study fungi that play a critical role in the environment.

Soudan Underground Mine State Park houses an internationally known research facility to study elusive subatomic particles. A chamber a half mile below the surface shields the experiments from cosmic rays from outer space.

The Minnesota DNR has used the parks to study white-tailed deer impacts on vegetation, including collecting browse counts. The agency has recently used parks to study which hunting regulations are the most effective in reducing deer herds.

Whenever parking lots, structures, or even outhouses are built at state parks, state archaeologists check for historic artifacts. Their finds—from Paleo-Indian tools to musket balls—give scientists new information about human activity at the site. ⊠

For anglers seeking bass and bluegills, Annie Battle Lake at Glendalough State Park is a step back in time. For more than eighty-five years, the 335-acre lake in Otter Tail County was a private fishing retreat, the only development around it a cluster of cabins known as Glendalough Camp. The clear lake and surrounding property had been owned since 1928 by a string of Minneapolis newspaper magnates, but in 1990 the Cowles Media Company donated the land to the Nature Conservancy, which in turn handed it over to the Minnesota DNR.

Glendalough State Park was established in 1991, and, in turn, Annie Battle became one of the state's distinctive public fishing lakes. Today it is called a "heritage fishery" and no motors—not even motorized ice-fishing augers—are allowed. Annie Battle might be the only Minnesota lake where electronic fish locators aren't found in anglers' boats: the sonar devices are also prohibited. It is catch-and-release fishing, too, for northern pike and largemouth bass.

Lake Carlos State Park

Judge C. R. Magney, an early and influential supporter of Minnesota state parks, famously foresaw that parks should be "everyman's country estate." But a perhaps underappreciated fact is how many parks have protected some of the state's most pristine water bodies, like Annie Battle Lake.

Glendalough State Park

Lac qui Parle State Park

Minnesota has 11,842 named lakes; not surprisingly, thirteen state parks have lakes in their names. Three parks commemorate rivers—Cascade, Buffalo, and Whitewater—and another, Split Rock, is named for a creek. Wild River State Park gets its name indirectly from bordering the St. Croix River, which was designated one of the nation's first Wild and Scenic Rivers in 1968. Lac qui Parle State Park has a namesake lake, which is the French translation of the name Dakota Indians gave to the water body: "lake that speaks." When hundreds of thousands of ducks and geese arrive each fall at Lac qui Parle, with the din of their honking and quacking, the lake surely lives up to its name.

McCarthy Beach State Park, a popular picnic area between Sturgeon and Side lakes in the 1930s, was named for the property's former owner; its signature feature was once ranked one of America's best sandy beaches by *Highways Magazine*. Minnesota also has a park named after a bay—Zippel—which overlooks sprawling, fifty-five-mile-wide Lake of the Woods. The DNR considers the park among the best destinations in the state for walleye fishing. Zippel

Bay's fine sandy beaches lure swimmers and strollers; the park's sand and sloping topography derive from another lake, Glacial Lake Agassiz, which covered the region during the last ice age.

State park lakes owe a lot of their splendor to glaciers, and nowhere is this more evident than at the 1,880-acre Glacial Lakes State Park. Located in western Minnesota, Glacial Lakes' hilly, prairie terrain lies in the Leaf Hills region, an area up to twenty miles wide described by the DNR as "unlike any other [place] in the state." When glaciers crept southward, they sliced off everything in their path, right down to the bedrock, and when they retreated, they left large, rolling hills of rock and gravel. Glacial Lakes may be known as a wildflower park, but those glaciers also sculpted fifty-six-acre Mountain Lake—perhaps a misnomer in the tallgrass prairie landscape—which is fed by deep springs that create gin-clear water. One enthusiastic description declares Mountain Lake to be "one of the clearest in the state." While the lake isn't a state heritage fishery, rules restrict boaters to paddles or electric motors—no gas engines allowed.

Travel south and slightly east of Glacial Lakes to 187-acre Monson Lake State Park, where thirty thousand years ago glaciers also scoured the landscape. Huge blocks of ice became lodged in the remaining till and eventually melted, leaving Monson and West Sunburg lakes. At Sibley State Park, Andrew Lake was similarly formed by a giant ice block that was either partially or completely buried in leftover till and then melted into a lake.

Zippel Bay State Park

Farther north, Lake Carlos State Park was shaped by glaciers, which gouged out the park's namesake, the largest and deepest lake in the Alexandria chain. It shares with Monson Lake the characteristic of being created by a large block of leftover, glacial ice. But the 2,520-acre lake isn't a destination for quiet solace; it is one of the park system's most popular boating and swimming lakes, and most of the shoreline is developed. Still, the clear lake supports a well-balanced community of native fish such as largemouth bass, crappie, bluegill, and northern pike.

Not content with this bounty of lakes, Minnesotans have over time dammed rivers and created new ones, many of which exist

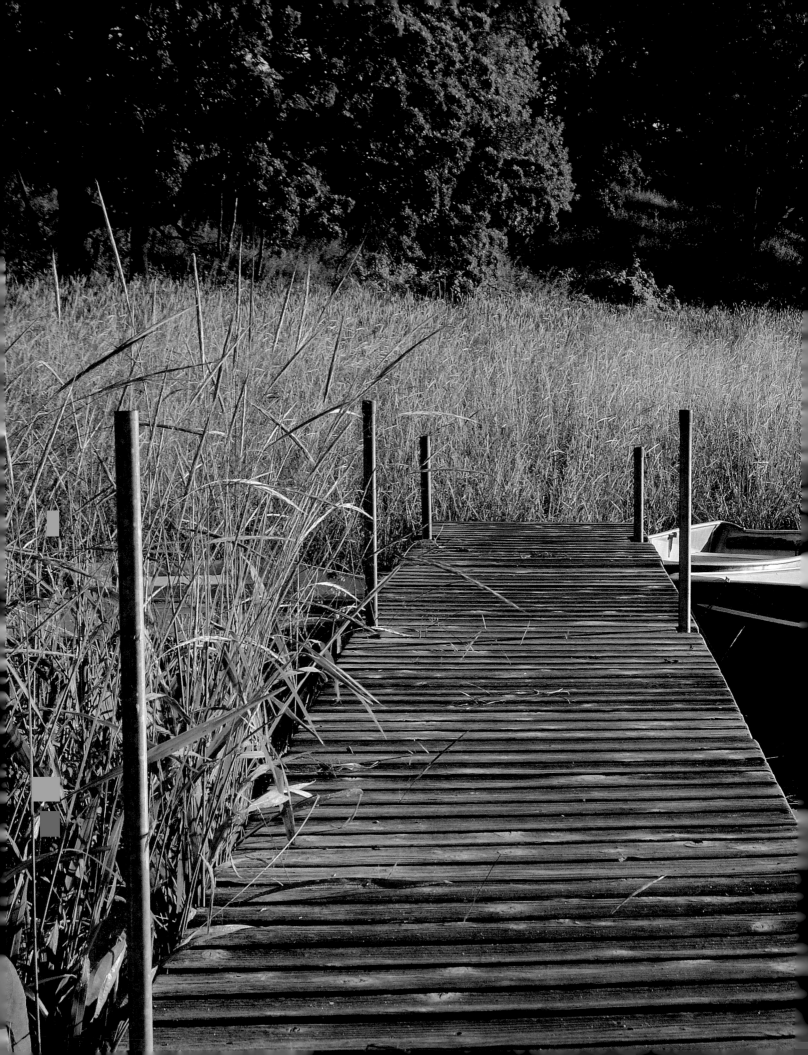

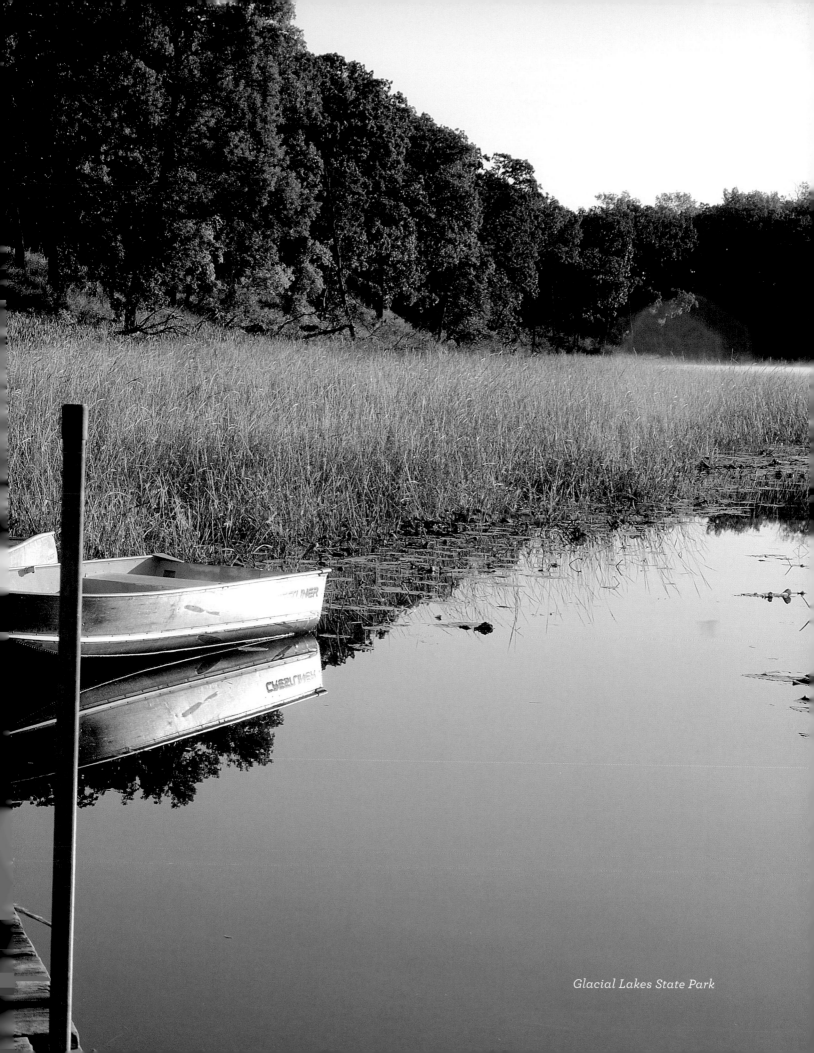

Glacial Lakes State Park

in state parks and are deeply rooted in early settler and Great Depression history. Lake Louise State Park near the Iowa border is considered the state's oldest continuous recreation area. Prior to statehood, the area was surveyed in 1853, the town of LeRoy was platted, and settlers built a dam and gristmill on the Upper Iowa River. The mill was eventually abandoned, but the Lake Louise millpond—originally named Wildwood Park—became a community swimming and recreation area, named after one of the original owners' daughters.

Lake Bemidji State Park

The massive Lake Bronson Dam in that northwestern state park was built in 1936 and 1937 by the Works Progress Administration (WPA). The project provided a dilemma when designers discovered quicksand on the site. They fixed the problem by using the dam's weight to force water out of the quicksand and into surface pipes, earning the structure widespread accolades in engineering journals. The WPA also built dams at Blue Mounds State Park (1938) and Old Mill State Park (1939) and small water diversion structures at a handful of other parks.

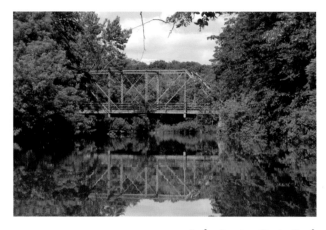

Lake Louise State Park

Perhaps no Depression-era structure— or fifteen yards of gurgling water—is more recognizable than the Mississippi Headwaters Dam, designed by the National Park Service and built in 1941 by the Civilian Conservation Corps (CCC) in Itasca State Park. CCC workers poured a layer of concrete across the north outlet of Lake Itasca and, according to original plans, pressed stones and pebbles to make it "appear as natural as possible." Through those stones flow the headwaters of the Mississippi River on a 2,552-mile journey to the Gulf of Mexico. Nearly a half million visitors come to Itasca State Park each year, and many make the pilgrimage to walk the stones across the headwaters. Of the stone stepping, DNR commissioner Gene Merriam once remarked, "I grew up thinking of it as a rite of passage, somewhere between baptism and confirmation."

Rice Lake State Park's namesake is a shallow, designated waterfowl lake where hunters can pursue mallards and ring-necked ducks. The lake at Lake Shetek State Park becomes a draw for ice anglers seeking crappies. Lake Alice at William O'Brien State Park is a backwater of the St. Croix River but also a popular spot for

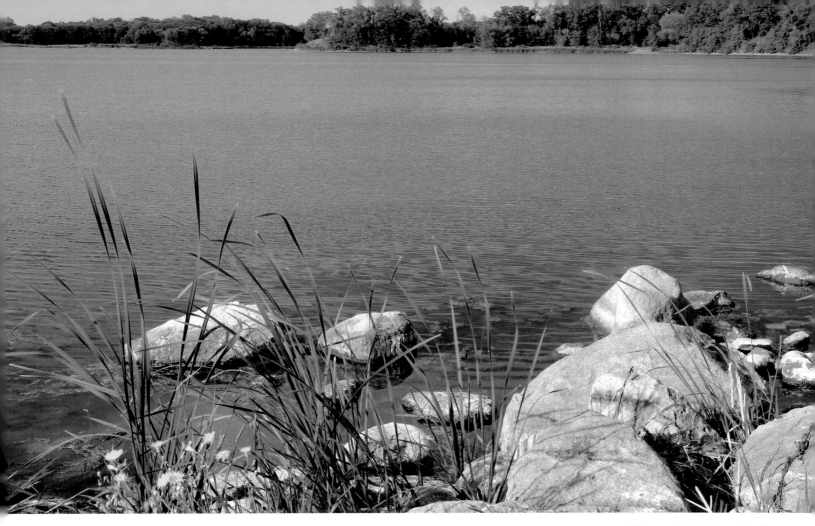

Monson Lake State Park

The BWCAW Alternative

Bear Head Lake is situated in the heart of canoe country, just south of Ely, and surrounded by birch, aspen, pine, and fir trees. In 1959, two state employees were struck by its beauty. Local conservationists agreed it should become a state park.

Two years later, the Minnesota legislature unanimously approved creation of the four-thousand-acre Bear Head Lake State Park with the eponymous 674-acre lake as its centerpiece. Today, Bear Head has all the amenities of a modern state park, with access to the multiuse Taconite Trail and other trails catering to skiers and hikers. It offers a blend of the low-impact activities of the nearby Boundary Waters Canoe Area Wilderness and the traditional comforts found at state parks. Guests can choose from standard, pull-in, or electric sites, five camper cabins, and a house for large groups. The park has five remote backpacking sites and one site accessible only by canoe or motorboat. ⊠

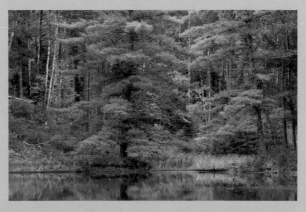

Bear Head Lake State Park

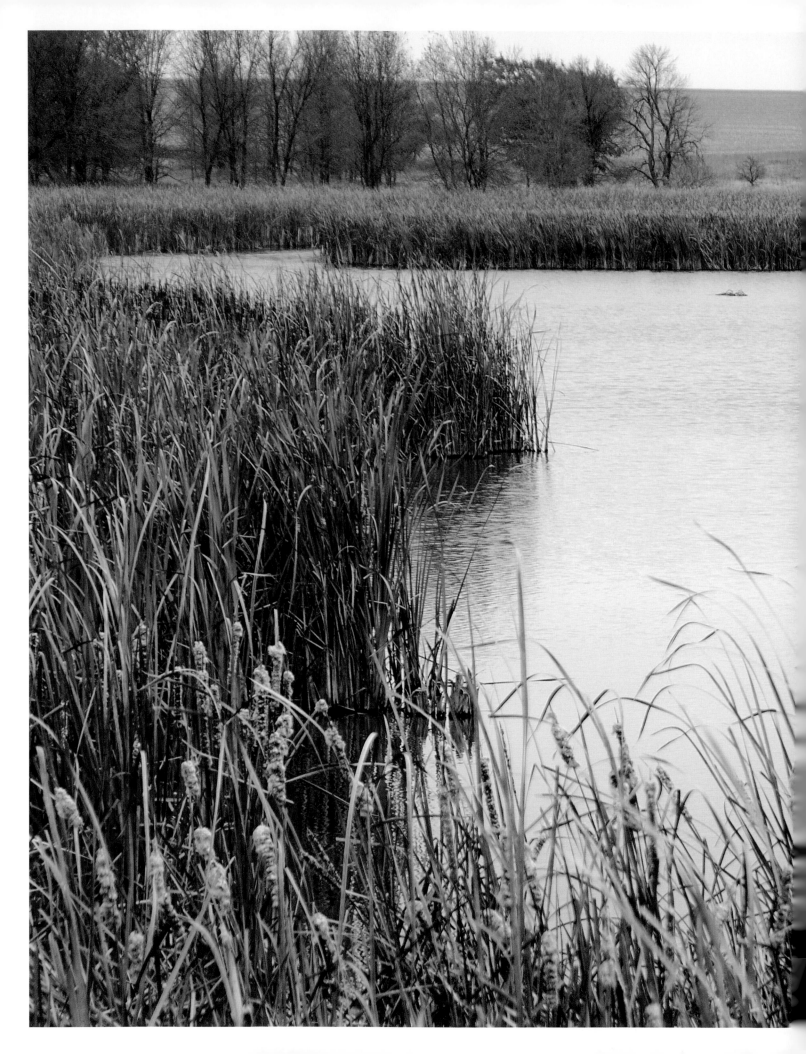

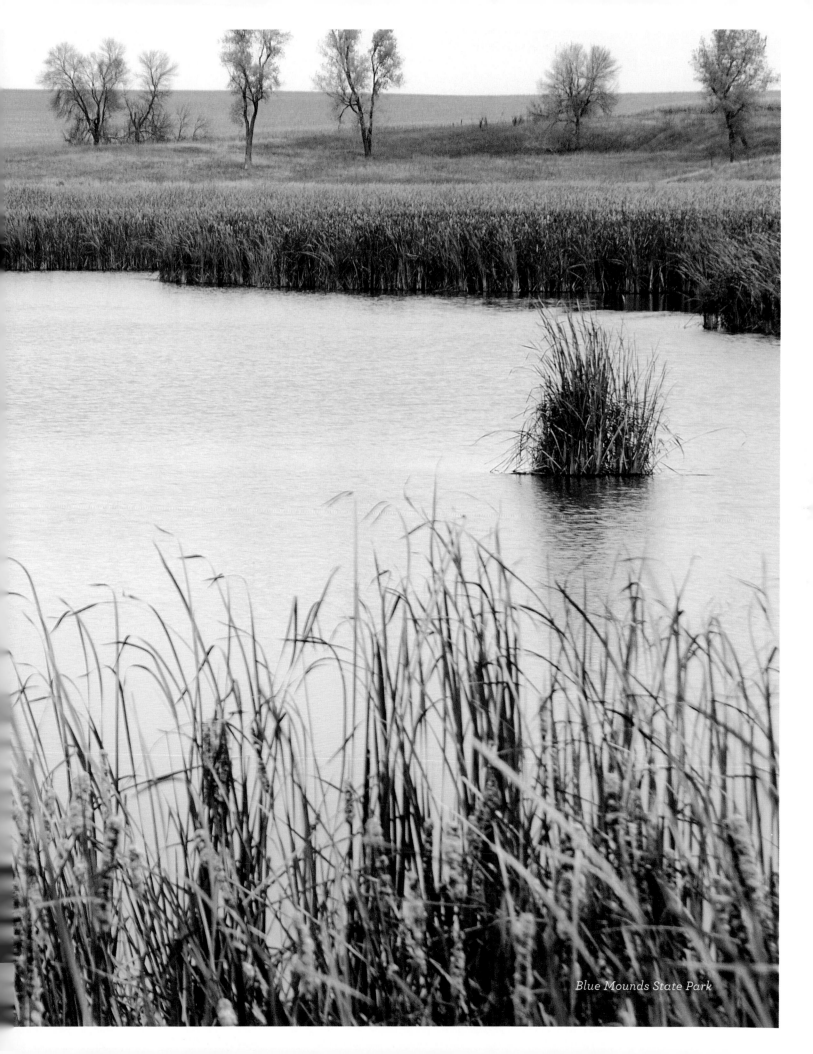

Blue Mounds State Park

Itasca State Park

Milling's History in Parks

The German-style mill at Minneopa State Park is a throwback to an era when grain mills were powered by wind. Louis Seppman designed the mill, completed in 1864, which was based on examples from his native Germany. In a good wind, it could grind 150 bushels of wheat in a day. When a tornado struck the mill in 1890 and its arms were broken off, they were not replaced because such mills were no longer profitable. The armless, stone structure still stands.

Minneopa State Park

St. Croix State Park

Old Mill State Park

Lars Larson wasn't fortunate in the mill business, either. When he homesteaded the land around today's Old Mill State Park, he couldn't catch a break. A flood destroyed his water-powered mill in 1886; three years later, a storm blew down his wind-powered mill. His son, John, eventually started a mill in the same area using a newfangled Case steam engine No. A359, which was recently restored. During the annual Grinding Days demonstration in late August, you can see the engine in action and eat bread made from grain processed by the old mill. ⊠

Myre–Big Island State Park

children to catch bluegills and other sunfish. You won't find moose at Moosehead Lake in Moose Lake State Park, but you can catch northern pike and walleyes. The lake at Lake Bemidji State Park has produced toothy muskies over fifty pounds. At Franz Jevne State Park on the Rainy River, anglers can access some of the world's best springtime walleye fishing as hordes of the state fish stage in the river prior to spawning. For a wilderness fishing experience, hike into Benson Lake at George H. Crosby–Manitou, the first state park designed primarily for backpackers. Here you can fish for brown, rainbow, and brook trout and maybe catch a hybrid fish called a *splake*, a cross between brook and lake trout.

Did planners foresee a wealth of beautiful lakes and rivers when the park system was created? Some did. One enthusiastically endorsed creating Glendalough State Park because of its undeveloped lakes and shorelines, saying, "Of the sixty-five existing state parks in Minnesota, most are built on or near some water feature but very few have anything like Glendalough's six miles of undeveloped shorelines." Today it is indeed everyman's country estate. Be sure to bring your swim trunks and fishing rods. ⊠

Jay Cooke State Park

Scenic State Park

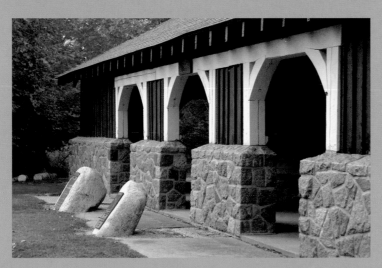

Lac qui Parle State Park

Building a Heritage

Launched in 1933, the New Deal forever shaped Minnesota state parks. With the country facing debilitating unemployment, President Franklin Delano Roosevelt's administration created three national work programs: the Civilian Conservation Corps (CCC), the Works Progress Administration (WPA), and the Veterans Conservation Corps (VCC). In the process, legions of men were sent to Minnesota state parks, where they built hundreds of stone and log buildings and structures that endure today. Twenty-seven parks still have New Deal–era structures, many of which are listed on the National Register of Historic Places. Some highlights:

:: **Flandrau State Park:** the beach house

:: **Gooseberry Falls State Park:** the Lady Slipper Lodge and lakeview shelter

:: **Itasca State Park:** the stone and log Forest Inn and the stepping stones at the headwaters of the Mississippi River

:: **Jay Cooke State Park:** the popular swinging bridge spanning the St. Louis River and the River Inn Visitor Center

:: **Lac qui Parle State Park:** the model shelter

:: **Lake Bronson State Park:** the water tower with observation deck

:: **Scenic State Park:** the shelter pavilion and the Naturalist's Cabin ⊠

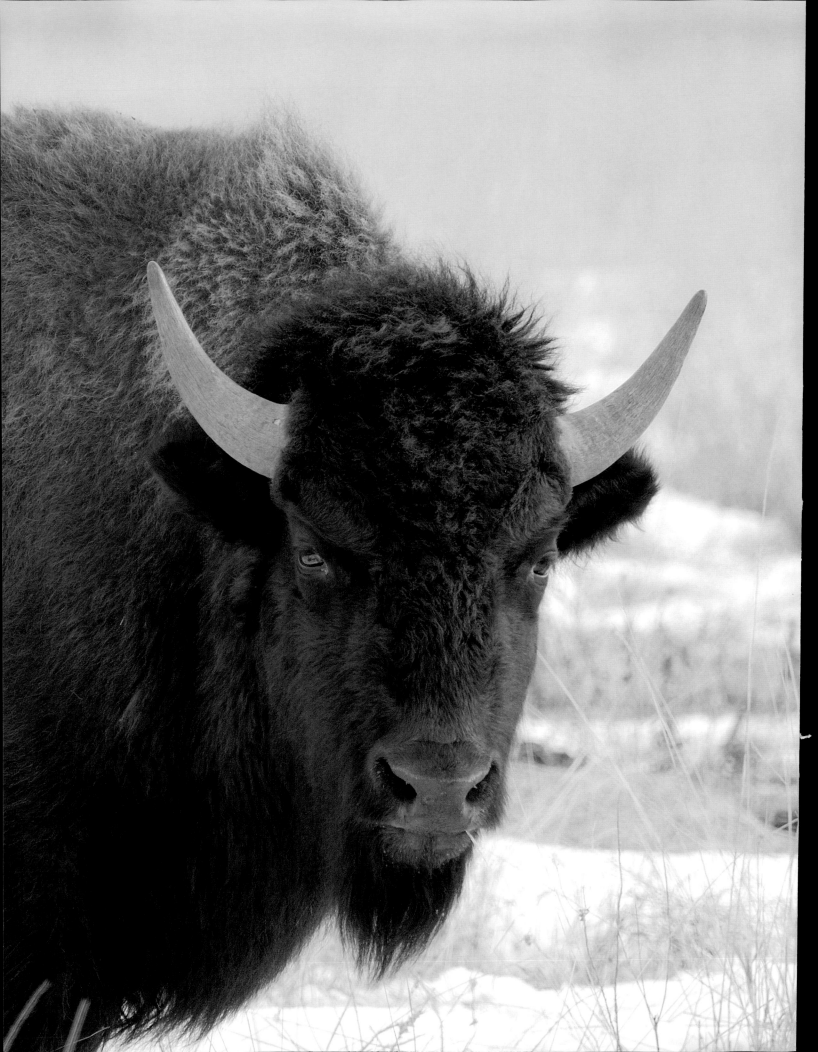

Rick White and Dan McGuire are nervous. "You might want to put up the tailgate," McGuire says as the bison herd approaches.

"You think?" White retorts.

On a rare windless but still cold day in February at Blue Mounds State Park, I am about to be surrounded by the park's main attraction. Park visitors can only observe the bison herd from behind the fence, but park manager White has agreed to take me in a pickup truck out on the prairie to mingle with the shaggy icons of the West. Of course, we will be a few feet off the ground, protected by the truck's sheet-metal bed. And its tailgate will be up.

McGuire is the park's building and grounds keeper, but in his sixteen years at the park he's developed a sixth sense about bison. I get the feeling you'd want him nearby in the event of a stampede. He is along to provide a second pair of eyes, in case any of the thick-shouldered, unpredictable animals decide to turn us into mush. During the next hour, McGuire's eyes never leave the herd.

This bison herd is the only one at any Minnesota state park, and the DNR wants the animals to remain as wild as possible. This herd of eighty-five to 115 has little contact with humans during the 365 days it spends on the restored prairies at Blue Mounds. For the most part, park personnel don't feed the bison, letting them graze on native prairie grass pasture. Today, however, McGuire and White have brought along a hay bale to chum the herd closer. When McGuire throws out the hay, the free-ranging animals don't come galloping along; they

Blue Mounds State Park

mosey, taking their time as if they are the rulers of this grassland—which of course they are.

"Our mission is to provide people with a view of bison in a natural setting. We don't want to turn them into cattle," White says. In 2001, the herd's native pasture was increased from 150 to 535 acres to give them more room to roam. While the pasture is fenced, White says the stout wire couldn't actually stop a randy eighteen-hundred-pound bull. Or, for that matter, a smaller cow separated from her calf. "You never want to get between a cow and her calf," White warns.

As the herd approaches the truck, it's evident White and McGuire have great appreciation for the animals and respect for their unpredictability. I am not to step out of the truck's bed. McGuire stands on the ground but keeps a truck door open in case he needs protection inside the cab. Being among bison is an entirely different experience from walking among cattle. While the large Holsteins at my grandfather's dairy always seemed awkward enough to do me personal harm, their personalities were gentle and dim. With these bison, I'm comfortable surrounded by the steel-sided truck bed.

I can see the distant park office, a corral for fall roundups, and the fence, yet it's not difficult to imagine a different, wild landscape when you're among bison. And that's the concept of Blue Mounds State Park—an escape to an earlier period of Minnesota, when large wooly beasts carpeted the prairie, about sixty million of them striding across North America in 1800, according to some estimates.

Little is known about the abundance of bison in Minnesota. Alexander Henry, a young representative of the North West Company, traded with Native Americans from 1800 to 1808 on the western bank of the Red River in what is now North Dakota. The "beasts," Henry wrote in his diary, shaped the plains in every way, cropping the prairie and hardening the shores of watering holes. Bison were so numerous along the Red River that drownings from falling through weak springtime ice filled the waterway with animal corpses. One of the best collections of Minnesota bison herd accounts comes from Evadene Burris Swanson, whose 1940 PhD thesis, *The Use and Conservation of Minnesota Wildlife, 1850–1900*, for the University of Minnesota was reprinted in 2007. She notes that explorer Henry Schoolcraft saw bison above present-day Minneapolis in 1820. Things had changed by 1846, when future governor Henry Sibley, while on "sporting adventures," noted that a man

Blue Mounds State Park

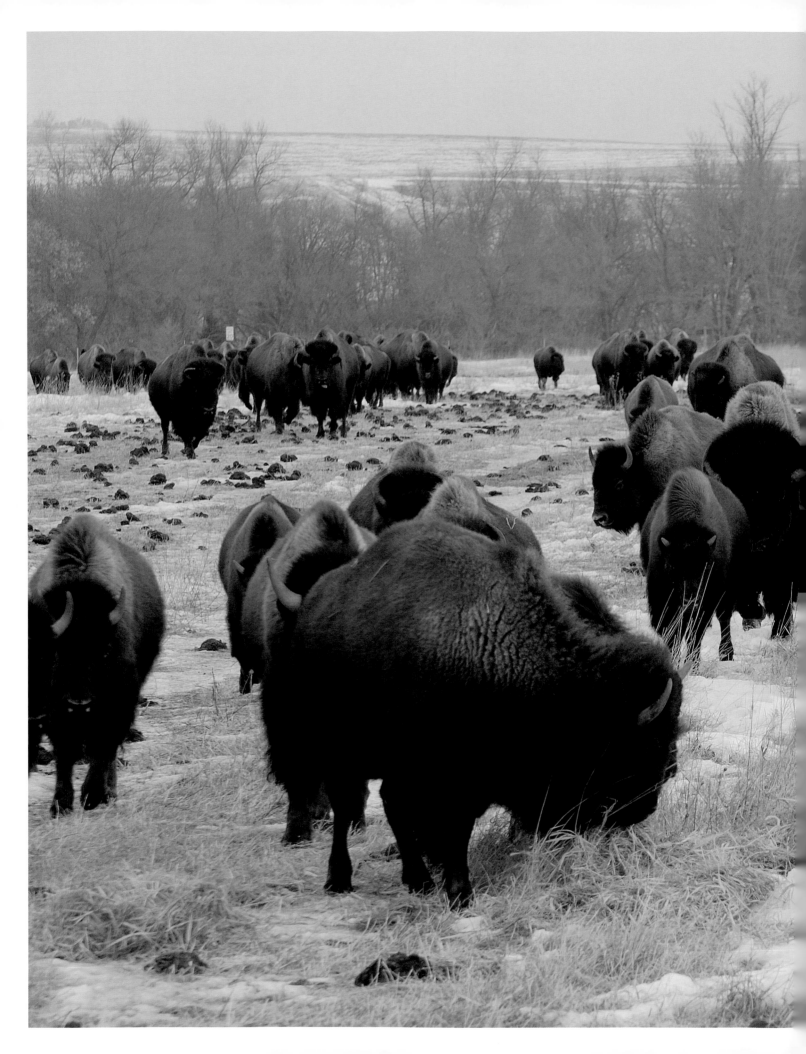

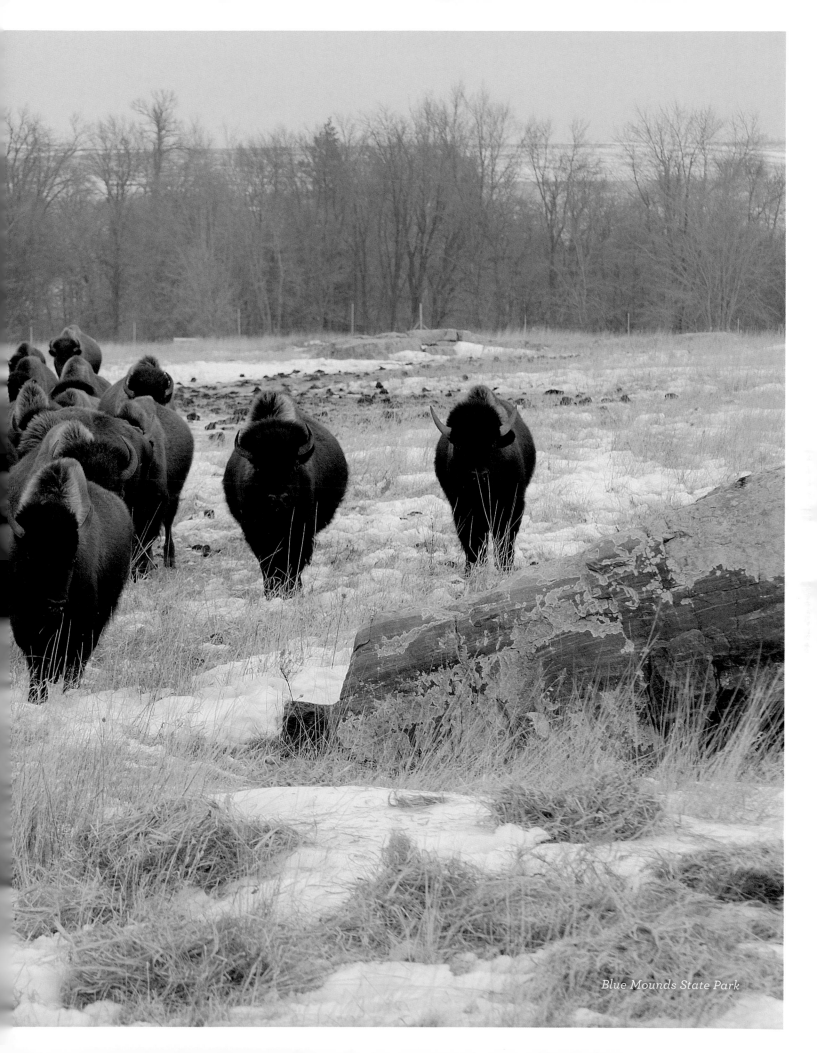

Blue Mounds State Park

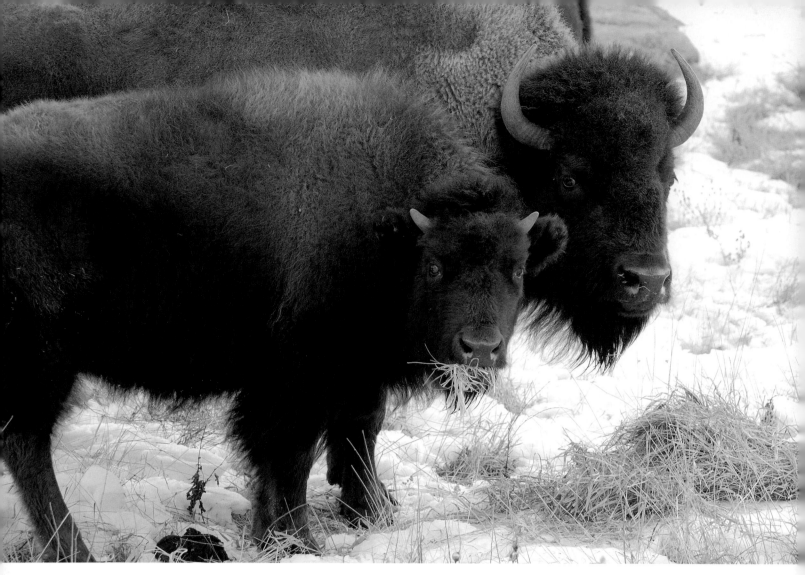

Blue Mounds State Park

"might roam for days and without seeing a single [bison] herd, a great contrast to the former years."

By the 1870s, settlers were reporting mostly bison bones, and few bison, among the wildflowers on the Minnesota prairie. In the next decade, with bison mostly extirpated from the state, a new industry of "bone picking" employed people scavenging the countryside for sun-bleached bones, which were turned into charcoal or fertilizer. Swanson writes that railcars were filled by pickers earning five to six dollars a ton. In the Red River Valley, according to an 1893 newspaper report, "Six years of steady picking by 400 families working over a strip of country six miles on each side of the railroad had not exhausted the supply."

The Blue Mounds herd was started in 1961 with three animals brought from Niobrara National Wildlife Refuge in Nebraska to graze on fifty acres of pasture. White describes them as an "exhibition herd" whose enclosure resembled a zoo setting rather than a

↓

Blue Mounds State Park

Blue Mounds at Our Feet

Tucked among the Sioux quartzite rocks at Blue Mounds State Park is a curious plant: the brittle prickly pear cactus. Squat with thick, spiny pads, it's one of three cacti that live in Minnesota. The brittle prickly pear is suited to the state's freezing temperatures: it can handle minus forty degrees Fahrenheit but not persistent, desertlike conditions. It is not threatened or endangered and can be found on rocky outcrops in southwest Minnesota, along the Minnesota River valley, occasionally in the St. Croix River valley, and far to the north at Garden Island State Recreation Area. It likes dry sandy soil and persists in the toughest conditions, not unlike those determined Scandinavians and Germans who settled the state. ☒

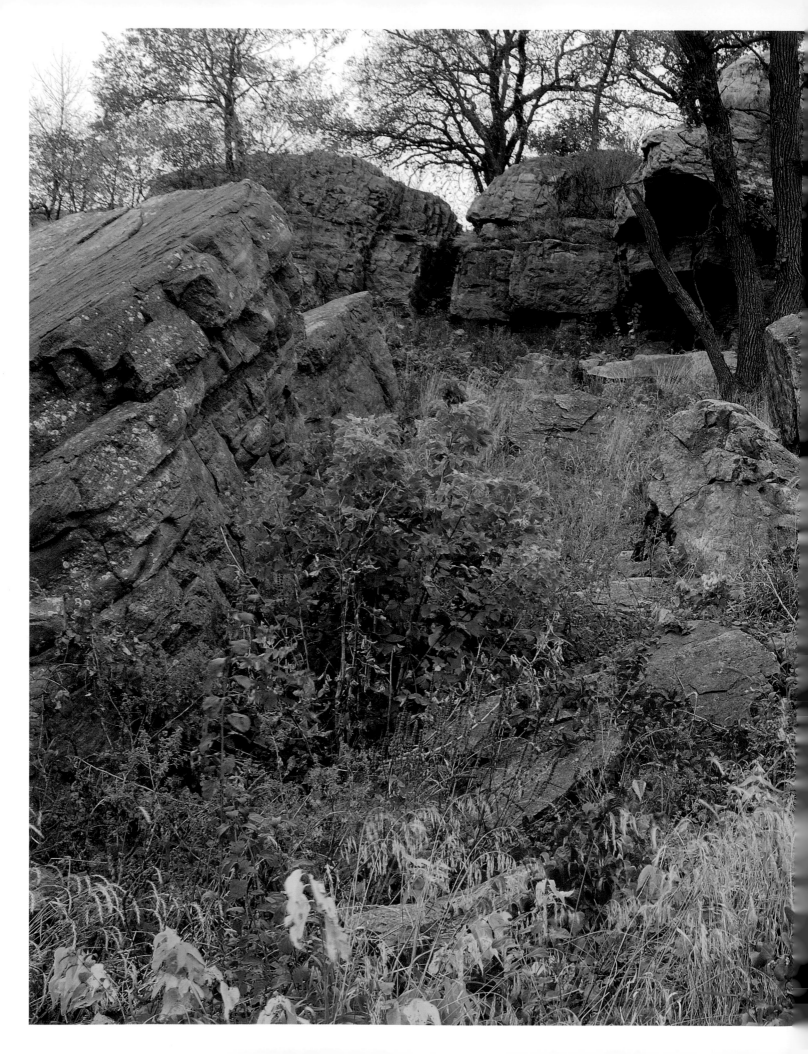

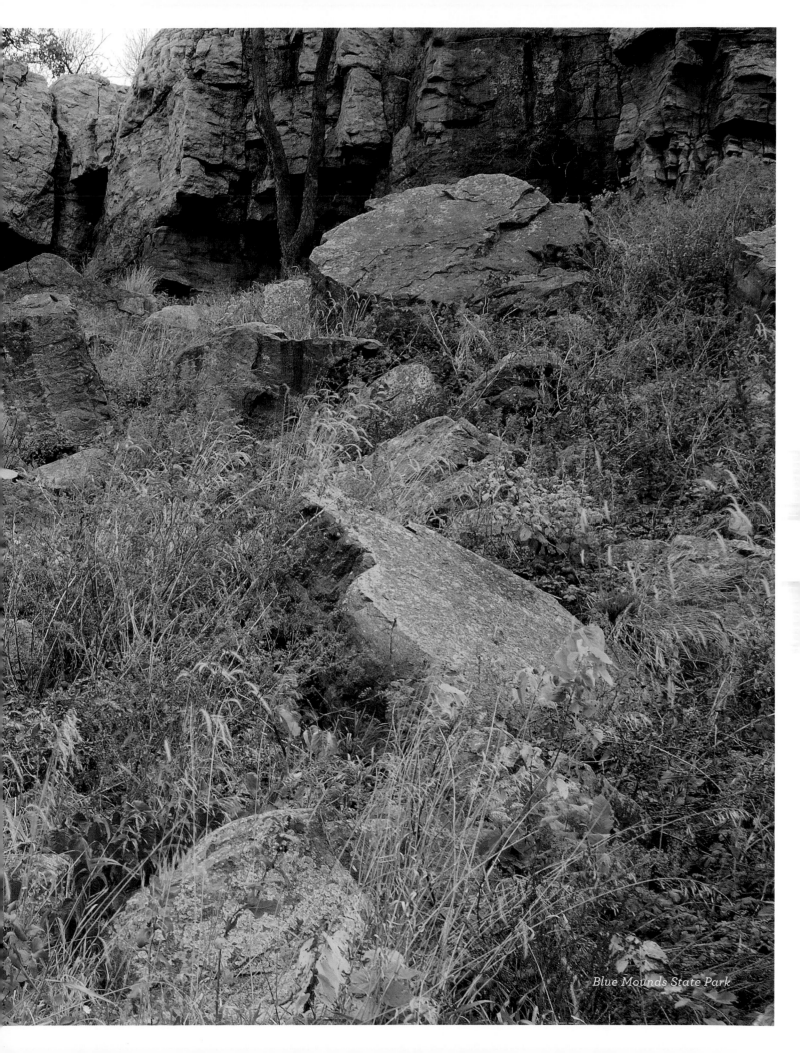

Blue Mounds State Park

Blue Mounds Mystery

It's not Stonehenge, but a rock formation at Blue Mounds State Park is a mystery waiting to be solved. At the park's southern end, a 1,250-foot-long stack of rocks is nearly perfectly aligned in an east-west direction. No one knows who stacked the rocks or what their purpose was, but experts agree the formation was the work of humans. Curiously, the rocks' alignment matches sunrise and sunset on the first days of spring and fall.

Were the rocks left by ancient humans as an astronomical aid? Did Native Americans use the wall to direct stampeding bison to their deaths over a nearby cliff? (The latter theory isn't supported by any bone debris below the cliff.) A plausible explanation is that a settler stacked the rocks as a property line border, but perfect alignment with the equinoxes leaves visitors scratching their heads as they ponder the mysterious rocks. ☒

Blue Mounds State Park

natural prairie. The animals were fed hay regularly and were tended much like cattle, with little regard to their breeding or a diversity of age or sex. "There was no strategic plan," White says. Today, the herd is augmented with free-ranging animals from Custer State Park in South Dakota and Wind Cave National Park in Wyoming. The herd's sex ratio is 60–40 in favor of cows, with a dominant bull that generally keeps the peace. Younger bulls are apt to challenge the lead bull during the late July through September rutting, as they would in natural herds.

White has become a student of bison bulls, looking for prime males to introduce new genetics into the herd. He picks new bulls based on the nineteenth-century paintings of George Catlin and Karl Bodmer, who captured scenes of the Old West and Native Americans. White believes their paintings depict the true build of a bison before cattle crept into their genealogy. "I look for bulls with big horns, big shoulders, big head, and a long, lean body," White says. "Basically, a large front end and a small hind end. Those bulls are really something to look at. Those big shoulders—it is what they use to plow through snow to get to their feed."

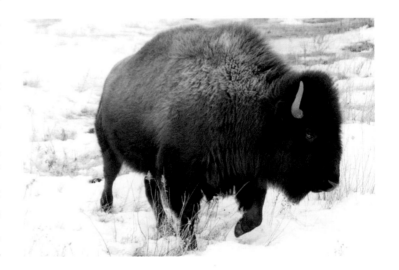

Blue Mounds State Park

As we observe the herd from the rear of the truck, White points out the dominant bull on the group's periphery. Since both cows and bulls have horns, it is difficult for me to differentiate until White notes the female's horns are slightly more curved than a bull's. "You can see his size difference compared to the other bulls and cows," White says of the big bull. "We've had bigger dominant bulls, but he's a dandy."

The bison at Blue Mounds don't have names, they have only a few distinguishing brands ("we'd like to get rid of all our brands if we can figure out a system to ID them," White says), and to most people, the only difference between individuals is size. But White and McGuire know these animals well.

"See that old cow with the bent horn?" White asks. "She's an old gal." Cows, he says, can live into their early twenties. One cow,

I notice, has a deep scar on her back. "Breeding," White says. "Look back there," he continues. "There is a nice young bull. You can tell he's going to be a good one—big shoulders."

The herd is a constant symphony of soft, guttural sounds, the subtle means by which its individuals communicate with each other. While dominant bulls have breeding rights, the old cows occupy the top of the herd's pecking order. They feed first, aggressively butting anyone who gets in their way. They are extremely attentive to calves, but the one- or two-year-olds don't get the same attention; if you're a young bull, White explains, you're "pretty much at the bottom of the food chain in the herd." He points out the "teen" bulls hanging on the edges, waiting to move in closer for the choicest hay, but the old cows won't let them. Because they occupy the outer edges, young bulls are the most vulnerable to predators and were likely the first shot by Native Americans as hunters took aim at a herd.

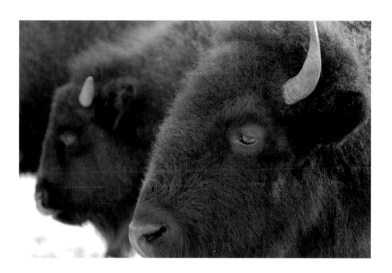

Blue Mounds State Park

The park has a large outcrop of quartzite cliffs, which appeared blue to settlers headed west in the 1860s and '70s. A common visitor question is whether Native Americans used the cliffs as a "buffalo jump" to drive herds to their deaths. While local folklore insists there are large quantities of bones buried at the bottom of the cliffs, an excavation in 1969 revealed none. No other evidence has been found to support the jump theory.

Every fall, an auction is held to sell off extra bison when the herd population exceeds the park's management plan. The park also donates a bison each June for the annual Buffalo Days in Luverne; the entire animal is ground and formed into bison burgers, which are barbecued and served free of charge. "We give away an entire buffalo in two hours," White says.

This winter afternoon, the herd pulls apart the hay bale and munches under a leaden sky. Soon they lose interest in our presence. The calves stick close to their shaggy mothers, and the lead bull stands alone, defiant, watching us drive back across the prairie to park headquarters. ⊠

Ask David Breyfogle how hard it is to reconstruct a Minnesota prairie, and his answer is surprising and cautionary. "It's impossible," Breyfogle says emphatically, even though his job with the DNR requires him to restore prairies at eight state parks in southwest Minnesota. "It takes the hand of God and tens of thousands of years to reconstruct a prairie. Where a remnant prairie might have three hundred plant species on it, I'm tickled if we get thirty to forty species."

Minnesota once had eighteen million acres of prairie. They stretched from the southeast bluff lands of the Mississippi River, where dry "goat" prairies thrive on steep hillsides, to the northwest corner of the state, where the tallgrass prairies were flat and lush and sustained bison and elk prior to settlement. Today, agriculture and development have reduced the state's prairies by 99 percent, making the biodiverse grassland the state's most endangered ecosystem.

Scientists now understand prairies aren't simply grass growing over a flat or rolling plain. They have found the complex relationships among plants, soil, fire, and grazing bison are not fully understood—or easily re-created. The only true native prairies are those not destroyed by a plow or highway, making them invaluable.

Luckily, select Minnesota state parks are among the best places to see remnant or restored prairies. At Buffalo River State Park east of Moorhead, hiking trails curve through some of the state's largest remnant prairies, where

Great River Bluffs State Park

250 plant species thrive. At Kilen Woods State Park near Lakefield, the state's largest population of the threatened prairie bush clover, a type of prairie legume found in fewer than one hundred places in the United States, is carefully monitored by Girl Scouts, 4-H volunteers, and local prairie enthusiasts.

Travel to Big Stone Lake State Park near Ortonville, and you can visit the 115-acre Bonanza Prairie Scientific and Natural Area, which contains a glacial till hill—a gravelly, well-drained mound left by glaciers that was never touched by settlers' plows. It is home to little bluestem grass, purple coneflower, and the rare prairie moonwort.

Kilen Woods State Park

"It has been central to the mission of state parks to preserve and perpetuate natural communities," Breyfogle says. "It means having a place so people can see what Minnesota looked like prior to statehood."

Breyfogle's job of overseeing prairie restoration at state parks makes him a difficult person to track down: he's on the road a lot, consulting with park managers and biologists. After several tries, I finally reached him by cell phone one summer afternoon while he was touring some new projects. He described his job as being like Lieutenant John Dunbar in the movie *Dances with Wolves*, where Dunbar is sent to a remote western outpost and left to do the best he can until reinforcements arrive. "Sometimes I go home at night and wonder if we're winning the battle," Breyfogle says.

You wouldn't think that restoring prairie—at least one with a good diversity of plants—is a chore, but it is. Prairies are fickle: getting one established can be a maddening affair, and the results aren't obvious in the first few years. I asked Breyfogle to elaborate.

During the first stage, his unlikely ally in prairie restoration is the herbicide Roundup, which is used to kill all plants on a restoration site before native prairie seed is applied. It's about starting from scratch, creating a bare palette, Breyfogle says, and that especially means ridding the soil of undesirable invasive species. Once the soil is prepped, crews plant a wide range of grasses with colorful names, like little bluestem, sideoats grama, porcupine grass, Indian grass,

Buffalo River State Park

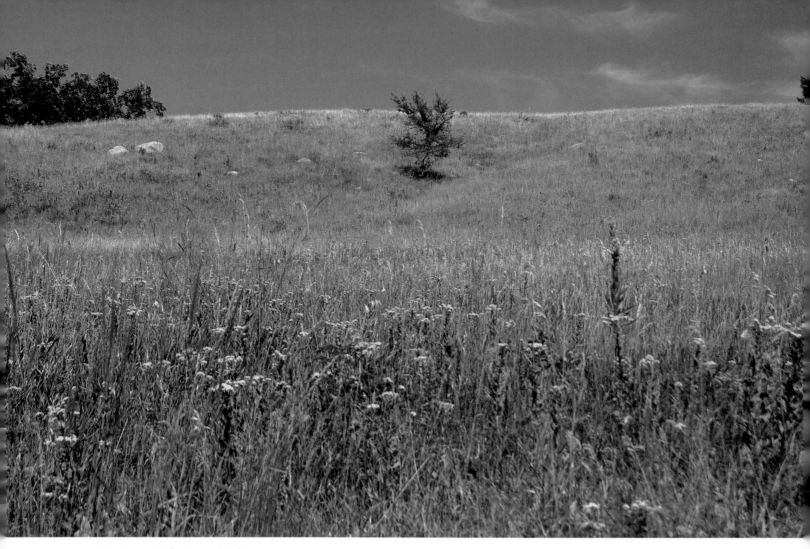

Big Stone Lake State Park

Glacial Lakes
State Park

140

Lac qui Parle State Park

and prairie dropseed. Dropseed is a clumping prairie grass that turns richly golden-rust at harvesttime; little bluestem shades to russet red in the fall and forms light tufted tops. (While many state park visitors hit the road to see blazing maples on Lake Superior's North Shore, yet another spectacular color show unfolds on prairies in southern parks.) A prairie restoration might also include heath asters, purple prairie clover, stiff goldenrod, heart-leaved golden alexanders, and long-headed thimbleweed.

Once planted, the native grasses may look sickly to the untrained eye. "In the beginning, you need a large measure of optimism," Breyfogle says with a laugh. In the first year, the grassland is thin and surrounded by exposed soil, hardly a robust-looking crop. The reason, says Breyfogle, is prairie plants need to establish their root systems, which can eventually grow to depths of five to fifteen feet. "Prairie plant systems are like icebergs, with two-thirds of the plant belowground for protection in drought and fire. It's a design that works well for them. Fire and grazing are important processes in determining which plants thrive on the prairie," he notes.

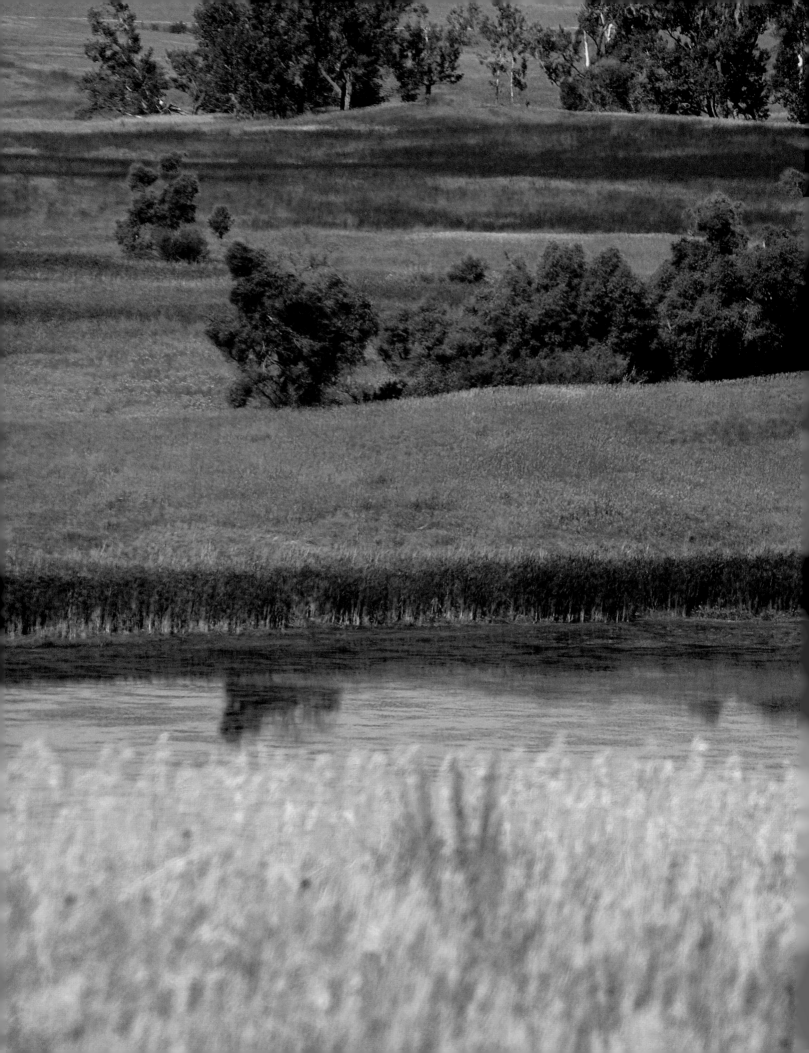

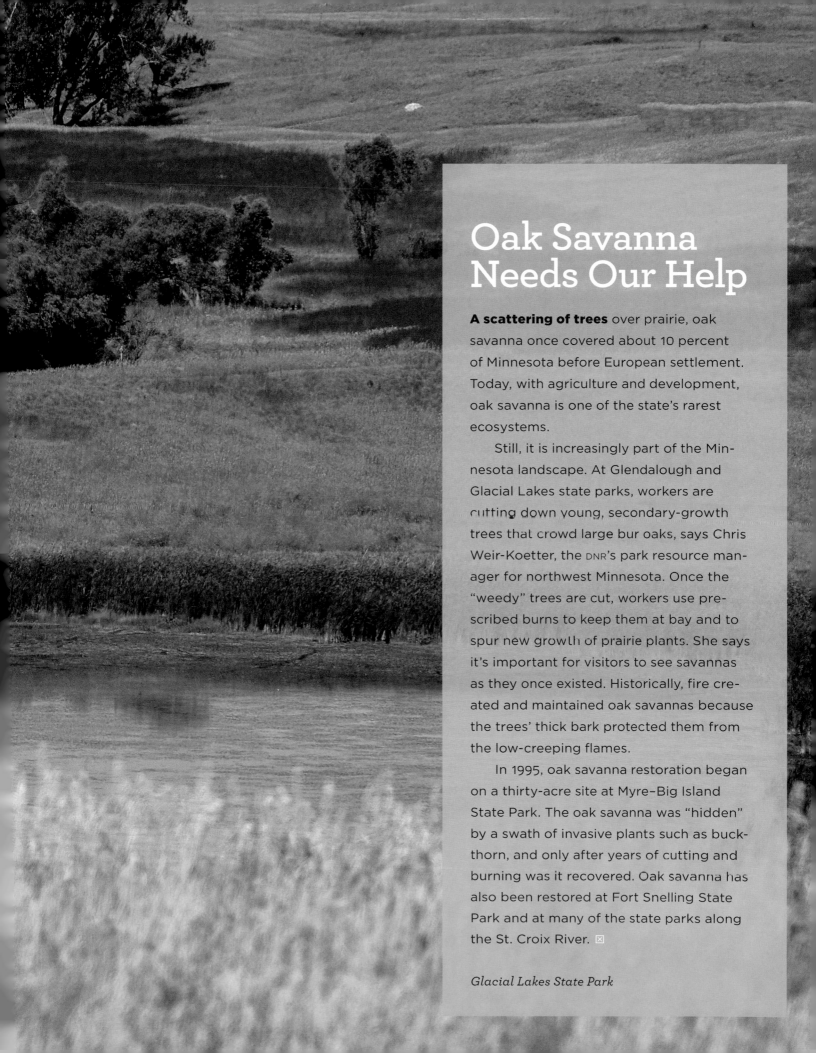

Oak Savanna Needs Our Help

A scattering of trees over prairie, oak savanna once covered about 10 percent of Minnesota before European settlement. Today, with agriculture and development, oak savanna is one of the state's rarest ecosystems.

Still, it is increasingly part of the Minnesota landscape. At Glendalough and Glacial Lakes state parks, workers are cutting down young, secondary-growth trees that crowd large bur oaks, says Chris Weir-Koetter, the DNR's park resource manager for northwest Minnesota. Once the "weedy" trees are cut, workers use prescribed burns to keep them at bay and to spur new growth of prairie plants. She says it's important for visitors to see savannas as they once existed. Historically, fire created and maintained oak savannas because the trees' thick bark protected them from the low-creeping flames.

In 1995, oak savanna restoration began on a thirty-acre site at Myre–Big Island State Park. The oak savanna was "hidden" by a swath of invasive plants such as buckthorn, and only after years of cutting and burning was it recovered. Oak savanna has also been restored at Fort Snelling State Park and at many of the state parks along the St. Croix River. ⊠

Glacial Lakes State Park

Once the prairie plants are on firm footing, the next battle is waged against unwanted invasive plants. "Some of the plants that occupy these old fields, well, you can't get them out of there," Breyfogle laments. "Things like crown vetch, bird's-foot trefoil, leafy spurge, and nonnative thistles. How hard are they to get rid of? Imagine if you only had one desirable species in your planting. That's different from our diverse plantings of grasses and forbs. Any herbicide we use for unwanted plants is going to take out some of your native things."

On this day, while observing newly restored prairies, Breyfogle remains upbeat. "I was visiting a restoration at Camden State Park this morning, one that is probably eight years old. I can remember when we started that project, it was a field of soybeans," he says. Before undertaking the 240-acre Camden project, Breyfogle researched the property's land record and discovered it had a long and extensive history of drainage. "We hired a local contractor to find and remove drainage tile that had been installed over the farming history of the land," he says. "More than ten thousand feet of clay, concrete, and plastic drainage tile was broken and removed." Today that project is a diverse upland prairie with restored wetland complexes where drain tiles had kept the land dry for decades. At another site, also a former soybean field, workers planted seed at the end of June; later, as Breyfogle drove past the parcel on his way to work, he recalls, "It looked just like the Dust Bowl days, and I thought, 'man, it will never amount to anything . . .' Today, it's probably the best reconstruction we've done."

Native prairie plants surprise and mystify us. Prairie bush clover, deemed threatened by the federal endangered species program, is not a particularly attractive specimen, as compared to another threatened species in Minnesota, the western prairie fringed orchid. While much of Minnesota's prairie bush clover has been lost due to agriculture, scientists have found it thriving in Kilen Woods State Park, numbering around hundreds of thousands of plants. For

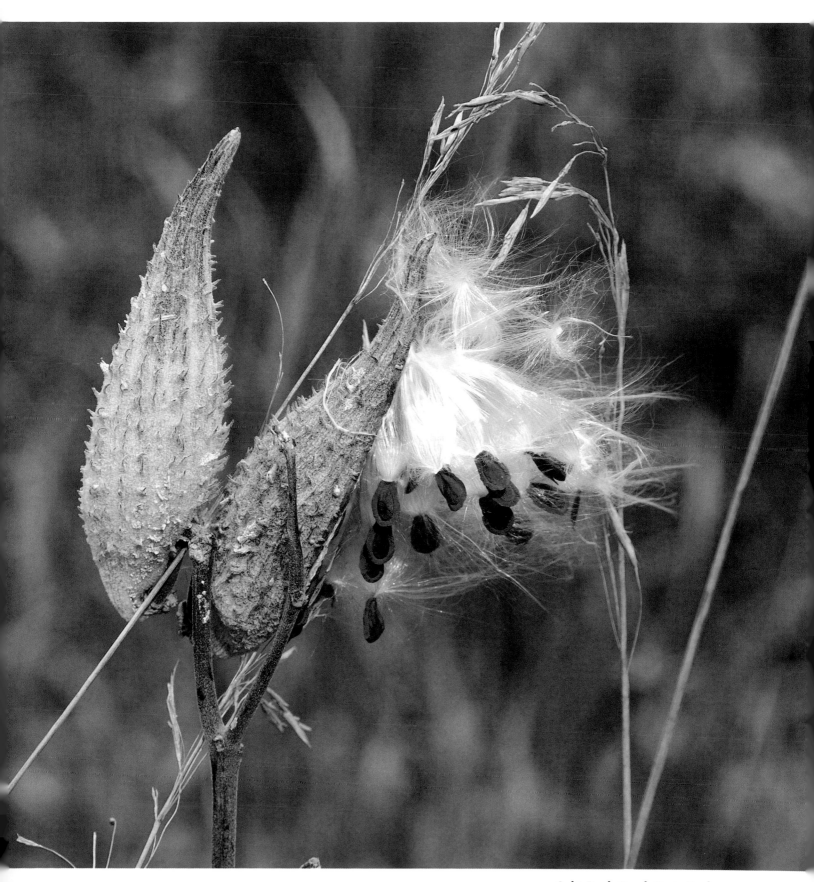

Split Rock Creek State Park

Glacial Lakes State Park

Sibley State Park

Rice Lake State Park

Big Deal about a Little Flower

The delicate and elusive dwarf trout lily can claim an unfortunate distinction: it is on the federal endangered species list. In wooded areas, typically near streams and rivers, in Steele, Rice, and Goodhue counties in Minnesota, the dwarf trout lily grows, "and nowhere else on Earth," says Elaine Feikema, manager of Nerstrand–Big Woods State Park, the state's only park the lily calls home. Finding one isn't easy. Areas where the lily grows are marked to encourage visitors to protect

Nerstrand Big Woods State Park

the plant by staying on trails. For two weeks at the end of April, the lily puts out a tiny flower—the only way to differentiate it from the similar white trout lily. Luckily, park staff direct visitors to Hidden Falls trail to find the lily, though "even if people go to the spot, they may not see them," Feikema says. The most dwarf trout lilies ever seen by park staff is seventeen individual plants, "so you'll be lucky to see one, two, or three." A rare plant, indeed. ⊠

some reason, the knee-high rare clover has proven resilient in Kilen Woods, thanks in part to the Girl Scouts and other volunteers who have tended it. It's not easy to locate, though. "You have to do some bushwhacking to find it," says Nancy Sather, an ecologist with the county biological survey, an arm of the Minnesota DNR.

The western prairie fringed orchid, a stout, erect plant with lacy blooms, is even more enigmatic. Populations at Buffalo River State Park have declined in recent years, says Sather, an orchid expert. The plant produces flowers irregularly, but they are very fragrant at night and require nocturnal hawk moths and other insects to complete a complicated pollinating process. Moreover, the tiny, dustlike seeds rely on soil fungi during germination, a relationship that isn't entirely understood. In a word, the orchid is finicky. "This plant is very unpredictable," Sather says.

Blue Mounds and Lake Bronson state parks have small populations of the western prairie fringed orchid, though the Lake Bronson plants appear sporadically. In 2009, none were found. At Blue Mounds, the orchid defies scientists by living atop quartzite cliffs and not in wet, lowland prairies. "We don't fully understand this," reports Sather. The orchid survives in other parts of Minnesota; 80 percent of its known locations are preserves or other publicly managed areas. Sather and others are protective of these sites, but there are programs where volunteers can help count plants.

Minnesota has made prairie and other native community restoration a priority after voters in 2008 approved a sales tax increase to fund natural resources programs. Parks got a share of the money, and Breyfogle and others are focused on restoring these critical grassland systems. "It's an overused simile, but natural communities like prairies are like canaries in a coal mine," he says. "It's about healthy natural communities ... Some of these species are very specialized. Regal fritillary butterfly larvae only feed on violet leaves. If we have a grassland with no violets, there are no regal fritillary butterflies." Even with the challenges it presents, restoring the prairie clearly is a winning proposition for Minnesota's future. ⊠

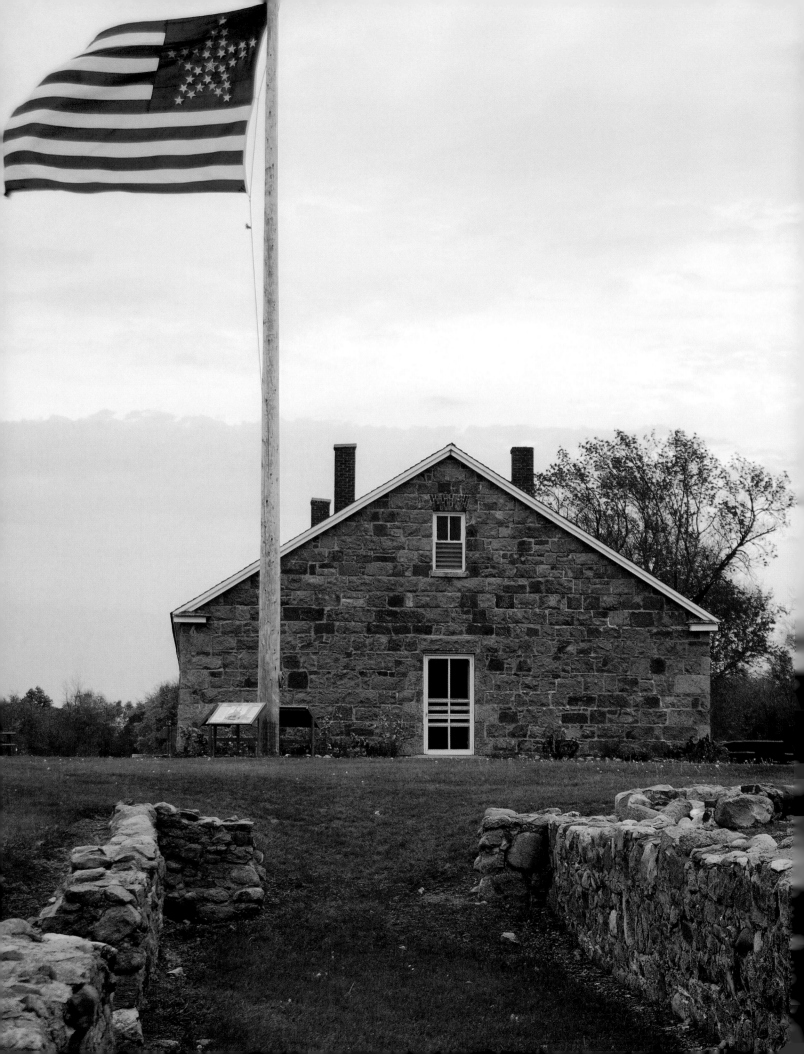

Looking Through
a Window of Pain

In a corner of the Thomas Savage Visitor Center at Fort
Snelling State Park, a bay window looks over a small prairie and into a dense,
shady grove of oaks and cottonwoods. As I mull over the displays and stop to
gaze out the window, I'm struck by how this interpretive center differs from
the many I have visited in other state parks. I realize it is because this room is
devoted to Dakota Indian culture—the Dakota people's
deep history here where two rivers meet, and the horrors
their ancestors endured on a low, flat plain along the Mis-
sissippi, just beyond this window.

But let's start at the beginning: long before white
explorers probed the Upper Mississippi River valley
and the U.S. military erected a fort, the Mdewakanton
Dakota, also called the Sioux, considered the confluence
of the Mississippi and Minnesota rivers to be the center
of creation. It was the place from which all Dakota people
had come, a spiritual and sacred homeland. As I pore over the interpretive signs
in the visitor center, I come across a quote from a contemporary Dakota Indian,
Gary Cavender: "For the Dakota, this was Eden."

From over my shoulder, Judy Thomson, a DNR regional naturalist, directs
my attention out the window. She, too, is looking toward the verdant forest
below. "It's a cruel irony," Thomson says. She explains that the Dakota's Eden

*Fort Snelling
State Park*

Fort Ridgely State Park

would come to symbolize their holocaust during the U.S.–Dakota War of 1862. "The irony is that this window looks down on the internment camp for hundreds of Dakota women and children. It was later named a concentration camp by the Dakota."

At no other state park are the events of the U.S.–Dakota War so brutally spelled out as at Fort Snelling. Elsewhere, the conflict is rooted in three western state parks along or near the Minnesota River: Upper Sioux Agency, Lake Shetek, and Fort Ridgely. After losing their lands and enduring a poor harvest and delays in government supplies and payments, the Dakota rose up in August 1862. Fought along the western Minnesota frontier in a series of battles and chaotic skirmishes, the conflict resulted in the deaths of at least five hundred white settlers and innumerable Dakota warriors and the eventual hanging of thirty-eight Dakota men. After defeating the Dakota who had fought, the government determined to purge all Dakota people from the state, including those who had opposed the war and sheltered whites. Sixteen hundred women, children, and elderly men were marched to Fort Snelling. They arrived November 13 and were confined behind a twelve-foot stockade surrounding an area of two to three acres along the Mississippi. By May, when the prisoners were put on a boat and exiled from Minnesota, three hundred Dakota had died in the camp, making it "a symbol of the Dakota holocaust to the contemporary Indian," says Leonard Wabasha, cultural resources director for the Shakopee Mdewakanton Sioux Community.

Lake Shetek State Park

No markers or memorials indicated where the camp existed, until 1987, leading up to the 125th anniversary of the war, when the state began preparing for the Year of Reconciliation. "I was interested in having some kind of marker for the camp because it wasn't well known," Thomson says. She decided to research the camp's location and the Dakota families who had been held there. Instead of working solely within the DNR, Thomson approached the Dakota community and gauged members' desires for a permanent memorial at the camp. From a modest beginning, and with leadership from the Dakota, a memorial was established below the bluff from Fort Snelling and a marker made of pipestone was carved and placed at the site. On October 30, 1987, about a hundred Dakota attended

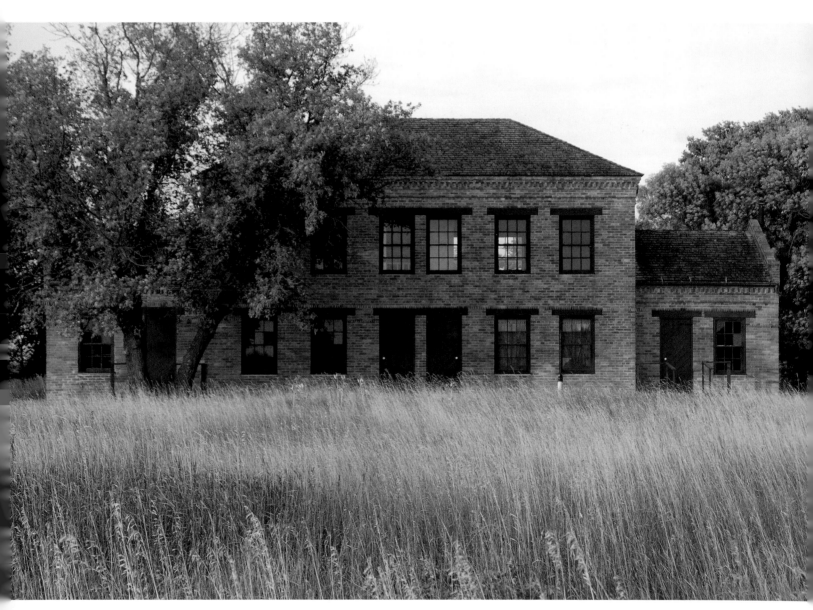

Upper Sioux Agency State Park

the dedication ceremony, and many told moving stories about their relatives who had suffered there. Thomson says the effort to honor those who suffered and died at the internment camp, later renamed a concentration camp by the Minnesota Indian Affairs Council, has brought the truth about the camp before a modern audience. "This is a very important place," she says. "It's a place of truth telling and brings forward the feelings and beliefs of modern-day people. It brings the Indian culture to the present."

On December 26, the Fort Snelling memorial is the start point for an annual relay by Dakota runners to Reconciliation Park in Mankato to honor the hanging execution of thirty-eight Dakota men after the war. Several hundred runners participate in the event. "Our history is more than a single event, though [the war] almost destroyed our entire culture," Wabasha says. The Fort Snelling memorial is a place where modern Dakota leave offerings and prayers "to remember the sacrifices these people made so we could be survivors today."

Digging into Time

Mille Lacs Kathio State Park

The Petaga Point Archaeological Site at Mille Lacs Kathio State Park lies on a peninsula where the Rum River leaves Ogechie Lake. Scientists have documented nine thousand years of human history at the site, which is within the Kathio National Historic Landmark District. At least nineteen archaeological sites have been identified at the park, and archaeologists have found evidence of copper tools being made there. University of Minnesota experts undertook major investigations at the park in 1965, 1966, and 1967.

Thousands of artifacts have been found at Petaga, including ceramic pots, spear points, knives, scrapers, and numerous styles of arrowheads. One obsidian flake found there originated at Obsidian Cliff in Yellowstone National Park. Visitors can see replicas of these items on display at the park. Each year in September, the Minnesota Archaeological Society hosts the popular Mille Lacs Kathio Archaeology Day, at which visitors can gain a hands-on sense of digging into the past. ⊠

Lake Shetek State Park

More of the story is told far to the west of Fort Snelling. In the spring of 2008, as the last of the snow was melting from road ditches, I drove to visit Lake Shetek State Park. On August 20, 1862, three bands of Dakota warriors descended on a small settlement along the lake and killed fifteen settlers, many of them women and children. In 1925, a twenty-five-foot granite monument with the names of the slain settlers was placed on a small hill along the lake's southeast shore. The park was officially created in 1937, though years prior Works Progress Administration (WPA) workers had built a picnic area, entrance road, bathhouse, campground, and beach. Today, the 1,109-acre park in Murray County has lovely restored prairies, a lakeside campground, and a refurbished settler cabin from the late 1800s. At the visitor center, I picked up a brochure on a nearby waterfowl area, owned by the U.S. Fish and Wildlife Service, which bears the name Slaughter Slough. It was in this slough, not far from Lake Shetek, that fleeing settler families sought to hide from the Dakota warriors. During the siege, the

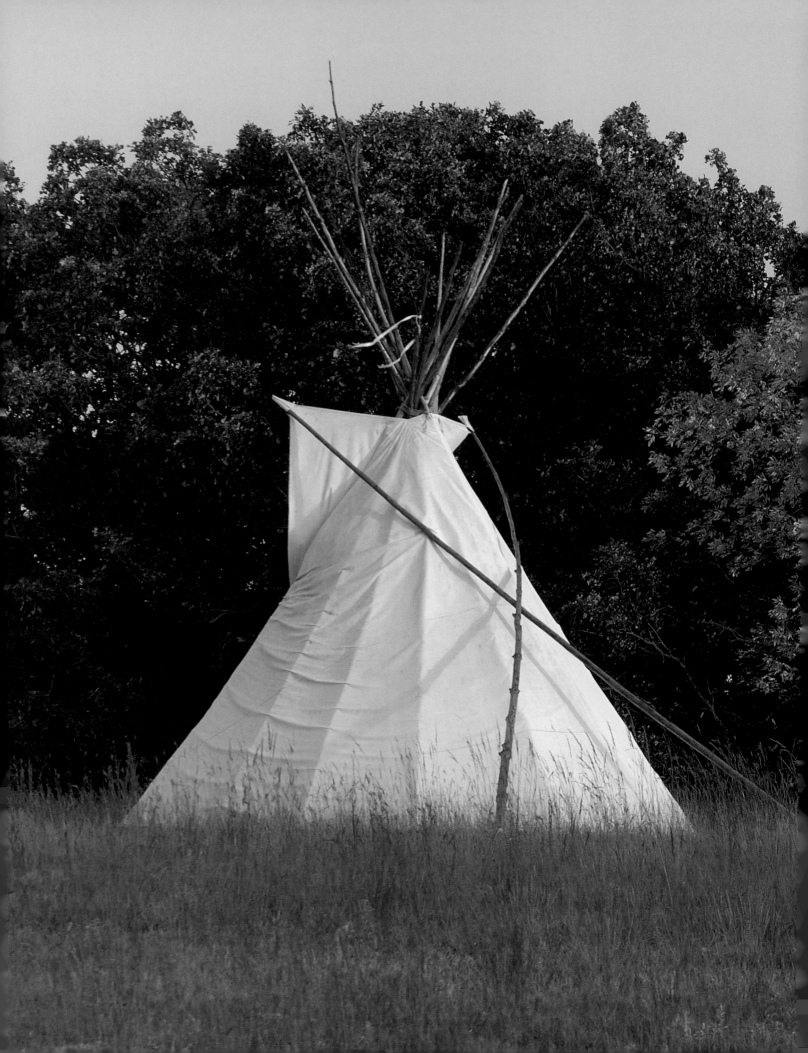

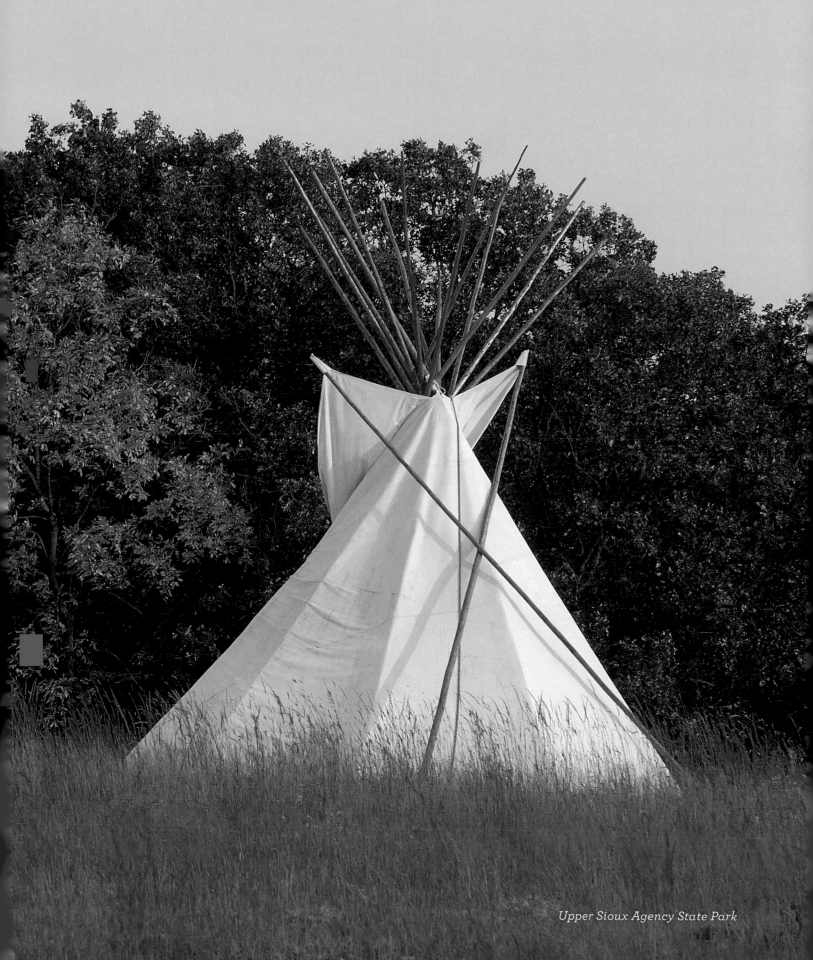

Upper Sioux Agency State Park

Flandrau State Park

POWs at State Parks

During the latter years of World War II, two state parks were enlisted in the war effort in an unusual way: they housed prisoners of war. Facing a shortage of rural labor, state agricultural leaders devised a plan to bring POWs, mostly Germans, to Minnesota from other major camps. Their presence is well documented in Dean B. Simmons's 2000 book, *Swords into Plowshares: Minnesota's POW Camps during World War II.*

Prisoners arrived at Whitewater State Park in 1944 and were housed in nine barracks formerly used by Civilian Conservation Corps and Works Progress Administration men. The POWs worked at local canneries, harvested crops, and did other manual labor on area farms. At Whitewater, "The POWs were enchanted by their camp's surroundings, framed by a steep cliff whose white-gray color helped create a 'romantic sight,'" Simmons writes. The men were

generally treated well and had no incentive to escape. One turkey farmer, happy with the POWs' work, gave them beer and whiskey, Simmons reports. The camp closed on October 10, 1945.

Prisoners were also housed at Flandrau State Park near New Ulm, which was called Cottonwood River State Park until 1945. Just as at Whitewater, the POWs worked in the fields and local canneries, but their experience here was heightened by the fact that New Ulm was a German community, where many residents were recent immigrants or still spoke German daily. Two residents were charged with aiding a prisoner's escape when he spent a social evening with them but was returned to camp the next day. The man and woman were each fined three hundred dollars and lectured by the judge. The camp closed in December 1945, and the POWs were sent back to Europe. ⊠

Indians fired their guns whenever tufts of grass moved, eventually killing one settler and wounding several others. When the Dakota offered safety to the women and children, the settlers emerged from the slough, only to be shot once they cleared the grass. Many of the remaining settlers were captured and held for three months before being released.

Not far from the entrance road, I hiked to the gray granite memorial and read the names carved there. Nearly 150 years have passed since the settlers died, but seeing the children's names sent a shudder through me. The U.S.–Dakota War exacted its greatest toll on civilians and the innocent, whether they were settler children or Dakota babies who died from disease at the Fort Snelling camp. Turning away from the marker and scanning the horizon, I wondered how many Shetek visitors know of the war and will make the short hike to this important moment in Minnesota history. Few, I speculated.

Northeast of Shetek, along the Minnesota River bluffs, Fort Ridgely State Park commemorates a military outpost established in 1853. Its name might suggest a fortified stockade, but Fort Ridgely was merely a collection of unprotected buildings at the time of the Dakota War. On August 18, 1862, after the Dakota launched a series of attacks on settlers along the Minnesota River, about two hundred refugees fled to the fort. The Dakota attacked it twice and were repulsed both times. While the fort would later lose its importance as a military installation and fall into disrepair, a fifty-two-foot monument to the battles was dedicated in 1896. The state park was established in 1911; a golf course built in 1927 was renovated in 2008. Today, visitors can learn about frontier and military life at an interpretive center; the park also has well-used hiking and horseback riding trails and a popular winter sliding hill.

Upper Sioux Agency State Park is further upstream along the Minnesota River, at the terminus of the Yellow Medicine River. During the U.S.–Dakota War, a collection of a dozen buildings, unfortified like Fort Ridgely, was located at the site. The Yellow Medicine Agency, as it was known, was created to administer the 1851 Treaty of Traverse des Sioux, which had moved the Indians from Iowa and Minnesota to a reservation about twenty miles wide along the Minnesota River. The agency was where payments of supplies and gold coin were made to the Dakota, and it represented the root of their long-simmering complaints with the U.S. government. Not surpris-

ingly, it was destroyed by Dakota warriors. Most of the settlers were spared and fled into the countryside. By the time the state park was created in 1963, little of the original agency remained. A historic stone house was eventually restored, and the foundations of several buildings exposed. The park also has an interpretive center focusing on the Dakota War and still serves as a meeting place and a center for Dakota powwows. Bob Beck, the regional state park naturalist who oversees programming at the Upper Sioux Agency and other western parks, says telling the story of the U.S.–Dakota War is a major purpose of Lake Shetek, Fort Ridgely, and Upper Sioux Agency. "The Dakota tell their part of the story," he explains. "In the past, they have put on programs about the conflict. During the 125th anniversary, we invited reconciliation at Lake Shetek, where several Dakota speakers talked about what the conflict has meant to them. They have a story to tell about the conflict, and their history is pretty extensive."

At Fort Snelling, Thomson and I walk down to the Dakota memorial, which was enlarged and updated in 1997. Inside the memorial, which consists of large wooden posts and beams, the pipestone marker lies under a plastic case. The names of different Dakota bands are listed, along with the words, "All my relatives." On top of the case sits a bundle of sage. Thomson tells me Dakota people regularly visit the memorial, leaving sacred offerings of tobacco and sage. In November, an annual march commemorates the march of the sixteen hundred and a wreath is laid at the marker. "Indian history is still largely invisible," she says. "But in working with the Dakota on this memorial, I was surprised at how present the history is with many Dakota families." As we sit in the shade of the oaks, a school bus pulls up and children trundle out for a tour. They are about to learn about a dark time in Minnesota history. "This is a place where something happened. It has become a sacred spot," Thomson says. "We have a responsibility to manage it in a way that is respectful to people today, and to remember." ⊠

Fort Snelling State Park

A Name Change Guide

What's in a name? Plenty for Minnesota's state parks, some of which have changed monikers to suit local sentiment or to avoid confusion.

⊞ The original Baptism River State Park was incorporated into Tettegouche State Park when the latter was created in 1979.

⊞ Forestville State Park was renamed Forestville/Mystery Cave State Park when a nearby cave complex was added in 1987.

Fort Ridgely State Park

- O. L. Kipp State Park along the Mississippi River was named after Orin Lansing Kipp, an assistant chief engineer of the state highway department, but the name was changed to Great River Bluffs State Park to better reflect its location—and spectacular views.

- In 1953, the state officially designated Helmer Myre State Park in honor of a senator, but locals always had called the park Big Island. It eventually became Myre–Big Island State Park.

- First called Nerstrand Woods, this park's name changed in 1990 when several large parcels were added. Today it's known as Nerstrand–Big Woods State Park.

- Wild River State Park originally opened as St. Croix Wild River State Park, but confusion with St. Croix State Park prompted its name to be shortened. ⌧

Golf's State Park Niche

Can you name Minnesota's historic state park with a newly remodeled golf course? If you're familiar with links in southwest Minnesota, you know that Fort Ridgely State Park has a nine-hole golf course built in 1927 that received a complete makeover from 2006 to 2008. The greens, which had artificial turf, were upgraded with natural grass, and the fieldstone benches from the 1930s were reconstructed. The fort was the site of two important battles during the U.S.–Dakota War of 1862, so the DNR spent three hundred thousand dollars on archaeological surveys and digs to make sure the renovation did not impact any archaeological resources and the battlefield landscape. Since human activity at the site goes back five to eight thousand years, archaeologists were also looking for objects left prior to 1862. The makeover included prairie and oak savanna restoration, and golfers now walk among native wildflowers and wild turkeys—a lovely, historic setting for a round of golf. ⌧

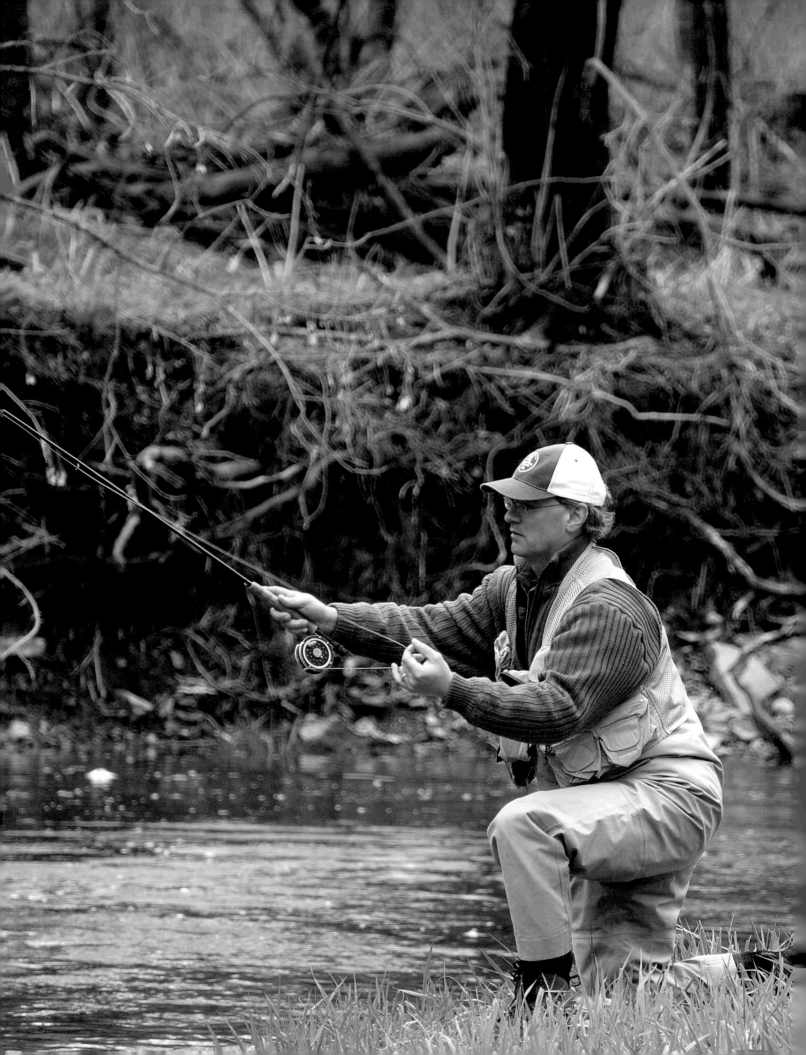

Dawn: windshield wiper doing double-time, two fishing rods packed away in the back, and my future wife curled up in the passenger seat, sleeping.

We are going trout fishing. Any trout worth catching is worth getting up at 4:00 AM for, so we slipped out of the sleepy metropolis in the dark, following a string of semi-trucks south on Minnesota 52 toward Rochester. It has been raining all night—a bad omen if you wish to combine a lover's sojourn and a limit of brown trout in the same morning.

We are headed for Forestville State Park and the South Branch Root River. There are two other state parks with high-quality trout streams in southeast Minnesota—Whitewater and Beaver Creek—and I never tire of walking their banks among the limestone bluffs and ancient oaks, but the Root River, with its cool, tight canyons and long runs, is something special. Thaddeus Surber, a biologist with the old Minnesota Game and Fish Department, spent the better part of the early 1920s walking the Root River watershed—some claim he walked a thousand miles—and when he finished his surveys, not only did he know all the best fishing spots but he had become a fervent advocate for better trout-stream management. I can only imagine what Thurber would have thought of a gully-washer morning like this, when the runoff turns the streams into roiling brown water. He might have stayed home.

Forestville State Park

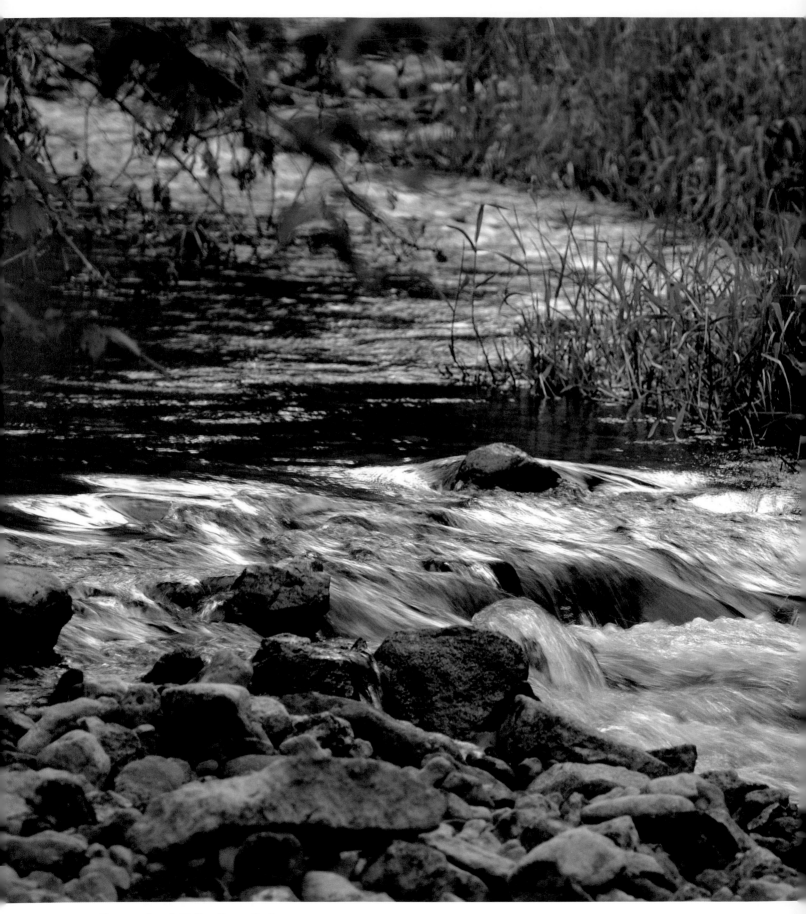

Beaver Creek Valley State Park

Just south of Rochester, I stop at the first river overpass and see in the dull light water rushing over the grassy banks. Diana is awake now, sitting up and cheerful. "Bad news?" she asks, detecting my grimace.

"The river's jumped the bank a bit, but all is not lost," I say brightly, but I am not good at hiding my fishing emotions. The same dark clouds hanging over these valleys have crept into my head. Through Chatfield and on toward Preston, I explain the fickle feeding nature of trout and the negatives of high, soil-stained water. We stop in Preston, home to a large statue of a brown trout, and pull into a park near the river. On this, the opening day of trout season, few people are out: another bad sign. But while I am putting together the rod sections, the clouds break and suddenly it is a warm, springtime morning.

My mood brightens. I have a fly rod and Diana has a spinning rod. It is her first time trout fishing, and I labor over choosing the right lure that both attracts fish and is easy to flip into the river and retrieve. A small brown Rapala catches my attention, so I tie it onto her line. We walk down to the stream, and she makes a cast. Her first retrieve returns a clump of weeds swept into the water by the rain. Her second cast goes awry, and she snags an overhead branch. I manage to get the Rapala, with its twin set of small, sharp treble hooks, out of the branches without breaking the line. I point to a rock that parts the waters at midstream. "Cast behind that rock."

The little Rapala flies through the air and hits the water near the opposite shore, but when Diana begins turning the reel's handle, the lure jumps downward into the water, and the current sweeps it behind the boulder. I watch her rod tip, and the lure's rhythmic vibration,

telegraphed perfectly to the last eyelet, abruptly stops. "I think I have something."

My heart leaps. As I bend down, landing net in hand, to secure my beloved's first trout, the little Rapala suddenly pops out of the water. A moss-covered stick dangles from the treble hooks. The lure bounces around on the rocks until I am able to grab it and untangle the stick.

"Stick trout," I say enthusiastically.

"Felt like a fish, anyhow," Diana says.

"Try behind the rock again."

Under our feet, the cobblestones are tippy and slick; we are having trouble keeping our footing without slipping into the angry stream. Still, Diana flips the lure to midstream and hits the spot again. The lure dives under the water with similar results: it stops moving, and Diana's reel purrs slightly as the line begins pulling on the drag.

Our suspicions of another stick trout evaporate as a yellow-hued and spotted brown jumps in midstream. As I move into position with the net, I slip and one leg gets caught in the current. I recover quickly, but now I'm sitting on the rock and my knee is bruised. "Honey, are you OK?" Diana isn't reeling anymore, but my insistent look up at her must say "keep going," because in a few quick strokes of the handle she has the trout against the rocks and I slip the net under it.

The trout is a shade under a foot long, and its body is thick behind the gills, tapering back to a stout, squarish tail. It has been eating well, not like some trout whose heads are awkwardly disproportional to their bodies. Its back is peppered with black specks, and along its sides are blood-red bright spots. Its bottom flank is yellow like a dandelion. Its sharp colors contrast against the water's murkiness and the morning's general dreariness so that you would scarcely believe the trout belonged in the scene.

"Let's put it back," Diana says sympathetically.

I have triumphed over the Root River's brown trout with the tiniest flies of my own creation; I have been skunked and humbled while plumbing its depths with a garden worm; and I have caught fish after fish from a certain hole by casting a hand-tied nymph and letting it trickle across the bottom, almost lifelike, until I had to stop, guilty from fooling so many fish. A fisherman's heart is difficult to explain. But over time, Diana's first trout has lasted as the most

Forestville State Park

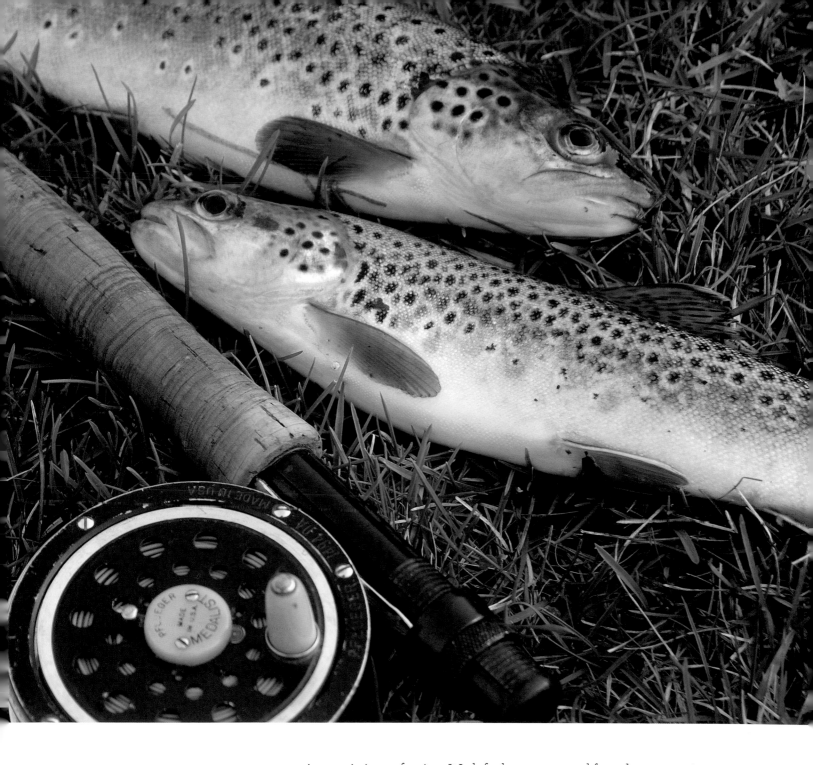

cinematic in perfection. We left the stream and found a gas station with hot coffee and eventually spent part of the morning walking through the ghost town of old Forestville. As the sun fought its way through the clouds, we watched anglers pop up along streams like mushrooms after the rain. On that day, we were among the fraternity of trout anglers who woke early and endured a cold soaking and caught a fish: just one, and a forgettable fish by size standards, certainly. But catching a brown trout—which is not truly a native (the species was originally brought to America from Germany in

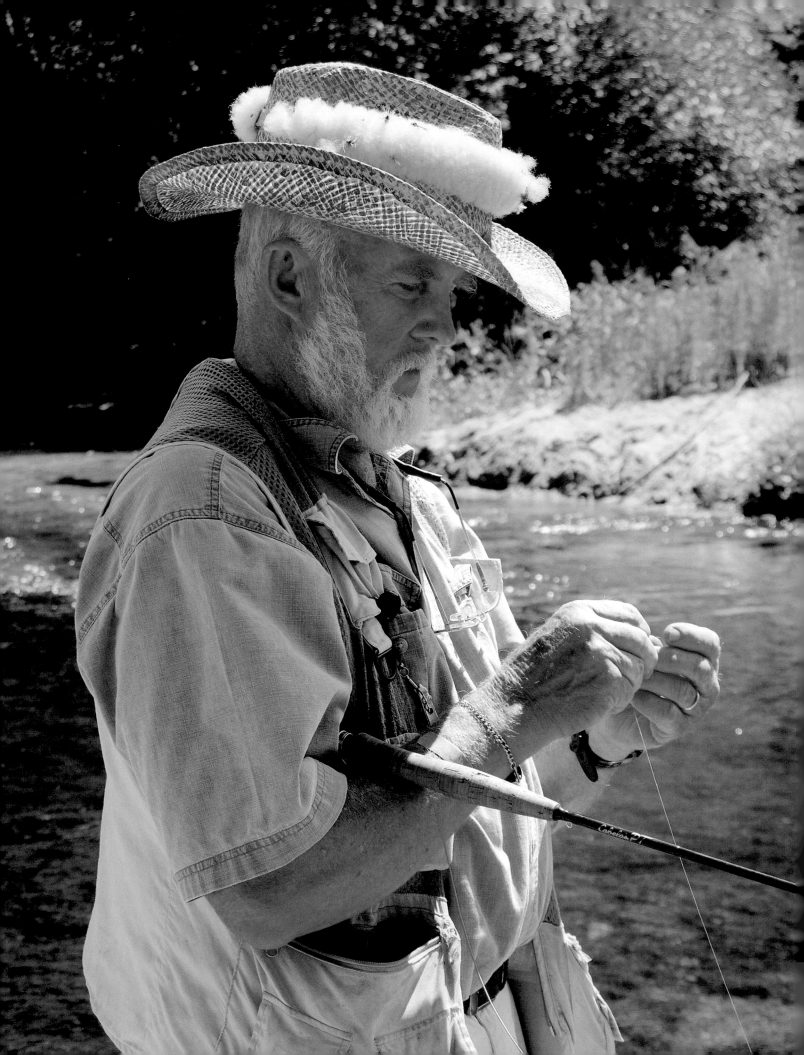

the 1880s and to Minnesota in the 1920s)—is an illuminating experience when shared by two who are in love.

I have met a great number of people along trout streams that include the Whitewater a year after 2007's horrific flood. After the waters receded, they all came to the stream out of curiosity but also out of love for the fish. I have met the solo, discreet anglers; the aged fathers and sons; fishermen with thick Russian accents and thicker beards; Cambodian refugees with gear still sporting a Wal-Mart price tag; and tony fly anglers unlocking trunks of BMWs and unfurling expensive bamboo rods. Incidentally, I met all those characters in one morning along the Whitewater, on the opening day after the flood, in a half mile of stream. Only one had caught a fish, but all were happy.

The fishing couple, however, is an unusual act. Once at Whitewater State Park in search of an interview, I knocked on a camper

Itasca State Park

trailer with fishing gear piled against the aluminum siding. A man answered. He held a beer can. Behind him, a partially dressed woman sat on a narrow cushion. She held a beer as well. A radio was on, playing eighties rock. "How's fishing?" I blurted out, mentioning awkwardly that I was a newspaper reporter. "Tell him the fishing sucks, but the party is great!" came the woman's voice. The man winked and closed the door.

I was skulking around the Root River at Forestville State Park one spring day, waiting for a mayfly hatch to begin, when two middle-aged anglers ambled up the stream. They wore new fishing gear—their waders weren't scuffed—and her hair was done up in a manner reminiscent of my grandmother's. They looked more suited for a day of shopping. I was mistaken. They had driven north from Kansas in search of trout, and they eagerly absorbed my descriptions of blue-winged olive mayflies and Hendrickson hatches and the lack of caddis flies early in the season. I let them select several flies from my box. On this Tuesday, they had the park to themselves, which they said was surprising because the park manager had told them there were two thousand trout per mile in the stream. "So many trout and so few people!" she said with delight.

Whitewater State Park

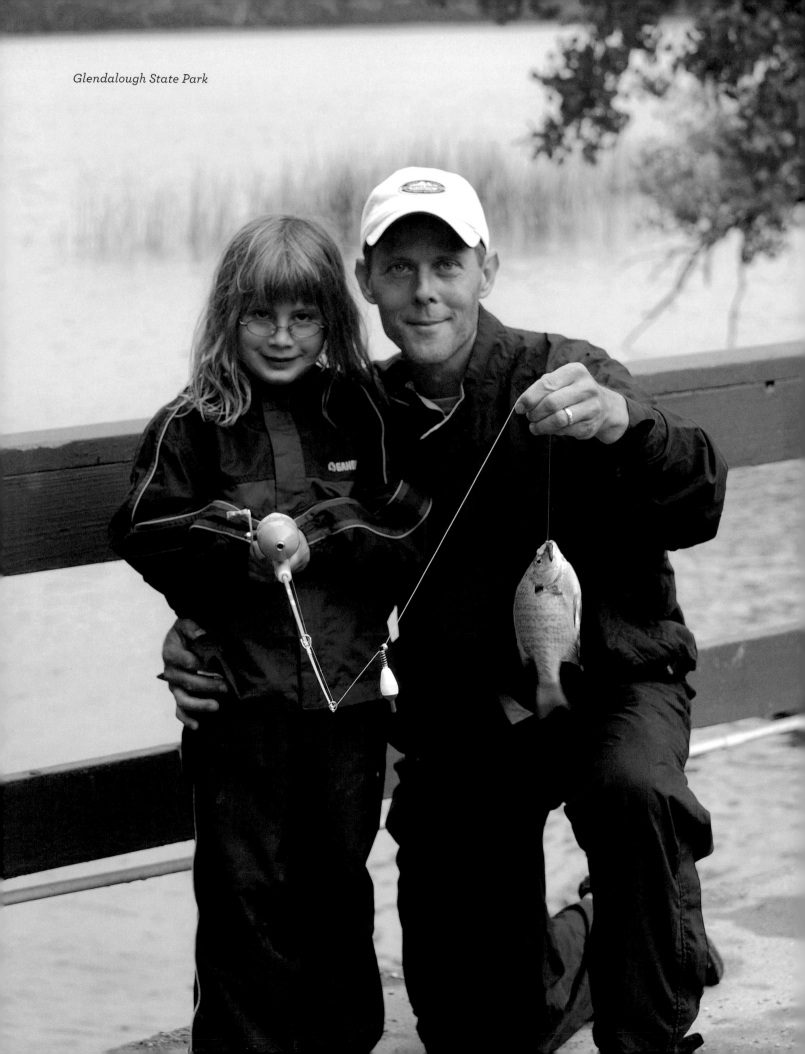

Glendalough State Park

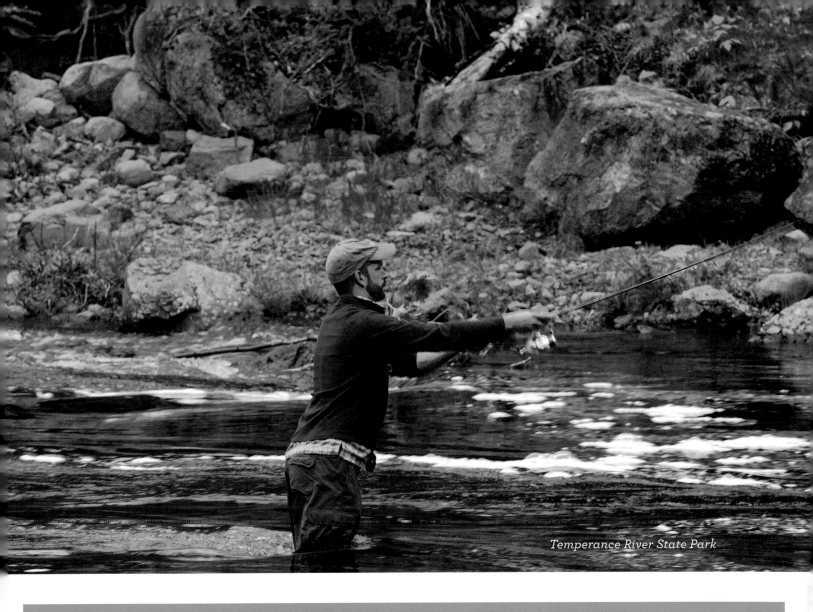

Temperance River State Park

On Alert at Whitewater

It was one of the most expensive and destructive event in Minnesota state park history: during a twenty-four-hour period starting on August 18, 2007, eleven inches of rain fell upstream of Whitewater State Park, creating a flash flood that ripped through the park, causing an emergency evacuation. Special river monitoring devices placed along the Middle Branch Whitewater River triggered alarms in the middle of the night, prompting staff to evacuate five hundred campers. No one was hurt, but the flood wiped out three bridges; damaged campgrounds, restrooms, and a group hall; and tore apart the park's septic and water systems. It changed the river's course by a full hundred feet, depositing eight feet of gravel in one spot. Damages added up to $4 million, the most expensive repair job in state park history.

Federal and state emergency funds helped put the park back together, and more than a thousand volunteers donated six thousand hours of labor. The twenty-seven-hundred-acre park reopened a year later, and by summer 2009 nearly all the repairs were complete. ⊠

Lake Carlos State Park

A Small Town Caught in Time

Along the South Branch Root River, the historic town of Forestville tells the story of a frontier town's boom and decline. Illinoisan Robert M. Foster purchased land in the Root River valley in 1853, and friend Felix Meighen followed and opened a general store. Soon, they were joined by Forest Henry, for whom the town is named. Within four years, Forestville had more than a hundred residents, along with a new brick general store, two hotels, a pair of sawmills, and a gristmill. It continued to grow until the Southern Minnesota Railroad bypassed the community in 1868, after which it began to decline.

By 1890, Felix's son, Thomas, owned the entire village. All fifty residents made a living working on his farm. Eventually, even Thomas moved to nearby prospering Pres-

Forestville State Park

ton. He closed the store in 1910, leaving all its stock intact.

Today, the Minnesota Historical Society oversees interpretation of the village site, presenting programs that show town life in 1899. Thomas Meighen protected the area until his death in 1936 and asked the state to consider turning it into a state park. It wasn't until 1963 that the Minnesota legislature created Forestville State Park, which formally opened to the public in 1968. Many other ghost towns simply faded away, but Forestville remains preserved, drowsing in long summer afternoons, a place out of time. ⌧

She was the chatty one, and he patiently allowed her to interrupt his many questions as if it were part of their agreed-upon dialogue. I fished downstream, but curiosity got the best of me and I watched them in action. He hovered over her shoulder, pointing at flies and gesturing to various fish covers until she waved him off and he scooted upstream. They fished apart but close enough to cheer each other if a trout was hooked or landed. In my opinion, they worked the same stretch far too long, spooking the fish with excessive casting, but that wasn't the point. Later, when we met again along the stream, I asked to take their picture. He threw a long, lanky arm around her shoulder and pulled her close, and she blushed and playfully elbowed him in the ribs. I don't think I saw them catch a fish, but they took great delight in living in the moment, together along a trout stream, a long way from Kansas. ⌧

Carley State Park

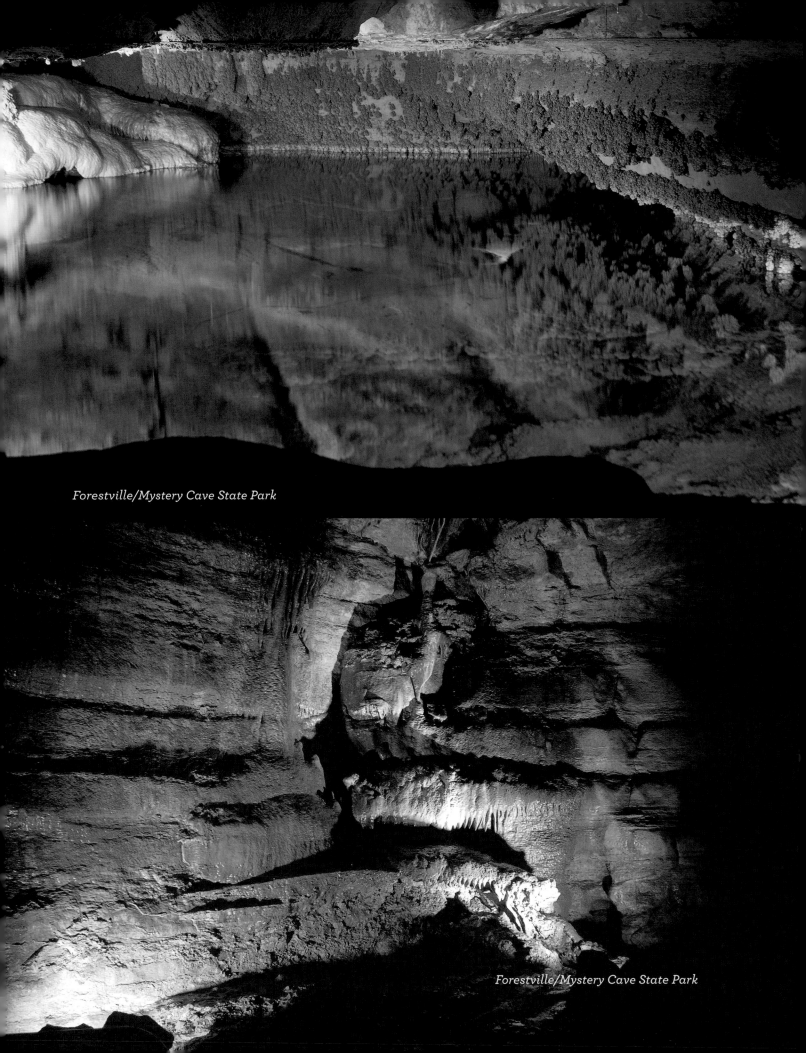

Forestville/Mystery Cave State Park

Forestville/Mystery Cave State Park

A Canoe in a Cave and Other Wonders

After about a half hour of hiking deeper into Mystery Cave, during which I'd seen fossils of ancient sea creatures and watched a river disappear into the ground, Warren Netherton brought us into a dark corridor for the tour's highlight. He found a small electrical panel on the wall and, as he had done to illuminate the other limestone corridors, flipped a switch controlling a set of special moisture-proof lights. What appeared next was otherworldly: a large phosphorescent pool of water tucked away in a dark corner of the cave. The pond—big enough to paddle a canoe in—looked like it had been lifted from a Hollywood film lot for an Indiana Jones movie. But this was a real geological wonder: an underground lake that seemed to glow by itself.

Soudan Underground Mine State Park

"This is Turquoise Lake, probably the most memorable spot on our cave tour," gushed Netherton, manager of Mystery Cave, which is part of the Forestville/Mystery Cave State Park complex in southeast Minnesota. He moved us closer to the lake, which was embedded in rock about waist-high and looked shallow but actually measures eight feet deep. "The color comes from the dissolved minerals in the water that come from the limestone," said Netherton. "You see the ripples in the water? There are little sheets of water coming across the flowstone," the sheetlike stone structures made when water flows over the walls of limestone caves.

Netherton actually paddled a canoe on Turquoise Lake—that's how he and another worker performed the delicate task of placing several lights on the lake bottom without damaging the cave's sensitive calcite formations. "It was unnerving," Netherton said of the light installation, but since Mystery Cave was purchased by the state in 1988 from a private owner, it has been developed—and to some degree preserved, by keeping people from damaging its resources—with a vast array of improvements. With thirteen miles of corridors, many of them oddly straight and uniform, Mystery Cave is Minnesota's longest cave and one of its busiest: about eighteen thousand people a year put on jackets and sweaters (the cave is forty-eight degrees year-round) and take the trip underground. Park staff offer one- and two-hour-long tours but also a "wild caving" option that takes visitors through crawl-only passages and undeveloped portions of the cave.

*Hill Annex Mine
State Park*

"This is a big system," said Netherton of the Mystery Cave complex. It's not uncommon for workers to stumble into new passages. "We have a big effort under way to survey the cave in great detail. Who knows how far it could go?"

Geology isn't the sexiest science, but the story of the Earth's rocks and formations is a significant part of the experience of visiting the state's parks. "Minnesota's geologic heritage is rich and varied and fortunately much of it has been captured within our state parks," wrote J. Merle Harris, a University of Minnesota professor, in 1972. In every corner, a geologic story is told in a state park, whether it is the Sioux quartzite that forms the rock bastion at Blue Mounds in southern Minnesota or the two-billion-year-old Rove Formation and its soft, erodible bedrock at Grand Portage and the resulting spectacular High Falls on the Minnesota-Ontario border.

Some state parks exist precisely because they are large holes in the ground with a rich history. Hill Annex Mine State Park near

*Hill Annex Mine
State Park*

Calumet is a large, open-pit ore mine that operated from 1913 to 1978. On a ninety-minute bus tour, you can trace the route miners took down to the working levels of the pit, which has filled partially with water. The tour guides visitors through successive layers of geologic history, starting at glacial debris left near the surface, down through Cretaceous beds where fossils were formed 86 million years ago, and finally to iron-ore deposits left two billion years ago. The mine is also open to fossil hunts during which visitors find shark teeth, clams, and other ancient ocean animals. Recently, the park's cliffs have become a release site for peregrine falcons.

Soudan Underground Mine State Park

Soudan Underground Mine State Park outside of Tower isn't an open-pit mine, so visitors don hard hats and ride an elevator cage down a half mile into a mine shaft to tour the bowels of Minnesota's first iron-ore mine. Here, the bedrock is 2.7 billion years old and the elevator stops at the twenty-seventh level, where a railcar continues the tour deeper into the shafts. About 15.5 million tons of ore came out of Soudan, and above the mine visitors can mull the accoutrements from the heyday of ore extraction: the big ore crusher house, the drill shop, and the engine house where a powerful motor kept the mine running.

While working on a magazine story about the Soudan Mine in the 1980s, I toured the most fascinating and complex research site open to the public in Minnesota: the Soudan Underground Laboratory, located in a cavern within the park. Scientists have used a huge cave in the mine for more than twenty-five years to try to answer fundamental questions about the formation of the universe. The University of Minnesota has joined with leading physicists around the world to build large, complicated detectors that study the smallest particles yet known. In one experi-

Moose Lake State Park

Interstate State Park

ment, scientists are trying to determine whether the ghostlike neutrinos have mass. Physicists are also studying fundamental questions about matter and so-called dark matter—material thought to exist in the universe because of its gravitational pull on other objects. The Soudan Mine is an ideal environment for this exploration because its deep, subterranean location protects experiments from a bombardment of cosmic rays from outer space. Daily tours offer visitors the opportunity to see the massive laboratory up close and ask big questions.

A tour that delves into more recent influences on Earth lies along the St. Croix River, where on a warm summer day I hiked around other holes in the ground: glacial potholes. Interstate State Park, Minnesota's second-oldest state park, is a fascinating display of the forces of rock against rock. The potholes appeared after melting glacial water created whirlpools of swirling debris that ground away at the bedrock. Interstate State Park has the greatest concentration of glacial potholes in the world, some of them sixty feet deep. The holes were created around ten thousand years ago when glacial St. Croix River carried water southward from Glacial Lake Duluth (now with a nicer name: Lake Superior), a torrent of water that cut deep channels in the basalt. The water shaped walls along the channels, today called *dalles*, and along the dalles it drilled holes into the rock.

Early settlers weren't always so impressed with the potholes, which in the late 1800s were vandalized and filled with trash. Protecting the potholes became a priority for conservationists, and the state park was created in 1895. Noted Minnesota historian and University of Minnesota president William Watts Folwell once wrote of the park's creation, "The rescue of the Dalles

of the St. Croix from neglect and vandalism was the most creditable proceeding of the legislature of 1895."

Travel north from Interstate State Park on Interstate 35 and you come to Moose Lake State Park, where visitors can pore over Minnesota geological history at the Agate and Geological Interpretive Center. Here you'll see impressive examples of Lake Superior agates, the state gemstone, but one summer afternoon I became engrossed in the center's interpretative display on things mined from Minnesota. Who knew, beyond iron ore, that sand and gravel, horticultural peat, and industrial silica sand were such important industries in Minnesota? As for Lake Superior agates, they can be as small as a pea or as big as a human head, and today they're often found in gravel deposits left by glaciers, which gouged and pushed the agates from ancient lava beds and polished them.

Glaciers are responsible for shaping most of Minnesota's landscape, and their handiwork is well represented and interpreted at state parks, whether in the moraine, or mounds of glacial dirt, left at Mille Lacs Kathio State Park or in the eskers, or long curvy ridges, created by melting glacial rivers at Scenic State Park. The notable exceptions are the southeast Minnesota state parks, including Mystery Cave, where glaciers missed the bluff lands of southeast Minnesota and failed to scrape and reform the landscape. Here the shaping factor is water—dripping, running, and cascading water that pours into the cave from the nearby South Branch Root River and erodes the limestone walls and creates a "disappearing river."

The wet, dank environment maintains a humidity around 95 percent, and as Netherton guided us through the heavy, metal door that protects the cave from floods, I noticed a small brown bat clinging to the ceiling. It was late April, and the bat was very still against the cool stone wall. "There has been a bat hibernating in that spot for eight years, so maybe it comes back to the same one every year," Netherton said. "Bats are very loyal to their roosting spots. I suspect that one is still hibernating."

Unlike the brown bat, I was happy to be back in the spring sunshine, where the gurgling Root River flowed past the cave's entrance and a new hatch of mayflies excited a brown trout swirling in a distant pool. ⊠

*Hill Annex Mine
State Park*

Hill Annex Mine State Park

Preserving a Mining Heritage

Hill Annex Mine State Park near Calumet is not only one of the smallest Minnesota state parks, it's also one of the most unusual. In 1988, the Minnesota legislature approved creation of the state park on a former open-pit iron mine that operated from 1913 to 1978. When the mine closed and pumps were turned off, water seeped back into the hole, creating a series of lakes. Trees and other plants have grown back in the area, draw-ing gray wolves, bear, and ruffed grouse. Hawks and eagles cavort among the reddish-hued cliffs, and peregrine falcons have been released at the park. The 635-acre park receives about ten thousand visitors annually. Most come to take the ninety-minute tour down into the mine pit, where you can see ancient marine fossils embedded in the 2.7 billion-year-old bedrock. The mine is listed on the National Register of Historic Places. ⊠

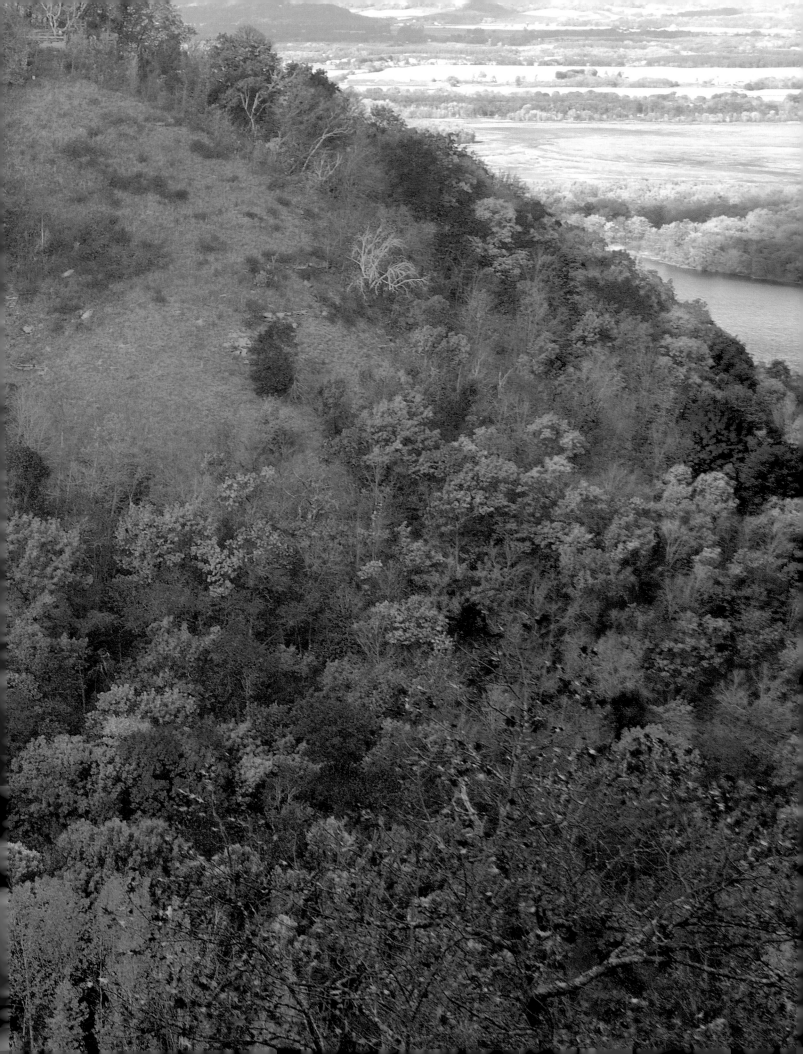

High on King's Bluff, a hot summer breeze blows up from the Mississippi River valley. It tousles the delicate heads of black-eyed susans growing in a nearby goat prairie, where tough-as-nails and well-adapted plants eke out a living in poor soil. I'm standing on layer upon layer of silica and lime, deposited millions of years ago on the floor of a great ocean. The deposits reached depths over a hundred feet, then hardened into alternating layers of dolomite and chert and eventually pushed upward, creating this ridge in Great River Bluffs State Park. Glaciers did not touch this region, but a mighty river and its tributaries did their scouring, transporting vast amounts of meltwater from glaciers to carve the deep, rugged valleys around King's and nearby Queen's bluffs.

Glacial Lakes State Park

I learn these details from a pair of interpretive signs placed along the last few hundred yards of the King's Bluff trail. I'm a goat-prairie-and-chert sort of guy, but at this moment I'm more compelled to soak in the impressive view of the modern Mississippi River valley lying five hundred feet below me.

Minnesota's state park trails—and there are thousands of miles of them—are graceful journeys through human and geologic history, whether you're afoot, on skis, or on horseback. This is my second hike of the day (I began the morning at Afton State Park), and for the past hour I've been hot on the trail of this

Great River Bluffs State Park

John Latsch State Park

Great River Bluffs State Park

The Long and Steep of Trails

Which Minnesota state park has the most miles of hiking trails? That honor goes to St. Croix State Park, which has 127 miles of hiking trails, more than double what the next two parks on the list can claim (Jay Cooke has fifty miles and Itasca forty-nine).

Park manager Jack Nelson says the Two Rivers Trail is his favorite. It begins at the Kennedy Brook parking lot and heads downstream along the Kettle River to its confluence with the St. Croix. "This hike provides an intimate connection to the rivers, their sights, their sounds, and their wildlife," Nelson says. And the River Bluff Trail, offering overviews of the St. Croix River and an interpretive section of the Yellowbanks Civilian Conservation Corps site, is a visitor favorite, Nelson reports. The park's best view comes from atop a hundred-foot fire tower.

The honor of having the steepest trail goes to John A. Latsch State Park near Winona. More than five hundred steps give hikers a workout on their way to a bluff overlook of the Mississippi River. ☒

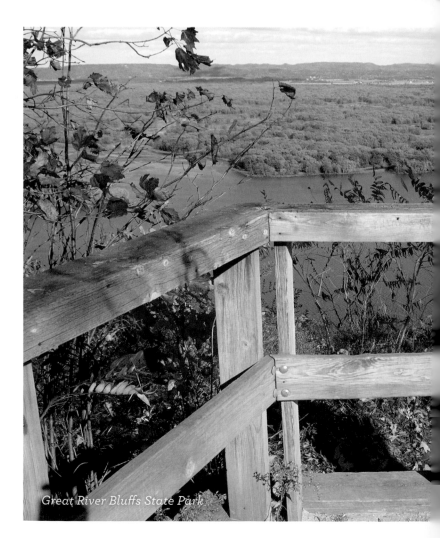
Great River Bluffs State Park

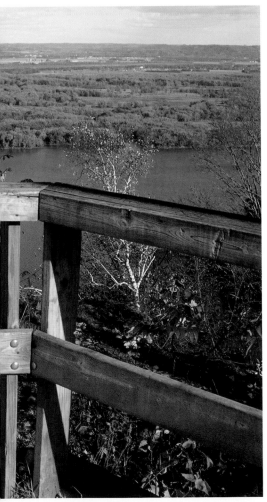

bluff-top, panoramic view. Sucking in the hot blowing air, I survey the braids and backwaters of the Mississippi River lying to the east. I spot a cabin cruiser cutting a perfect V-shaped wake through the water, and I catch the sound of a train speeding up the river valley. Beyond the river are tidy Wisconsin farms, their tight rows of corn punctuated by blue silos. I'm surprised by the abundance of hardwood forests I can see from my ridge perch. A turkey buzzard rides the thermals between me and Queen's Bluff across the way.

Turning 180 degrees toward the afternoon sun, I peer down into a lovely valley with a neatly organized Minnesota farm and a curving field of corn nestled along an oak-studded hillside. The hills are steep, rising to more fields and silos—the great modern American breadbasket, powered by diesel tractors and the ingenuity of fertilizer, herbicide, hybrid seed, and products of global agribusiness.

At my feet, I'm hoping to catch a glimpse of a timber rattlesnake, a species known to bask in these dry, rocky prairies, where only a thin layer of soil covers the bedrock and, presumably, only a goat would dare tread. Author Paul Gruchow once wrote, "If you want to stretch your sense of what a prairie is and if you have strong legs and lungs, visit one of the goat prairies of southeastern Minnesota." Gruchow hoped to see a timber rattlesnake when he visited a goat prairie, but he didn't. I turn and head back down the trail, deciding I am destined to go 0–1 in spotting one myself.

As soon I leave the steamy ridge, I'm thrust into a cool verdant hardwood forest of oaks and hickory. The trees are fire scarred, likely by a controlled burn set by DNR staff, and I'm reminded that the forests looked this way prior to settlement. Here was once the western edge of a great oak and hickory forest that began on the East Coast; once settlers arrived, they cut the forests and stopped the natural cycle of fires that kept the understory healthy. Following the trail along the bluff's spine, I am rewarded by a few brief vistas, but mostly I'm kept company by woodland birds and chipmunks. When I follow a new spur, I enter an entirely different forest of red and white pines, green ash, and black walnut. A sign tells me later my hunch is correct: these trees were planted by man in an effort to maximize the land's income potential. Purchased in 1963, the state park is still in a transitional phase; once the trees are large enough to cut, says the sign, they will be sold and the land planted with its original oak and hickory.

The trail emerges from the woods and skirts a prairie where I might have a chance to see the rare Henslow's sparrow. No such luck. Soon I'm at the parking lot, which is empty. Great River Bluffs is one of the least-visited state parks in the system, and on this summer weekday it is quiet, save for the chatting gray catbird in a nearby bush.

It is a contrast to Afton State Park, just a thirty-minute drive from downtown St. Paul. Earlier in the day, I followed Afton's long, paved entrance road that is shared with a downhill ski area and a golf course. Two wild hen turkeys and their brood of poults the size of forest grouse pecked gravel along the road. Among Twin Cities residents, wild turkeys are becoming as ubiquitous as Canada geese, so I wasn't inclined to stop. I drove past the birds, down a long and curvy road, and parked near the visitor center. It was 9:30 in the morning, and a few cars were already there. I'm a member of the DNR's state park Hiking Club, which rewards hikers with patches for accumulating hiking mileage in state parks. Each designated Hiking Club trail has a password posted on a sign at its midpoint. If I want to record my mileage for Afton State Park, I have to find this password.

Schoolcraft State Park

I located the trailhead and set out on my first leg: a half-mile walk through a restored prairie that is table flat and overlooks the St. Croix River. An interpretive sign told me that when a farmer bought the property in 1919, it was classified as "wasteland" because of its poor soil and sold for ten dollars an acre, including the river shoreline. Today a couple of acres of prime St. Croix River shoreline might sell for a million dollars.

I made quick work of the prairie walk and headed down to the river. A man and his family carrying backpacks from a remote site greeted me in Spanish. I found a spur and plunged deeper into the green, cool forest. The trail turned from pavement to dirt. A cottontail rabbit bounced out of the understory, caught a glance of me, and tore back into the woods. Around another turn, a supple whitetail doe suddenly reared out of the trail, then stopped just a few feet away and nibbled on leaves as I passed. A downy woodpecker chattered and lit on an oak, then flitted away again. When the trail straightened out, a bare-chested runner, looking to be sixtyish, bounded down the path. "Mornin'," he said and quickly trotted out of sight.

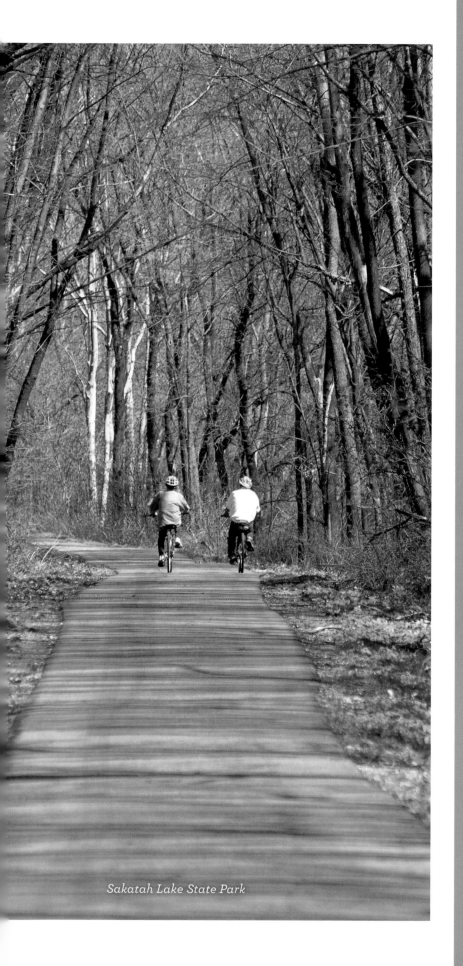

Sakatah Lake State Park

Savanna Portage State Park *Lake Bemidji State Park*

Above the Bogs

Bogs are nearly impenetrable swamps populated with fascinating plants and creatures. Luckily, we have bog walks.

Three Minnesota state parks and one recreation area have elevated walking platforms that guide visitors through these ecologically sensitive areas. The quarter-mile-long boardwalk at Lake Bemidji State Park takes hikers on a tour of spruce-tamarack forest carpeted with orchids and Labrador tea. The bog boardwalk at Savanna Portage State Park, built in 1998, traces through a spruce- and tamarack-forested bog where, among the sphagnum moss, curious flora like bog buckbean and pitcher plants live. Another boardwalk at Hayes Lake State Park ushers visitors through a northern cedar bog. The newest bog walk, and the longest in the state park system, can be found at Big Bog State Recreation Area near Waskish. A mile-long walkway takes hikers into one of the world's largest peat land complexes for close views of insect-eating plants like the pitcher plant and the sundew. ⊠

189

The Taste of Spring

In March, a handful of Minnesota state parks become a beehive of visitor activity: it's maple syrup making time.

Armed with drills, taps, and plastic buckets, park naturalists show visitors how sap from maple trees is gathered and eventually turned into the tasty sugary treat that's perfect on pancakes. The naturalists explain why the sap flows in the spring (trees are beginning to move their sap from the root systems to the branch sys-

Wild River State Park

tems) and how you need certain conditions to gather the most sap (warm days and below-freezing nights are optimal). The events are scheduled on weekends, with a later day reserved for the boiling process. Fort Snelling, Whitewater, and Wild River commonly hold the demonstrations, which are free but may require registration. In addition to enjoying an early spring day outdoors and learning about a process first practiced by Native Americans, visitors often go home with a special treat: a jar of freshly made maple syrup. ☒

Gooseberry Falls State Park

Maplewood State Park

190

William O'Brien State Park

Afton State Park

I was lost now. Not lost without a map, but lost in thought. The trail climbed, turned a corner, and followed a hillside until I suddenly reemerged in the parking lot. Did I remember to get the password for my Hiking Club booklet? Yes. I absentmindedly wrote it on the back of a store receipt. Refreshed, I found my car but wished for another loop through the woods.

IT IS WINTER, and I'm pushing my cross-country skis up a hill in William O'Brien State Park. A few days earlier, I was helping with a ski race at the park and marveled at the winners' effortless skat-

ing. They sped through the finish line, bent over panting, and then shook hands with their competitors. Once I was a racer; now I'm a plodder. My race today is with the sun.

Goodness, it is cold. I must be three or four miles from the park warming house, and I can smell brussels sprouts in bacon fat. Dinner is a long way home. Long shadows cut across the stilled prairie of big bluestem, and now I'm turned into the wind and frozen snot clings to my lip. I'm thinking about good skiing form, but no one is waiting at my finish line. The trail takes a gentle curve around the prairie and intersects another spur. I take the right trail, make two hard strides, and tuck. Love this hill. The skis squeak and crackle as I apply an inner edge into the groove. Speed is good. Suddenly the left ski behaves badly, refusing to rejoin its right brother, and for a moment I dangle on the cusp of wiping out. Then the left edge catches, and I pull the ski back under my body. Tucking inward, I streak down the slope, a giddy old racer heading for an imaginary finish line. ⊠

Fungi for Fun

Father Hennepin State Park

Be forewarned: with the exception of mushrooms and edible fruit, it's illegal to take plants, reptiles, and most wild animals from Minnesota state parks. Ditto for cultural or historical artifacts.

But morel mushrooms, those tasty fungi that sprout every spring, are definitely fair game for picking in Minnesota state parks. Now, getting information on locating the mushrooms is a different matter—you typically won't find park staff or fellow mushroom hunters willing to part with their prime morel locations. If you seek morels, start with a late-spring visit to any of the bluff land parks located in southeast Minnesota. Look for the mushrooms around dead elm trees— and don't be surprised if you cross paths with other fungi seekers.

Of course, don't eat *anything*, whether a mushroom or a berry, unless you're absolutely certain it's safe to do so. ⊠

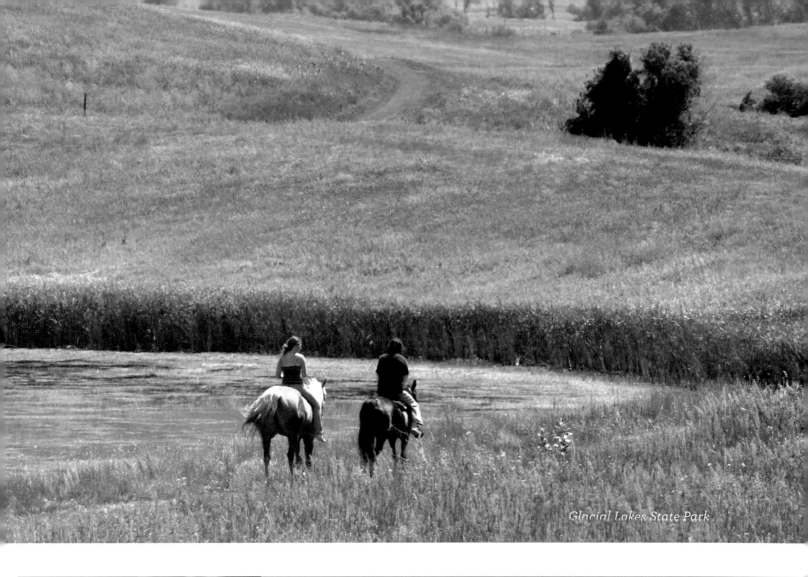

Glacial Lakes State Park

Finding the State Flower

The Minnesota state flower, *cypripedium reginae*, the showy lady's slipper, inhabits nine state parks: Gooseberry Falls, Hayes Lake, Itasca, Jay Cooke, Lake Bemidji, Old Mill, St. Croix, Scenic, and Zippel Bay. Found in swamps and bogs in much of Minnesota's central and northern hardwood and mixed conifer forests, the lady's slipper blooms from June to mid-July. Any number of flower guidebooks offer photos to help identify this delicate orchid. If you find a showy lady's slipper in a state park, don't even think about picking it or digging it up. These flowers belong to everyone and are protected from pilfering by state law. Park officials say lady's slipper poaching has become a serious problem; those caught can be subject to a fine. ⊠

Hayes Lake State Park

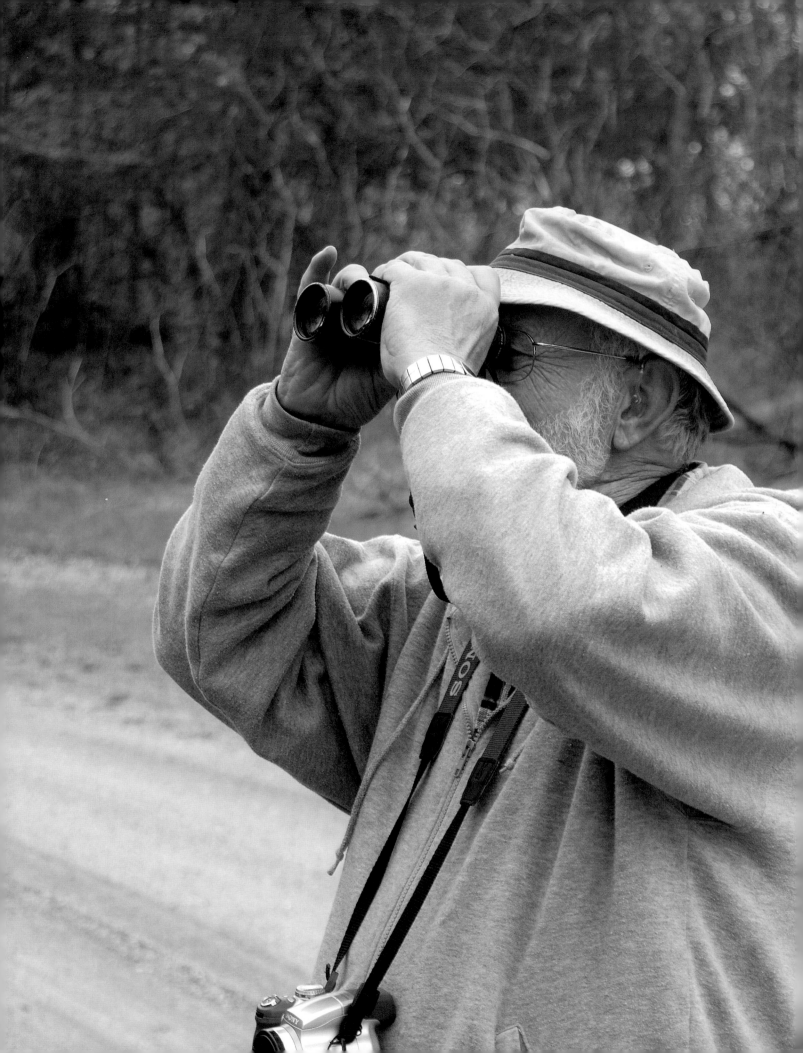

Bob Janssen's Big Bird Adventure

Bob Janssen's 1994 Toyota Camry has 314,000 miles on it. Janssen is a man of precision, especially when it comes to keeping track of milestones, so it is not surprising that he knows how far his indefatigable Camry has carried him. Not to brag, but Janssen has also been to every named place in Minnesota. That is, the 1,836 named places recognized by the Minnesota Department of Transportation. Counties? Janssen has been to all eighty-seven of them—and more times than he can count. He has also been to nearly every township in the state: there are 2,060 townships in Minnesota, and Janssen needs to visit just thirty-six more to round out his list.

Kilen Woods State Park

He's been to beautiful vistas and ugly towns. He's been to every state park and state recreation area, some dozens of times. There is scarcely a Minnesota hill, prairie, or block of forest that hasn't been subject to his prying eyes. "I'm very provincial," says Janssen, who turned seventy-seven in 2009. "Since I got my driver's license when I was fifteen, I've driven maybe two to three million miles in Minnesota. I get lost when I cross the border into Iowa."

Traveling salesman? Politician? Milk inspector? Surely such prolific travel is tied to a career on the road. Janssen worked as a salesman for a St. Paul envelope company for thirty-eight years, but that doesn't explain the midwin-

Minneopa State Park

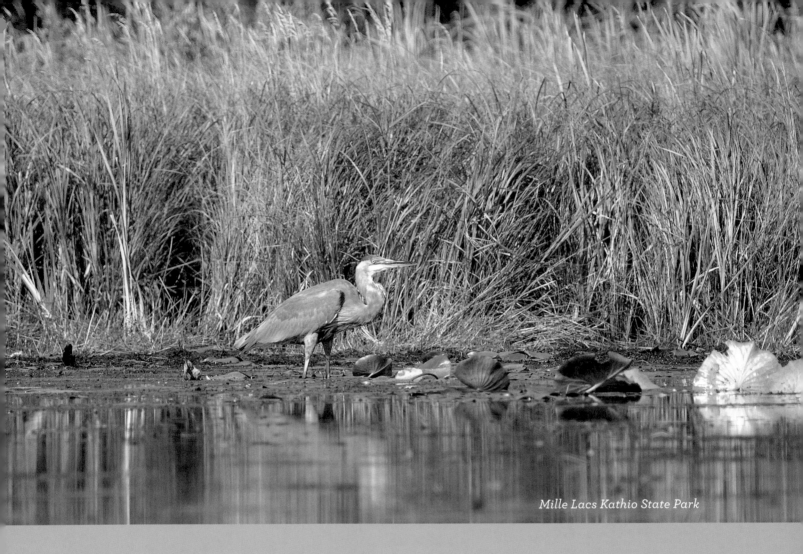

Mille Lacs Kathio State Park

A Bird-lover's Guide to Parks

Looking to take your bird-watching binoculars for a spin in a state park? Here are some options.

:: Afton, Whitewater, and William O'Brien state parks: Excellent places to watch wild male turkeys strut their stuff in the spring.

:: Beaver Creek Valley State Park: Home to the relatively large neotropical Louisiana waterthrush, the olive-colored Acadian flycatcher, and the cerulean warbler.

:: Itasca State Park: A major stopover for woodland birds for the first three weeks in May. Expect to be thrilled with many warbler species.

:: Lac qui Parle State Park: Watch for up to 150,000 Canada geese migrating through the area each fall from their nesting grounds in Manitoba.

:: Lake Bemidji State Park: At least two hundred different kinds of birds can be seen at this park, including Nashville and chestnut-sided warblers and scarlet tanagers.

:: Sibley State Park: Your best bet to see a common loon in west-central Minnesota, as well as prairie species such as bobolinks and grassland sparrows. ⊠

ter sojourns to Sax-Zim Bog or the spring hikes along the prairie bluff lands of Frontenac State Park.

Janssen is a birdwatcher, arguably the most-traveled birdwatcher ever to live in Minnesota. Janssen has spotted 402 different species of Minnesota birds, placing him second on the lifetime list recognized by the Minnesota Ornithologist Union (Kim Eckert of Duluth ranks first with 404 species). Janssen has written three books on Minnesota birds, served as MOU president, and spent thirty-eight years editing its magazine, *The Loon*. His methodical note taking and approach to birding has landed him several plum assignments conducting bird inventories, for which he has snagged the rarest of achievements for standing in the woods with a pair of binoculars: he earned a paycheck.

He says that for fifty years, birding was an avocation. Then he got a phone call from the Minnesota DNR. The state parks division needed someone to conduct a bird survey of some of its parks. Was he interested? "It was like the birding gods had looked down on me," says Janssen. "When I got that call from state parks, it

Itasca State Park

changed my whole life. It was the ultimate gig to go watch birds."

In 1972, Janssen had written an article for the *Minnesota Conservation Volunteer* that prophetically suggested an inventory of bird species for all the state parks was needed. "No one has ever undertaken the formidable task of making a list of the total bird species record in each of the state parks," he wrote in the article titled "A Tour of Our World of Birds," which described various species visitors could see at state parks. "The idea of putting together a list of birds for each of our larger parks would be a very worthwhile project for Minnesota bird-listers." Years later, Janssen could help make that dream a reality.

His first assignment was to conduct an inventory of birds at three parks—Afton, William O'Brien, and Fort Snelling—and the Minnesota Valley State Recreation Area, which is also overseen by the DNR. Janssen wrote a detailed plan for documenting the birds he would see, and for four years he visited each park and recreation area fourteen times. The result was the first complete list of bird species to be documented at each site. When Janssen completed his four surveys, he met with Ed Quinn, the park division's resource manager. They agreed that Janssen should continue his work at all the state parks and recreation areas. With sixty-eight more parks and recreation sites to survey, "it would take me 150 years before they would be completed," Janssen says, so he and Quinn decided to look at many of the parks' existing bird records. And they found them.

Some of the records were thorough: Itasca State Park, for instance, had documented bird sightings dating back to the early 1900s. Still, Quinn and Janssen determined there were

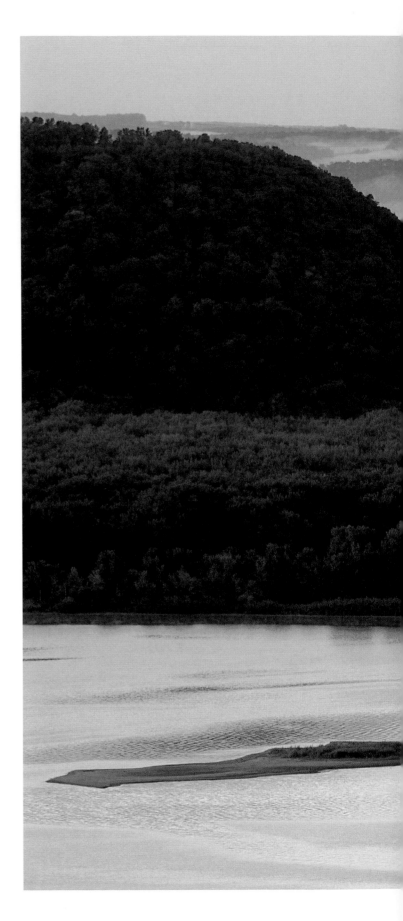

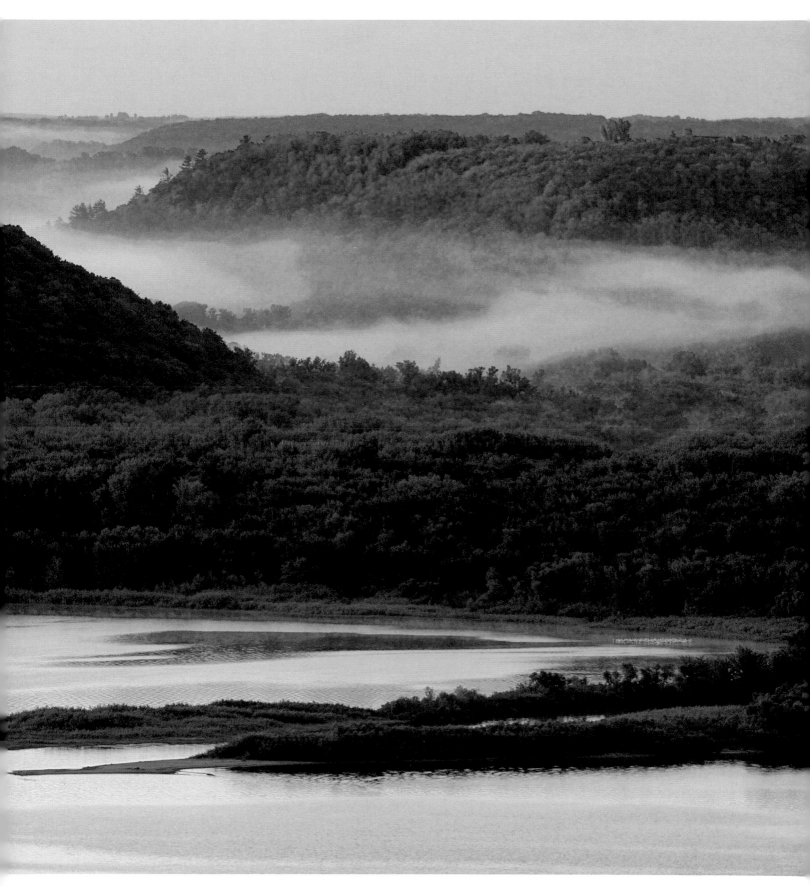

Frontenac State Park

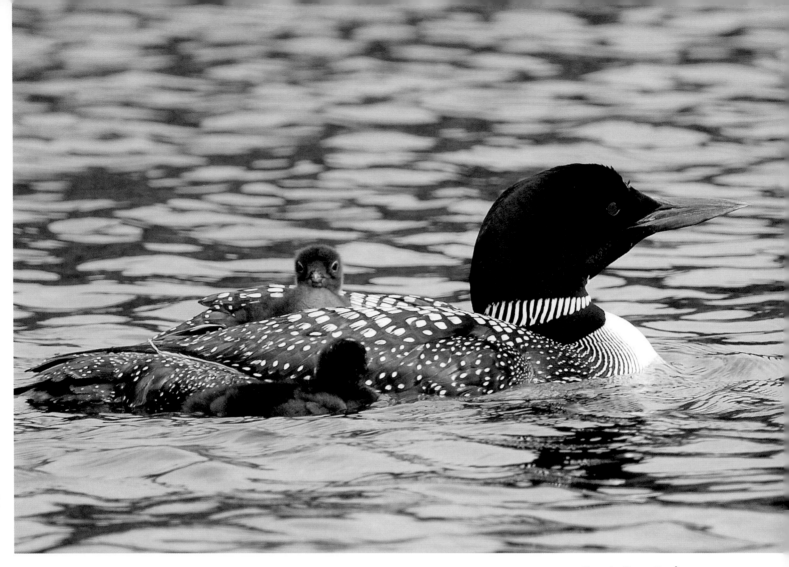

Scenic State Park

Unique Resources in the Big Woods

Nerstrand–Big Woods State Park contains the remnants of maple and basswood "big woods" that settlers found when they arrived in south-central Minnesota. The park, a study in the subtleties of a full-canopy forest garden, has eleven miles of shaded hiking trails.

In the spring, you'll find rare lilies, trillium, and Dutchman's breeches blooming along trails and stream banks. In the summer, cow parsnip, wild coffee, wild rose, and false Solomon's seal. In the fall, the hardwoods are ablaze with color, making them a favorite autumn visit for photographers. Among the animals found here are red and hoary woodland bats, deer, red-bellied snakes, and seven species of woodpeckers, including the increasingly rare red-headed woodpecker. ☒

thirty-five state parks that had little or no bird data collected. "One of the things that surprised [us] was we had very poor data on the North Shore parks," Quinn says. "We had very specific criteria, like a bird had to be seen within the park boundaries, but for some reason, we had very little information for the North Shore parks."

Janssen's new birding job began in 2001. His plan, or "protocol," was to visit each park fourteen times during the year. The season began with one visit in March and two in the months of April, May, and June, then one visit in August, two in September and October (to document migration), and one in November and December. The idea was to observe during peak bird activity (spring migration and breeding and fall migration), but not all parks received the full number of check-ins. The parks were surveyed over a two-year period, with between twenty and twenty-eight visits at each park, Quinn says.

Janssen didn't make the trips alone. His friend Jerry Bonkoski joined the project in 2003, and together they crossed the state in Janssen's Camry, staying in cheap motels and visiting park after park. Janssen, who describes himself as a "compulsive" birder, says the road trips and methodical methods they used never got boring. He spent six years working on the survey, earning $15.50 an hour. It was completed in 2007.

His most memorable experience was taking Quinn on a field trip to Afton State Park and spotting a white-tailed kite sitting in a dead tree, the first such sighting of the large-winged bird of prey in Minnesota. The species is more commonly found in the western and southwestern United States. "Within an hour, there were people from Duluth and Mankato on their way to see the bird. About fifty people added it to their life list of birds on that day. And here I am, finding the bird while on a birding hike with my boss," Janssen says.

Frontenac State Park

Today, every state park has a list of all the birds that can be seen at the park, available at the park's visitor center or online through the DNR's website. Janssen says he found "little treasures" in the park system. Monson Lake State Park, for example, had never seen many birders, but Janssen discovered it was a major stopover for birds on their migration route. "We were surprised,"

Homes for Bluebirds

Minneopa State Park

You see them atop fence posts at many state parks: small, triangular wooden boxes that look like they might house bird nests. If you guessed they're bird houses, you're right. More specifically, they're bluebird houses, often built, erected, and maintained by local bird enthusiasts.

You'll typically find these houses, which imitate a tree cavity, in or alongside prairies and open areas. Often they're near hiking trails. So-called bluebird trails provide birdwatchers with perfect opportunities to observe the birds tending to their nests and young, as adult bluebirds flutter in and out of the houses, feeding worms and grubs to their chicks. The sight and song of the bluebird—once uncommon in Minnesota—is now a familiar experience in the state's parks. ⊠

he says, "to find a little oasis in corn and soybean country. But if you look at a lot of these parks, they are an oasis of habitat where agriculture has become more intensified."

The state park bird database has twenty-eight thousand records of individual bird sightings in parks; twenty-seven of the twenty-eight rare bird species in Minnesota have been found at some point in state parks. Henslow's sparrow, listed as a Minnesota endangered species by the DNR, has been documented as a nesting species at Great River Bluffs State Park. The bird relies on grasslands for nesting, so the DNR has intensified prairie planting and burning to maintain the species' foothold there, hoping to shift the bird's nesting habits from the current nonnative vegetation to reconstructed prairie. "It's an excellent example of how having the bird inventory has translated into management decisions," Quinn says.

For park visitors keen on seeing birds, the lists are invaluable. If you visit Split Rock Creek State Park in the spring, you know you have a good chance of seeing a Lapland longspur, a bobolink, and a Tennessee warbler: all three species are listed as "common" spring-

time species on the park's bird checklist. Just northeast of Split Rock Creek, you'll find Lake Shetek State Park, which contains the headwaters for the Des Moines River. It attracts many marsh birds, and you'll have a good chance of spotting lesser yellowlegs, spotted sandpipers, Wilson's snipes, and maybe an upland sandpiper.

Farther north, Lac qui Parle State Park, known for its spectacular waterfowl migration in the spring, can attract twenty-five different species of warblers, including the yellow-breasted chat. Nearby Big Stone Lake State Park, also on the Minnesota River, boasts "one of the largest and most diverse" bird checklists of any state park; you might manage to identify five different species of swallows there. In north-central Minnesota, outside of Moorhead, Buffalo River State Park has dancing prairie chickens in the spring and numerous prairie sparrow species, such as the clay-colored, grasshopper, savannah, and secretive Le Conte's. The park's wooded areas are excellent for viewing migrating warblers, vireos, thrushes, and flycatchers.

On the other side of the state, along the Mississippi River, Frontenac State Park is recognized as the crown jewel of birding in the state park system. There have been 260 species identified at the park, more than at any other park, and Sand Point, a spit of land jutting into Lake Pepin, is famous for its excellent shorebird viewing.

Cascade River State Park

Because habitat has been spared from destruction and, in many instances, improved through reintroduction of native plant species and selective burning, state parks are critical areas for the future of Minnesota's bird species. Janssen knew as much in 1972 when he wrote in a magazine article that state parks "are downright necessary to the perpetuation of the sport [of bird watching]. Many of the parks contain woodland and wetland habitat that is essential to many species of birds." Janssen didn't know back then that he would play a central role in documenting every bird species at every state park. He only knew that it would be a good idea—not for him, but for future generations of bird-watchers. ⊠

Charles A. Lindbergh State Park

Famous Buildings at State Parks

In addition to scenic vistas, wooded hiking trails, and quiet campsites, Minnesota state parks are home to buildings steeped in history. A few examples:

⁞ Charles A. Lindbergh State Park: The boyhood home of Charles A. Lindbergh, Jr., was built in 1906 by his father, who served in the U.S. House of Representatives from 1907 to 1917. Complete with the original family furnishings, the state historic site tells of the famous aviator's boyhood.

⁞ Crow Wing State Park: A Greek Revival home, recently returned to its original spot in the park, was built in 1847 by Clement H. Beaulieu, who ran a branch of the American Fur Company. His home is the oldest standing structure in Minnesota north of St. Anthony Falls.

⁞ Itasca State Park: Built in 1905, Douglas Lodge was the first building in the state park system to adopt the rustic style that came to define future structures. In 1934, the Civilian Conservation Corps built its first edifice in the park, the Old Timer's Cabin, an impressive structure featuring walls made of only four giant pine logs.

⁞ Rice Lake State Park: Built in 1857, Rice Lake Church is the last remaining structure of Rice Lake village, which became a footnote in history when the new railroad was routed several miles south of town. ⊠

Lake Bemidji State Park

Crow Wing State Park

Photographer's Note

In life's work, there are periods of incredible high points, and for me this project will always rank near the top.

Prairie, Lake, Forest began as an idea that grew into an adventure. Early on, I was somewhat apprehensive and a bit overwhelmed with the task before me. Could I adequately capture the true beauty and uniqueness of each state park? It wasn't long before I forgot my fears and immersed myself into each subject. I began by marking the parks on my atlas to ensure I wouldn't miss even one, and then I eagerly set off down the road. At every destination, I found it helpful to ask the staff to share their thoughts on how I could capture with my camera the true character of their park. The ideas and information they shared was invaluable. It soon became evident that each park offered something unique to visitors. Grabbing a map and my camera gear, I hit the trails in a quest to showcase Minnesota.

My goal was not only to offer the reader spectacular scenic shots but to show the numerous ways our parks are enjoyed. From camping to bird watching, kayaking to rock climbing, Minnesota state parks have something for everyone. I especially appreciated watching families fishing together. Another highlight was the wildlife I spotted along the more remote trails. These sights kept the camera buzzing and the memory cards full.

Exploring what each of Minnesota's sixty-six state parks had to offer gave me an incredible opportunity to see our state in a new way. Sitting quietly along a riverbank or a rock outcrop provided me space to reflect on just how lucky we are to have these wonderful parks as our playground.

I want to acknowledge and thank the many park employees who made me feel welcome while visiting their parks. They helped me experience the best of the best. I thank my family for their support and understanding while I was away from home many days and nights; editor Shannon Pennefeather, MHS press director Pam McClanahan, and all the staff for their support; and Chris Niskanen, whose words breathed life into my photographs. Finally, a special thanks to the late Will Powers, who I know will enjoy this book from above. ⊠

Doug Ohman
New Hope, Minnesota

Index

Prairie, Lake, Forest
was designed and set in Archer and Gotham
by Brian Donahue, bedesign, inc.

Printed in China by Pettit Network, Afton, Minnesota.